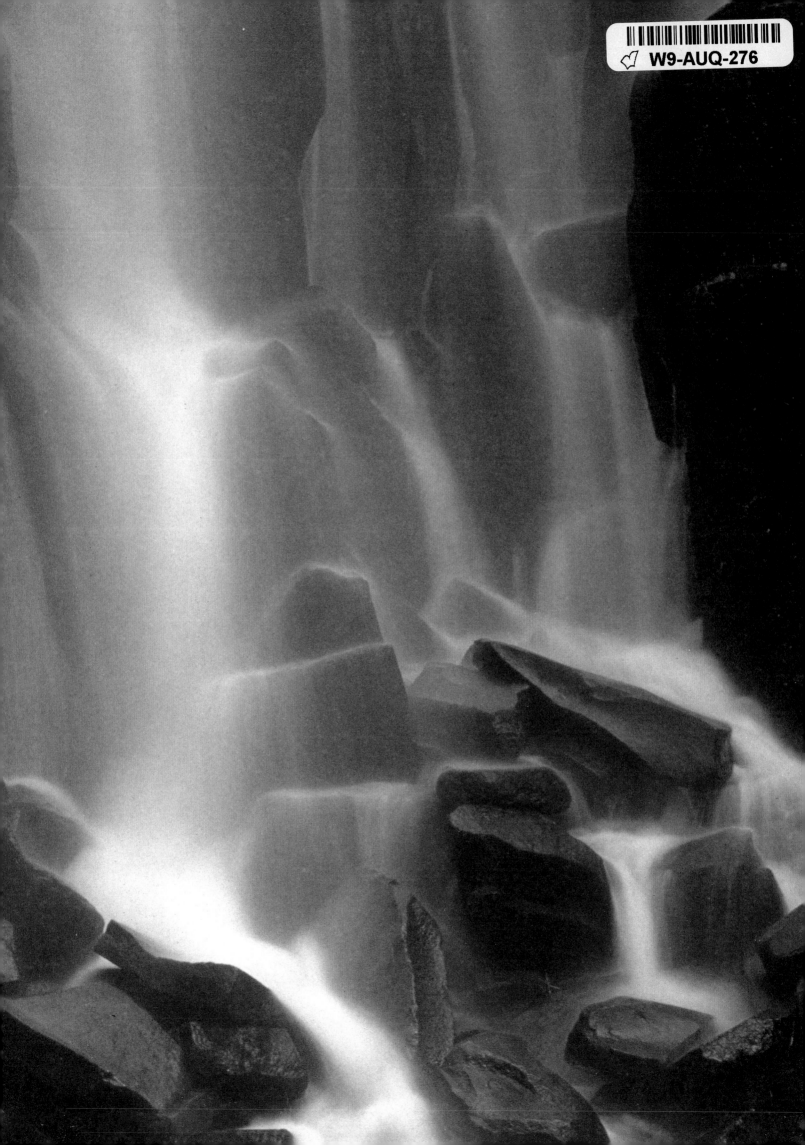

THE Kodak BOOK OF PRACTICAL 35 mm PHOTOGRAPHY

ISBN 0-87985-606-8

For rights information about the photographs in
this book please contact:

The Image Bank
111 Fifth Avenue, New York, N.Y. 10003

Manufactured in Singapore

Produced by Robert M. Tod
Art Direction and Design by Mark Weinberg
Written by Robert Herko
Edited by Elizabeth Burpee
Editorial Coordination by Elizabeth Loonan
Editorial Assistance by Ann-Louise Lipman
Kodak Editor: Derek Doeffinger
Kodak Editorial Assistant: John Fish
Assistant Art Director: Dana Shimizu

THE Kodak BOOK OF PRACTICAL 35mm PHOTOGRAPHY

PRODUCED BY THE IMAGE BANK
IN ASSOCIATION WITH EASTMAN KODAK COMPANY

C O N T E N T S

INTRODUCTION

Using This Book

Even though the technical aspects of photography are taught in many schools, important additional personal reactions must occur to create memorable photographs. Most successful photographs result from the combination of technical knowledge and the artistic vision of the individual photographer.

While many textbooks give detailed information on how to make a photograph, this book, to help you master 35 mm photography, combines the technology of photography with insight into the creative process. The exceptional photographs that accompany the text have been chosen from the millions available in the files of The Image Bank. They represent the creative and artistic vision of many of the world's best photographers. The captions provide a wealth of information about the creation of the images and demonstrate points made in the text.

Understanding how successful photographers use basic knowledge of photography to create images that are truly exceptional will help you to project your personal vision into your own 35 mm photography.

Key to Sections and Symbols

By using the cross-references between the picture index, and illustrations, it is possible to obtain information on specific techniques and equipment for most photographic occasions. The section on applying photography (Chapter Nine) presents examples of the way in which photographs are created and used to capture not only the visual impact of a subject or event but also the mood and feel of these views of the world that surrounds us.

The symbols provided with each caption direct you to the various sections of the text that give additional details on the lens, lighting, or technique used to create each photograph. Information can thus be obtained by finding a specific type of photograph within the book and then referring back to the chapters and sections indicated by the symbols accompanying the captions. In this way, the book can be used as a continuing reference by matching what you need to know to the photographs presented within the chapters.

A Few First Thoughts About Photography

The photographic medium has been in use for some 150 years, in various forms. Photographs provide pleasure, memories, documentation, and a form of relaxation or a living for many people who live and travel all over the earth. The history and achievements of society have been preserved and interpreted through photographs. No other medium has such power to convey emotional impact, visual detail, and a lasting impression of a place or an event to viewers who do not have to be present.

The 35 mm format has become firmly established as the most widely used camera and film type in the world today. The nearly universal acceptance of this film size and camera has been attributed to the introduction of advanced technology, which makes the correct exposure of film far simpler than ever before.

Recent estimates state that a total of 42 billion photographs are taken every year worldwide, by professional and amateur photographers. This sheer volume of photographs, about 95 percent of which are in color, is a testament to photography's popularity and to mankind's need to document and interpret the world that exists—and, in some cases, to provide a medium through which the fantasies of the human imagination can be shared.

As you read this book and come back to the sections time and again, remember that the photographs you make may reveal something about yourself to your viewer through the way you see and present your subjects, even if you make only casual snapshots. As a form of communication, photography may not be as precise as language, but a message is present in every image. A photograph may evoke memories, experiences, and emotions from those who view it, often quite intensely. As advances in technology continue to improve the ease of making a photograph, you must remember that it is the photographer, not the technology, who determines the content of the picture and who ultimately is responsible for the image.

The camera, like any other tool, is merely that—just another tool. It is the final product, the photographs, that are the basis on which the talent of the camera user is judged. Learn the fundamental rules and techniques of photography and be able to employ both to create those images that please you the most, and to express your emotions about the subjects of your pictures. But by all means do not become enslaved by photographic technology and its rules for their own sake. Use them as guidelines to help you discover more of yourself and the world that surrounds you.

① UNDERSTANDING 35mm CAMERAS

No other type of camera in history has had the popularity and acceptance of the modern 35 mm single-lens-reflex camera, called SLR for short. Advances in technology have provided a continual string of automation updates to the format, so that several models have become auto-everything and even include built-in motor winders that both load the film and rewind it automatically. This simplification in use of the 35 mm camera, along with better picture quality than other simple formats, has been a primary reason for its popularity. But then, of course, the image of the photographer from the 1960s with the motor-driven 35 mm hung over the shoulder still entices many individuals as a desirable self-image. And because it is easy to carry and operate, with practice its use becomes second nature. This simplicity, allowing quick response to split-second impressions, has made it the logical choice of amateur and novice photographers as well as professionals.

There are three basic types of 35 mm camera: that termed rangefinder, where a scene is viewed and focus adjusted through a second set of optics that corresponds to the view of the imaging lens; the simpler viewfinder model, also called the lens-shutter camera, which will be discussed later in this chapter; and the single-lens reflex, in which the picture field is viewed through the actual taking lens by means of mirrors and pentaprism. In this way, the SLR provides the most accurate view of the subject for final image composition.

Of the three 35 mm camera types, the SLR is by far the most versatile. There is only one true manual rangefinder camera in current production. Many of the other rangefinder cameras have either a zone-focus lens or an autofocus system that uses several distinct focusing zones to achieve a reasonably sharp image. Lens-shutter 35 mm cameras are widely available as compact, automatic-everything cameras that outsell the traditional SLR. They are small and quite convenient for quick photography and snapshot situations. Although they are not as versatile or adaptable as the 35 mm SLR, many photographers carry them for spontaneous, simple photo opportunities.

There are certain "bridge" cameras now coming onto the market. Although they are not fully versatile, multimode SLRs in the strictest sense, some are automatic-everything interchangeable-lens SLRs that can function as point-and-shoot cameras. They have a wider selection of lens types than is available with the compact lens-shutter cameras, even those that have permanently attached zooms. These cameras have built-in dedicated flash units that either function automatically or can be manually activated when fill-flash or complete illumination by flash is required. They fill the gap between the more compact lens-shutter cameras and the full-feature SLRs.

The 35 mm format still camera was invented by Oskar Barnack of the E. Leitz Optical Company in 1914 and named Leica. This revolutionary camera was first marketed at the Leipzig Fair in 1925. For a long period it was considered a miniature-film enthusiast's camera, even after many photojournalists started using it. The frame proportions, still in use today, were 24 mm by 36 mm, a 2:3 ratio that resulted from the use of double-frame 35 mm motion-picture film.

When the landmark single-lens-reflex camera, the Nikon F, was introduced in the late 1950's, many professionals began to use the 35 mm format for photojournalism. The speed of 35 mm Kodachrome film, which was introduced in 1936 with an ASA speed of 10, increased in sensitivity to ASA 25 for Kodachrome II film. Then another version, Kodachrome-X film, appeared with a rating of ASA 64, and the 35 mm camera became capable of producing spontaneous, dynamic color images that could be enlarged to the size of a page in *Life* magazine without really sacrificing any significant detail that might have been gained with a larger format film.

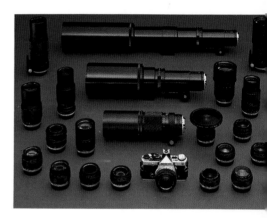

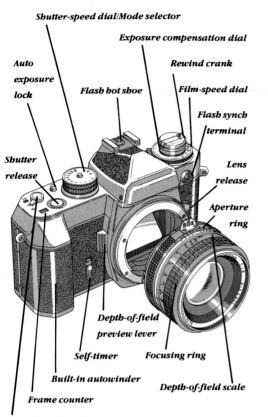

Shutter-speed dial/Mode selector

Exposure compensation dial

Auto exposure lock

Rewind crank

Flash hot shoe

Film-speed dial

Flash synch terminal

Shutter release

Lens release

Aperture ring

Depth-of-field preview lever

Self-timer

Focusing ring

Built-in autowinder

Depth-of-field scale

Frame counter

On-off switch/Battery check

On some cameras, you adjust film speed, aperture size, shutter speed, and exposure digitally by pressing the appropriate buttons.

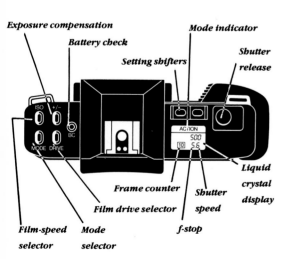

Exposure compensation

Mode indicator

Battery check

Shutter release

Setting shifters

Liquid crystal display

Frame counter

Shutter speed

Film drive selector

Film-speed selector

Mode selector

f-stop

CAMERA OPERATION

In manual mode, the operation of many of the modern SLR cameras is based upon the use of automatic-aperture lenses that do not, in spite of their designation, set the lens aperture automatically. The term actually means that the aperture stays wide open for better viewing while focusing and composing operations are carried out and then, when the shutter is released, closes down to the previously selected aperture setting for proper exposure of the film. Early SLR cameras required the aperture to be preset to the appropriate f-stop setting and had no mechanism for the automatic closure of the diaphragm blades at the moment of exposure, and so the entire focus-to-exposure process was somewhat slower.

Most 35 mm SLR models utilize a shutter that is very near the film plane. This shutter usually consists of a pair of curtains that travels either vertically or horizontally to provide a timed exposure. For shutter speeds up to the point of flash synchronization—that is, the highest shutter speed at which electronic flash can be used with that camera—these curtains open completely across the surface of the film being exposed: The first curtain travels to the open position, and then the second curtain follows at a specifically timed interval, halting exposure of the film. Only at these shutter speeds, generally $1/60$ second and slower, is the entire surface of the film completely uncovered at one time. At higher shutter speeds, the two curtains form a slit that travels across the film so that every part of the film surface receives exactly the same amount of exposure. The term "shutter speed" does not indicate how fast the curtains actually travel but simply denotes the length of time the film is exposed to the imaging light coming through the lens. The upper limit of "speed" for a shutter is determined both by the width of the slit between the curtains and the velocity that can be achieved by the curtains. Several models of SLRs now have top speeds of $1/4000$ second, with flash synchronization speeds of $1/250$ second. Most contemporary shutters have excellent performance characteristics: very even curtain travel and highly accurate shutter speeds attributable to the new generation of quartz-crystal timing and electronic, rather that mechanical, control.

When the shutter-release button is pressed on an SLR, a very precisely timed sequence of events follows. First, the mirror begins its upward travel and the viewfinder goes black. When the mirror is completely raised, the aperture blades close down to their set opening. The first shutter curtain then begins to open and, depending upon the shutter speed selected, the second curtain either begins its travel after the first curtain is completely open (low speeds) or moves after only a slight delay, forming the traveling slit for exposure at high speeds. When the second curtain has finished moving and the exposure is completed, the mirror snaps back down into place and the image is returned to the viewfinder. All this occurs within 45 milliseconds at very high shutter speeds; at lower speeds, of course, it takes proportionally longer.

Motor drives that operate at rates of up to 6 frames per second are either an add-on option with many system-oriented SLR cameras or built in as part of an integrated camera design. Although most photographers really do not require the speed of a motor drive, it adds convenience of operation because the camera need not be removed from the eye in order to advance the film or cock the shutter. It is invaluable for any type of action photography, be it sports, people, or wildlife, as the camera is virtually always ready to make another exposure. The only drawback with many of the external motor drives is their added weight and power requirements: They may need as many as twelve AA batteries for operation.

Rangefinder cameras were the very first type available in 35 mm format, and some famous photojournalists used these cameras for their work because they were fast and accurate and so could capture the spontaneity of many situations. Today, they are still revered for photojournalistic work because of their extremely quiet shutter operation and accurate focusing in low-light conditions. There remains only one true rangefinder camera with interchangeable lenses on the market today, but

the thousands of dedicated users have ensured that the legend that surrounds these remarkable cameras will continue as long as any is manufactured.

The true rangefinder 35 mm camera, as typified by the Leica M series of camera bodies, has a simpler exposure operation and a much more complex focusing mechanism than an SLR camera. Because the lens that makes the image on the film is not used for viewing the scene, an automatic-aperture-and-mirror system is not required; so these cameras can have their shutters directly behind the lens. Viewing and focusing require a separate viewfinder, preferably one that is capable of matching the field of view of the lens and providing a means for positive focus.

In the Leica, focusing is accomplished by a split-image triangulation rangefinder and a coupled, precisely ground cam on the lens helicoid. The field the lens covers is defined by a set of bright-line corners superimposed on a 28 mm field of view. As different lenses are attached to the camera, these field lines change to indicate the various coverage angles. The disadvantages to this are that the field lines at 90 mm and 135 mm enclose a very small portion of the entire viewfinder image and that depth of field cannot be previewed with any lens. The advantage of this type of camera is that the focusing zone, being a split image supplied by beam-splitter mirrors, is exceptionally bright and very accurate, especially with wide-angle lenses in dim light.

The more common type of camera manufactured today is often referred to as either "lens-shutter" or "leaf-shutter". It has a noninterchangeable lens of fixed-focal-length, generally around 38 mm, and a simplified zone-focusing system that either requires the user to estimate the distance to the subject, or is automatic. In most models, there is a leaf-type bladed shutter in the lens, and all exposure operation is usually completely automatic, without any input being required from the user. The viewfinder frames are fixed and do not compensate for the parallax present when used in close-focus position; so these cameras are not very accurate in critical close-up photographs, such as facial portraits.

These cameras also have automatic features, such as setting of the film speed by the DX electronic encoding system present on many film cassettes, automatic loading and rewinding, and automatic film advance between shots, all powered (in most models) by two AA cells. In addition, there may be a built-in flash unit that activates automatically in low light and is also powered by the camera's batteries.

Many variations of these cameras exist. Some can be fully immersed in water at depths up to fifty feet, others are dry-land models with continuously variable zoom lenses that also have coupled viewfinders, making them into a type of rangefinder camera system. A multitude of other types show variations on the basic theme, a number having two or three fixed focal length lenses or special close-up capabilities.

Some professionals carry cameras of this type for behind-the-scenes shots on assignment because of the speed at which they can make an image, without having to think about the shot beyond composing it within the viewfinder lines. The cameras can be quite versatile when used with color negative film, which has a large exposure latitude and can produce good spontaneous photography. Their versatility and usefulness are somewhat limited by their automation and their limited lens capabilities.

The loading procedure for most 35 mm cameras, whether automatic or manual, varies greatly, and it is best to refer to the manufacturer's specific procedure for each type of camera. In general, loading should be carried out in subdued light, especially with color film. Outdoors, try to find some shade. If there is none, the photographer can always create temporary shade simply by turning his/her back to the sun.

The points to remember in caring for a camera of any type are to avoid exposure to extreme heat and excessive dust and to check the batteries, particularly the AA type, for any leakage. If the camera is to be stored for any period of time, even as little as two months, the batteries should be removed, stored in a plastic bag, and

THE SLR SHUTTER CURTAIN

Virtually all current 35 mm SLR cameras use focal-plane shutters (so named because they're located just in front of the plane of focus—the film). Focal-plane shutters move either horizontally or vertically. They consist of two rolled-up curtains like miniature window shades or sometimes two sets of horizontally overlapping metal blades (shown at left). The practical operating sequence is similar in either case. At slow shutter speeds, say 1/60 second or longer, the first curtain or set of blades snaps open and uncovers the whole film frame to light. When the proper time has elapsed, the second curtain or set of blades closes and covers the film again.

At higher shutter speeds, focal-plane shutters do not completely uncover the film frame in one instant. Instead, the shutter curtains form a slit. The slit sweeps across the film, "painting" a band of image-forming light as it moves. The faster the shutter speed, the narrower the slit.

Focal-plane shutter blades open fully for slow shutter speeds.

The shutter blades form a moving slit for fast shutter speeds.

placed in a cool or even, except for alkaline batteries, refrigerated area. The lower temperature will help the batteries retain power for longer periods of time, and removal from the camera will prevent damage that might be caused by any possible leakage.

The lenses should be cleaned periodically to remove dust or fingerprints. Once in a while, check the film chamber and interior of the camera for dust and film particles and clean it with a very soft brush or a gentle stream of compressed air. While doing this, keep the shutter open at the "B" or "T" setting to prevent damage to the curtains; take extreme care to avoid having the dust brush or air stream impinge upon the surface of the shutter curtains. In all cases, remove the lens, if possible, so that any dust particles or fibers can be removed from the imaging area and the mirror chamber.

The mirror used in an SLR camera has a fragile coating of silver on its surface. Under no circumstances should the mirror be cleaned with a brush or lens tissue or have dust blown off its surface with compressed air. If there is an excessive buildup of dust or an accidental fingerprint, have the mirror cleaned by a qualified camera-repair professional.

Most camera bodies will not survive very well when dropped in water, but lenses have a higher chance of being saved. If a lens is dropped into salt water, rinse it immediately in fresh water and leave it submerged in fresh water after the rinsing is complete. Then send it, still in fresh water, to the nearest service center.

THE LEAF SHUTTER

Most compact 35 mm cameras use some variation of a between-the-lens leaf shutter. This type of shutter is positioned in the lens barrel between lens elements. It is composed of several metal blades or leaves that swing outward to open. The moment the opening forms, the entire frame of film is exposed to incoming light.

Regardless of shutter speed, a leaf shutter always fully opens to expose the film.

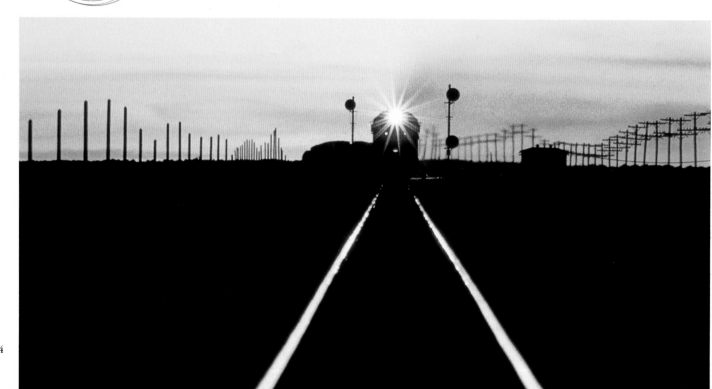

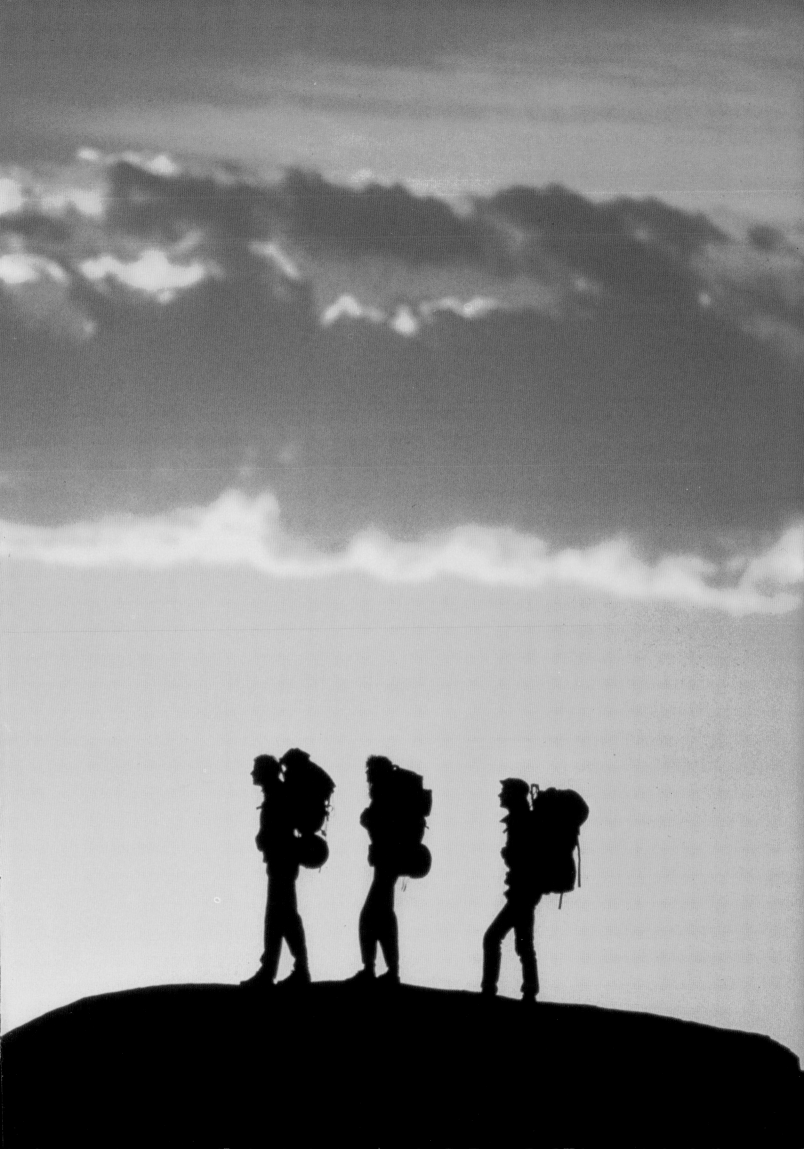

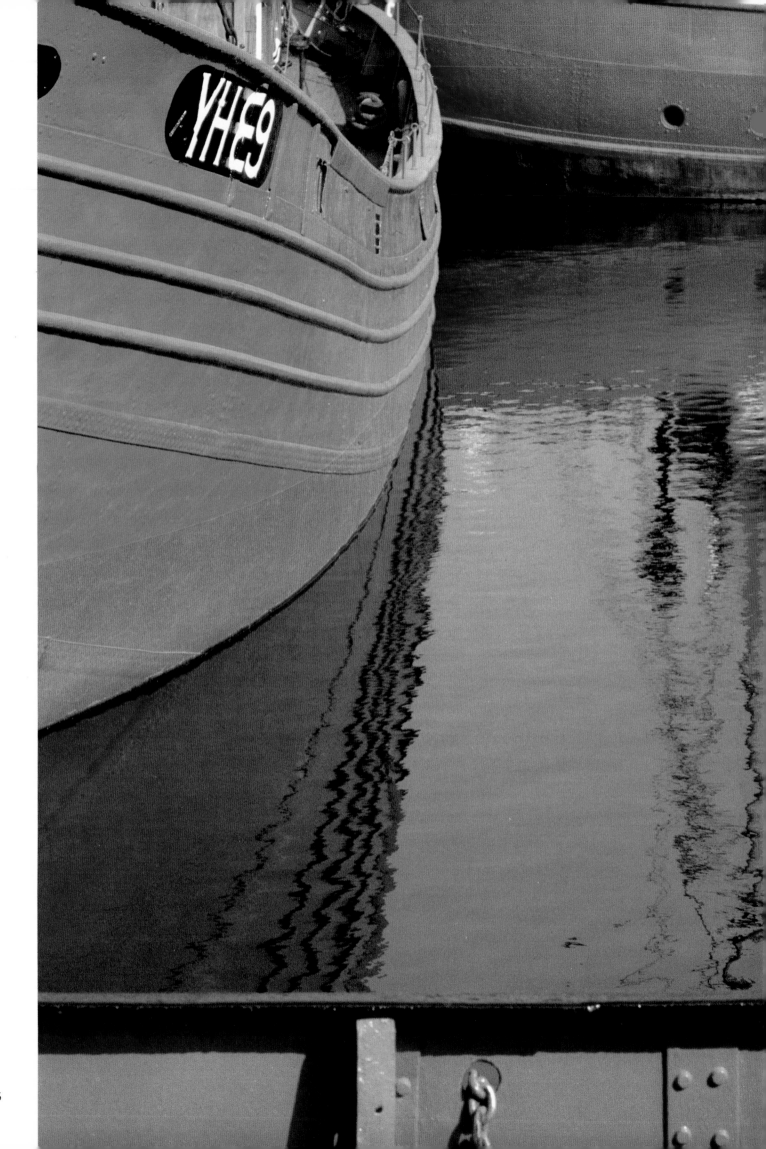

❷ AUTOFOCUS CAMERA SYSTEMS

The continuing infusion of technology into all aspects of modern life has led to the development of cameras with very sophisticated electronic autofocusing systems. The microprocessor systems contained in many of the newer autofocus cameras have achieved a level of complexity never seen before in optical imaging equipment for the commercial market.

The original automatic-focus cameras were introduced in the 1970s as rangefinder automatic-exposure cameras with fixed lenses. These cameras used either optical contrast, triangulation, or reflection of infrared emissions to determine focusing distance. They operated on a system of focusing zones that were consistent with the depth of field provided by their moderately wide-angle lenses. The simplest of these cameras used three zones, the most sophisticated had five. Now more accurate methods for autofocusing have been developed, primarily with either phase detection (optical contrast comparison) or infrared rangefinder focusing.

The infrared system, used mostly in lens-shutter 35 mm cameras, determines the focusing distance by emitting a small infrared beam and having a slit move internally over an infrared sensor until the reflection of the infrared beam is found. The extent of the slit's travel then determines the focusing distance for the lens. Occasionally, this focusing system will miss the focusing point when attempting to photograph through a window or pane of glass because the beam is deflected by the glass surface. This can be avoided by moving the camera to aim at an angle to the glass.

Cameras that employ this type of automatic focusing method have become one of the most popular types of 35 mm auto-everything imaging device available. The earlier types, with their single-focal-length lenses, have gradually been replaced by cameras with two built-in lenses of different focal lengths, or, in some cases, by continually variable zoom optics that also have synchronized viewfinders to show the relative area of lens coverage and magnification. Most of these cameras do not provide for any manual settings and have integrated motor drives for advancing the film and for rewinding it after exposure of the entire roll. These factors can limit their use in creative situations, despite the new versatility of their variable angles of view.

From time to time, autofocus lenses for many SLRs have been offered that have their entire autofocusing sensor system and drive motors mounted within their rather large barrels. For the most part, these lenses have not been well accepted because they have not been available in a wide range of focal lengths; besides, they are bulky and inefficient when compared to manually focused lenses.

Two new developments have changed all that. First, the introduction of special optical microchips called CCDs (charge-coupled devices) has led to the introduction of very sophisticated SLRs with autofocus capabilities. Most of these cameras are fully developed SLR systems with the autofocus control designed into the camera body. Matching lenses focus by means of micromotors controlled by the CCD in the camera body. And that was the other technological development needed to create a true autofocus SLR: the development of micromotors with sufficient torque to drive the focusing helicoid of a 35 mm lens.

Depending upon the manufacturer, these motors are either placed in the camera body and linked to the lens helicoid by a drive coupling or are mounted in the interchangeable camera lens barrel and provided with electrical contacts for the focusing signal. Because these systems operate on an infinitely variable focusing range, rather than the zone system of other rangefinder autofocus cameras, "focusing accuracy" means minimal overrun of the focusing point. The major difficulty has been the speed at which the micromotors could drive the lens for focusing and achieve a good degree of accuracy.

Many of the technical limitations have been overcome in the last few years, but these systems are not yet fast enough to focus on action that occurs at high speeds, such as basketball or horse racing.

The two models for the Canon EOS (Electronic Optical System) employ advanced electronic control and motor technology and have raised autofocus from a convenience to a practical, professionally oriented feature. The EOS system utilizes fully electronic lens-to-camera couplings with both focusing motors and aperture-actuation motors mounted within the lens barrel.

The Canon 28-80 mm EF zoom lens for the EOS cameras shown here is typical in external appearance to most autofocus zoom lenses. In the Canon EOS system the lens contains the drive motors for both focusing and the electronic aperture mechanism.

AUTOFOCUS OPERATION

The CCD-based autofocus systems employed in most SLRs use a system of phase detection to determine whether or not a subject is in focus. A portion of the image from the center of the frame is passed through a beam-splitter mirror, and a small percentage of the light coming in through the camera lens is sent to a separate optical module. This module usually consists of a field-limiting mask and a pair of separator lenses that project two images of the subject onto the surface of the CCD module. The CCD module then generates a signal for each image, and these two signals are compared to a reference signal to determine in which direction, and how far, the subject is out of focus. The microprocessor then generates a corresponding signal to drive the lens's focusing ring in the proper direction and to the necessary amount. Constant feedback to the microprocessor from the CCD module and from position sensors located inside the lens barrel allows the micromotors to be controlled to the exact point of focus.

Ongoing improvements in autofocus systems now make it possible for several camera models to provide adequate response in continuous light dim enough to require an exposure of about one second at an aperture of $f/1.4$ at a film speed of ISO 100. The autofocus tends to fail, however, at twilight or night-exposure light levels and must then be manually overridden for proper sharpness to be achieved. Also, if there is a lack of contrast within a scene, as when a person dressed in white stands in front of a white wall that is evenly illuminated, the CCD sensing module will not be able to make any image comparison and the lens will not come to a proper focusing point.

The more advanced autofocus cameras incorporate several new systems for achieving autofocus accuracy when special "dedicated" flash units are coupled to the camera. Dedicated flash units contain special circuitry and electrical contacts that link up to the camera circuits for proper operation. These flash units emit an infrared beam that enables the camera to focus itself even in complete darkness. It functions in this manner: When the shutter is released, the flash unit sends out a beam of infrared radiation that bounces back from the subject into the CCD module in the camera body, where it is used to establish the autofocus distance as though the subject were properly illuminated. The distance over which this operates is somewhat limited, about twenty-five feet for most types, but the accuracy is quite good.

AUTOFOCUS LENSES

Autofocus SLR camera systems operate only with specially designed autofocus lenses that usually carry an "AF" either in their description or on the box. Depending on the particular manufacturer, the lenses contain either a drive-coupling mechanism for the autofocus motor mounted in the camera body or have a self-contained micromotor within the lens barrel. In both types, microchips in the lens barrels provide information to the central processing unit (CPU) within the camera body concerning lens focal length, maximum and minimum aperture, and focusing position.

Most of the autofocus systems have developed an extensive array of focal lengths, from 15 mm full-frame fisheye lenses to 600 mm $f/4$ high-speed telephotos, and there is also a complement of zoom lenses in popular focal lengths. More engineering plastics have gone into the construction of these lenses in order to achieve lighter weight and to reduce the torque required for operation of the focusing rings in normal manual-focus types; so they are equivalent in size and weight to most manual lenses.

Most of the AF lenses do have manual focusing rings and a switch on either the camera body or the lens that permits them to be used in manual mode. The gear trains in the focusing barrels do not add much drag to manual operation of the lens. In fact, with the very low friction levels required for the micromotors, they actually have smoother manual focusing than do most manual lenses.

WORKING WITH AUTOFOCUS SYSTEMS

Two primary drawbacks of autofocus cameras have been their slow response speed and their inability to focus on low-contrast scenes. These will eventually be overcome with the further development of supporting technology for the CCD modules and micromotor technology. A third factor that still presents problems with the speed of operation of these systems is the aiming point for the autofocus sensor.

All the current autofocus SLR cameras have marks that create a target in the center of their viewfinders to indicate the spot where the autofocusing sensor reads the scene. But how often is the main subject actually in the center of the composition? To deal with this, manufacturers provide an autofocus-hold control or focus lock so that subjects that are not in the center of the frame can be brought into focus. In addition, the cameras have been equipped with several modes of autofocus operation, primarily single—also called focus-priority—and continuous.

The single mode of operation requires that a subject within the sensor target be fully in focus before the shutter fires. It is useful when the subject is not moving and when an exact point of focus is desired. The continuous mode keeps the focusing system in constant operation, tracking the subject with the focus target so that, at least in theory, the subject will always be in focus. However, this does not guarantee that the subject will always be in focus when the shutter is released. In most cases, acceptable results can be obtained with the continuous-focusing mode when the subject is at relatively far distances from the camera, so that less movement of the focusing drive is needed.

The focus lock is the single most important control on any of these cameras. It permits the focusing target to be placed on the subject (preferably not a moving one) and focus to be attained. At this point, the focus lock is activated and the particular distance setting is held, so that the desired composition of the scene can be made in the viewfinder without having to keep the subject inside the focusing target.

The advantages of the autofocus system are that photographers with poor eyesight or other limited abilities can now achieve excellent results in many circumstances where they would normally be hindered and unable to make a well-focused image with a conventional SLR. Also, in such situations as remote-control photography, sharp images can be guaranteed, at least when the subject is confined to the central area of the frame, even when there is variation in the subject's distance from the camera location.

BASIC STRUCTURE OF THE EOS AF SYSTEM

The increasing complexity of the autofocus camera's automation system ultimately makes the task of the photographer easier.

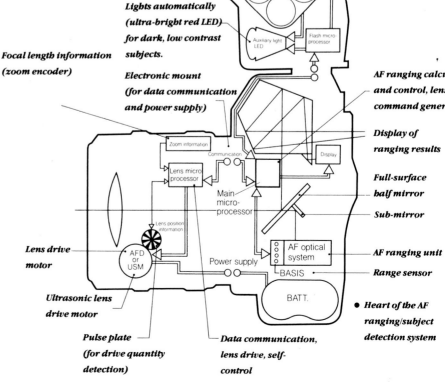

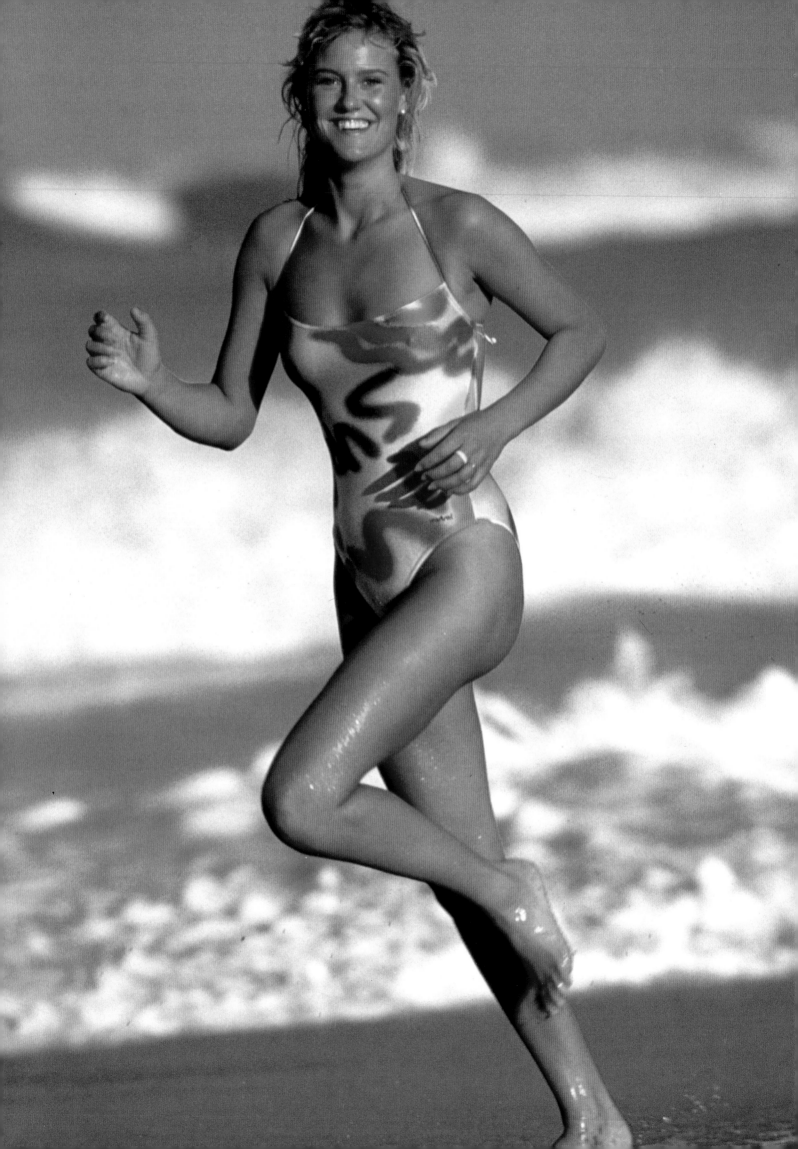

❸ BASIC PHOTOGRAPHY

The exposure of film has become extremely simple with the help of either the current in-camera light meters, called TTL meters (for through-the-lens), or with separate hand-held light meters. Each film is assigned an ISO speed that is a relative measure of the film's sensitivity to the amount of light required for a proper exposure. The initials stand for the International Standards Organization, and the speed numbers combine the formerly used ASA and DIN film-speed ratings. This ISO designation is the determining factor of a film's suitability to various photographic situations. Specific films and their usefulness will be discussed at the end of this chapter.

Films with a low ISO rating, generally around 25 to 100, are best for situations where there is an abundance of light, or when flash can be used. These films also have the highest sharpness and contrast of all types, with a potential for very high degrees of enlargement. With increasing film speed (at higher ISO numbers, generally 200, 400, and 1600) there is a tendency for the film to show increased graininess and less sharpness; this lowers its ability to record fine detail. Contrast differences are reduced in films with the higher ISO numbers, and the color rendition may not be as true as with the slower films. The advantage of these faster films is that they require less light in order to make a proper exposure. This can be a distinct advantage when photographs in low-level light are wanted and when the use of a flash is either not practical or not permitted.

The "graininess" of a film is the visible structure of the light-sensitive emulsion that coats it. In the case of color film, the final image after processing consists of individual dye clouds left in place of groups of silver-halide crystals that were present when the film was made and exposed but were eliminated by the processing. Slow films (low ISO numbers) have extremely small crystal structures that require more light for them to react whereas high-speed films have rather large (although still microscopic) crystal structures that are more sensitive to light energy but leave a highly visible granular pattern in the final transparency or negative. With recent improvements in the ability to manufacture smaller and more uniform silver-halide crystals, there have been substantial reductions in the graininess of many films, and consequently their ability to record detail has been increased. This has resulted in greater image sharpness and a grain structure that can only be seen under high magnification.

For certain special effects, films with high graininess are desirable for the creation of textured-looking images. The darkroom enthusiast desiring to produce a grain-textured photograph can do so with high-speed black-and-white film that is first overexposed, and then overdeveloped, preferably in a high-contrast developer. High-speed color negative film will also produce higher than normal graininess when overexposed and overdeveloped.

Grain in slides made with Kodak Ektachrome film can also be made more prominent by having the film push-processed to increase its effective ISO speed. The push-processing must be requested at the time the film is turned in for processing. If the ISO speed has been doubled, request a one-stop push. Some labs can compensate for two-stop and three-stop increases in the ISO speed. Besides increasing the apparent graininess of the slide, the disadvantages of doing this are a decline in the contrast and color fidelity and a decrease in the overall clarity of the image.

A high shutter speed, along with very precise timing, allowed the photographer to stop the motion of this woman running on the beach. With action such as this, a shutter speed of $^{1}/_{250}$ second or faster is recommended; of course, the larger lens aperture needed will produce a correspondingly shallow depth of field.

f/2

f/2.8

f/4

f/5.6

f/8

f/11

f/16

The lens diaphragm can be adjusted to regulate the amount of light passing through the lens. Specific settings are identified by f-numbers. Small f-numbers are associated with large lens apertures and large f-numbers are associated with small lens apertures.

The f-number stands for the focal length of the lens divided by the diameter of the aperture. Thus if the focal length of a lens is 50 mm and it is set to an aperture 25 mm wide, the f-number is f/2 (50/25 = 2). If it's 3 mm wide, the f-number is f/16 (50/3 = 16).

SHUTTER SPEEDS AND APERTURES

The shutter speed is what determines the amount of time that the film emulsion is exposed to the light transmitted through the lens of the camera. Most cameras have shutter speed ranges from 1 second to $\frac{1}{1000}$ second. Some models designed for professionals can go as long as 16 seconds and as fast as $\frac{1}{4000}$ second.

The aperture, or lens opening, is controlled by a set of diaphragm blades that create a variable-diameter opening through which light can pass. The larger openings are assigned lower numbers, called *f*-stops, whereas the smaller openings have higher numbers. The standard range for these aperture settings is *f*/1.4 to *f*/22. The *f*-stop numbers represent the ratio between the lens's focus length and the size of its opening.

The aperture settings that are marked on the lens are scaled in such a way that each successive whole *f*-stop transmits exactly half the quantity of light of the previous *f*-stop when going from low to high *f*-numbers.

Contemporary cameras also have shutter-speed settings that halve the amount of light reaching the film with each full step from low to high. At a given aperture, a shutter speed of $\frac{1}{8}$ second will allow only half the quantity of light to hit the film surface that would be allowed at a shutter speed of $\frac{1}{4}$ second.

Thus, there is an inverse relationship between shutter speed and aperture setting, whereby each whole step of either shutter speed or aperture represents a change by a factor of 2 from the previous setting, either double or half.

An effective analogy is to think of the film as a one-gallon bucket and light as water that must fill the bucket precisely. The lens opening, or aperture, functions like a pipe bringing water to the bucket. It can have different diameters. The shutter speed is much like a valve that lets the water flow for a certain period of time. The trick here is to let enough water into the bucket to fill it to the top, without overflowing and without leaving empty space in the bucket. With a pipe of large diameter, the valve need only be kept open a short time until the bucket is filled. This is analogous to a short exposure time at a very wide lens opening. If a small-diameter pipe is used, the valve must be kept open for a proportionally longer period of time in order to fill the bucket. This corresponds to longer exposures at small lens apertures.

For identical light intensity, there exists a series of paired aperture settings and shutter speeds that will provide proper exposure of the film. This relationship is called the law of reciprocity. The exact relationship is that if the shutter speed is doubled, the corresponding *f*-stop required to achieve proper exposure is one full *f*-stop smaller (higher *f*-stop number) than the previously set aperture value. A faster shutter speed (shorter exposure time) requires a larger lens opening (smaller *f*-stop). For each change in the shutter speed setting, there must be a corresponding change in the aperture setting in this reciprocal manner. In the same manner, a change of one full *f*-stop requires a change in shutter speed of either half or double, provided the light intensity remains the same.

There is a phenomenon that occurs with long exposure times that causes the reciprocity effect to no longer hold true, and then the relationship between shutter speed and aperture setting will no longer provide proper exposure. This effect, which begins at exposures of 1 second and longer, is called reciprocity-law failure, and to compensate for it additional exposure is required: either a longer exposure time or a wider aperture setting. Each film manufacturer supplies sets of tables that link the factors of film type, basic exposure time, and the required exposure correction, usually given in *f*-stops, along with any filtration required to compensate for reciprocity failure.

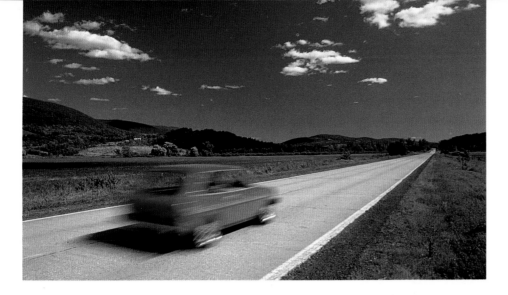

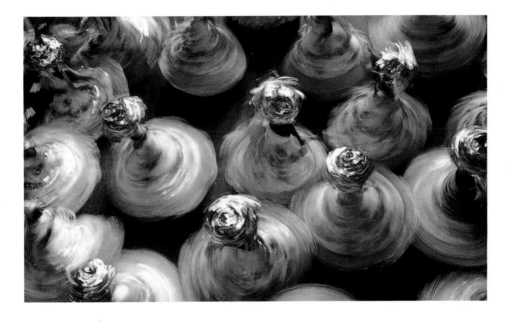

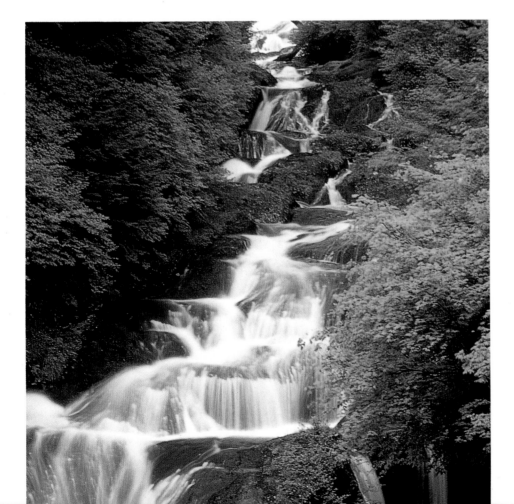

These three photographs use the same technique with very different subject matter to illustrate relative motion. For each of the exposures, the camera was on a tripod and a long exposure time was used. In the case of a waterfall, one second to several seconds' exposure will produce results such as this, whereas in the photograph of the car on the highway, any shutter speed lower than $^1/_{30}$ second will produce an appreciable amount of blur. The carnival dancers in Rio were shot with the same technique, using a shutter speed slow enough to make sure their circular motion would register on the film, while the camera was firmly secured.

Another way to illustrate motion and yet have a subject reasonably sharp is to move the camera along with the subject. This is called tracking (or panning). For this photograph of a horse race, the camera was set at a moderate shutter speed, in the range of $^1/_{30}$ to $^1/_{125}$ second. The photographer moved the camera along with the horses, trying to keep them in the same position in the viewfinder, and maintained this camera motion while the shutter was fired. The result: a very exciting image of running horses against a background blurred completely by the motion of the camera.

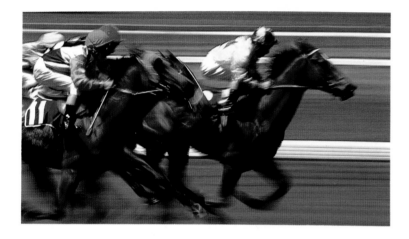

CHANGING BOTH SHUTTER SPEED AND APERTURE

1/60 second at f/16

1/125 second at f/11

1/250 second at f/8

1/500 second at f/5.6

1/1000 second at f/4

When you set the shutter speed or lens aperture, determine if the setting for the speed or the aperture is more important. If you are trying to freeze a downhill skier, you will need a fast shutter speed, such as 1/1000 second. If you are trying to get front-to-back sharpness of a flower garden, you will need a small aperture, such as f/16. Sometimes neither shutter speed nor aperture will be extremely important, and you can use intermediate settings such as 1/125 second at f/8.

The camera settings, shown above, let in the same amount of light: To create an impression of motion and yet define the subject to the viewer, the photographer used a long exposure to capture the movement of the Amusement Ride on the left side of the frame but timed his exposure so that the foreground wheel shows only minimal motion. The camera was on a firm support for the exposure. The one image provides both a description of the subject and an illustration of its motion.

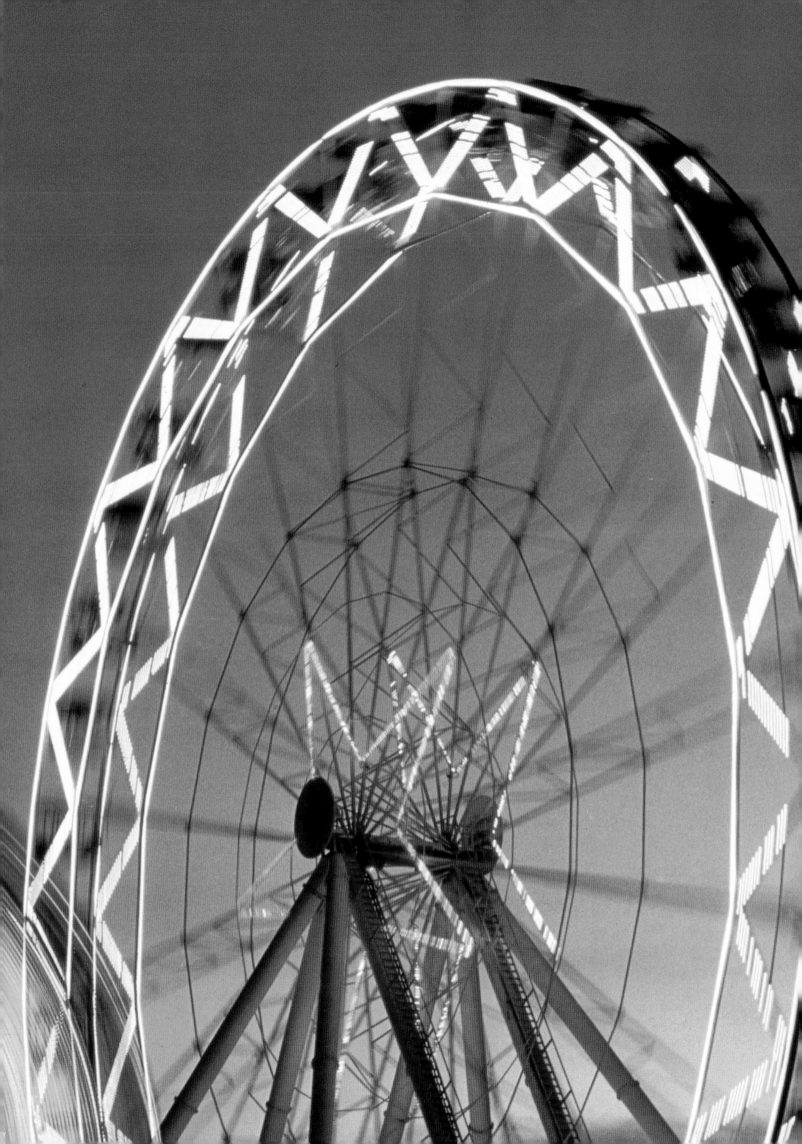

Proper exposure for people must be accomplished in spite of the direction and quality of the light. In the primarily backlighted photograph of the woman in the field, the photographer had to allow for the inflated meter readings caused by the bright background that would normally have led to underexposure of the woman's face. By taking a meter reading and then opening the lens as much as one full f-stop, this was avoided. Another, more accurate, method is to move in close to the subject for a meter reading of the skin tone, set the camera, step back, and shoot. The same situation is seen in the photograph of the man at the edge of the pool, although the effect is more subtle. The brighter patches of light reflecting from the water in the pool could easily inflate the camera's meter readings and cause underexposure of the entire picture, even though the blue of the water is very close to midtone in intensity. Experience with film under similar circumstances can help you determine the relative brightness of colors and the effect they will have upon actual exposure-meter readings.

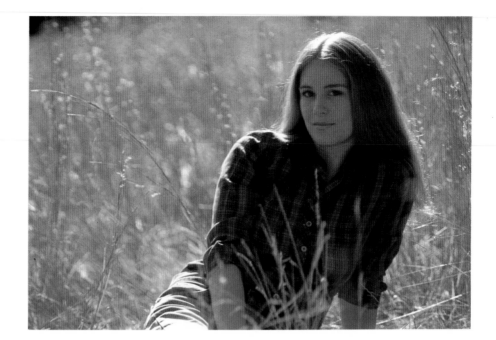

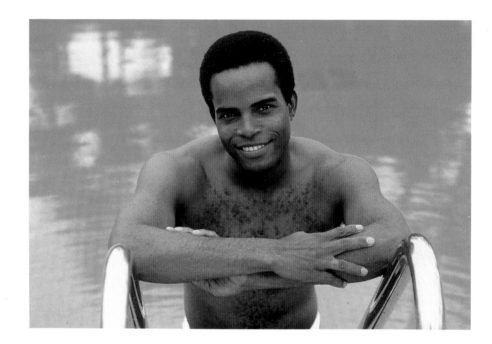

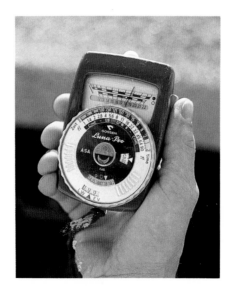

Hand-held light meters such as this one can be used for either reflected or incident-light measurements. The shutter speed and lens aperture settings can be read from the dial on the face of the meter.

LIGHT MEASUREMENT

Exposure metering is fundamental to being able to create a photograph. Two types of light are measured for photography: that which is reflected by the subject and that which is incident on the scene, falling equally on everything in it.

Reflected-light metering involves measurement of the intensity of light that is reflected by the subject within the scene. It has been scientifically established that a normal scene, as recorded on film, represents an average reflectivity of 18 percent; this is termed the middle tone or 18-percent gray. Although reflectance is defined in terms of gray, colors have reflective intensity and can be used to establish exposure. A clear blue northern sky and average green grass both have a reflectivity value of approximately 18 percent. The palm of the hand has a reflectance of about 36 percent, one *f*-stop higher (or one shutter speed faster) than this midtone value. Because color films, particularly color transparency types, are limited to a total recording range of about five full *f*-stops, it is important to meter this midtone accurately in any photographic situation when using a reflective-type meter, such as those built into cameras.

The reflected-light meter wants to make any subject it is pointed at appear to have this 18-percent-gray value. If the meter were pointed at white snow, the exposure information generated would cause the snow to appear middle gray in the final photograph. If the same meter were to be pointed at a dark subject, such as a freshly paved asphalt road, it would generate exposure data that would require the camera to receive too much light, and the black surface of the road would also appear as the gray midtone. For this reason, it is important to remember that, faced with a light subject, the photographer should read the exposure meter and then either increase the lens opening one or two full *f*-stops to allow more light in or drop the shutter speed by one or two steps. On the other hand, in a dark area or at night the meter will require too much exposure; so the photographer must either close down the lens opening by one or two *f*-stops or increase the shutter speed by one or two steps. In either case, only one correction should be made, whether it is the lens opening or the shutter speed; never both at the same time.

The incident-light meter measures the light that is striking the subject; it can measure the intensity of light on the shadow and on the highlight sides. This type of meter, too, is calibrated to average scenes with 18-percent reflectivity, but it is not affected by the light reflected from the subject. It usually has a translucent white plastic hemisphere that gathers light from all directions within its range of reception. The meter can be used either directly at the subject's location or at the camera position, provided the direction and intensity of light are the same as at the subject's position. Whereas a reflected-light meter is aimed at the subject, an incident-light meter is aimed at the camera position so it will see all the light falling on the side of the subject that faces the lens.

Incident-light meters are most useful where there are no midtones that can be metered with reflected-light meters, for instance very bright or dark scenes such as those encountered in snow, beach, or foggy weather, all of which can cause inaccurate reading by reflected-light meters.

Film can only record a limited range of brightness, up to 5-7 f-stops in difference between highlight and deepest shadow. Any tones beyond this range become either pure white or black. In this photograph, sunlight coming through a large window was the only source of illumination. Ordinarily, some sort of fill light would be required, from either an electronic flash unit or a white reflecting surface, to keep the shadows on the right side of the woman from becoming too deep. In this case, however, the room is painted completely white and has very glossy floors, and this gave a large amount of natural fill light. Some compromise was made in the image, since the direct sunlight on the walls tended to burn out the detail; but this in fact enhances the sunny, open feeling of the photograph. The difference between the bright portion of the wall and the darker section on the right was two f-stops. Exposure was determined by reading the light from the darker section of the wall, then increasing this exposure by one full f-stop to record the white wall as a bright surface. (If the exact meter reading had been used, the wall would have appeared as a middle-tone gray in the final image.)

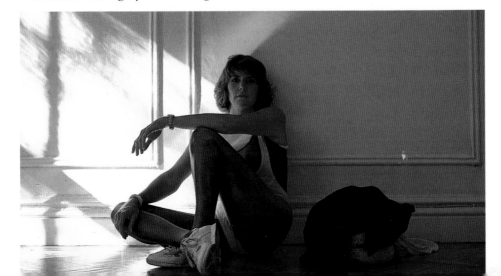

BRACKETING EXPOSURES

Most professional photographers tend to use a range of exposures when photographing a subject on transparent positive slide film, even when critical light measurement readings have been taken. This is usually not necessary for negative color films. In this procedure, called bracketing, exposures are made first according to the reading indicated by the exposure meter and then at a variety of settings that deliberately produce overexposed and underexposed photographs of the same

Suggested Exposures for Existing-Light Pictures

Picture Subject	ISO 64-100*	ISO 125-200	ISO 400††	ISO 1000
AT HOME				
Home interiors at night				
Areas with bright light	1/15 sec f/2	1/30 sec f/2	1/30 sec f/2.8	1/30 sec f/4
Areas with average light	1/4 sec f/2.8	1/15 sec f/2	1/30 sec f/2	1/30 sec f/2.8
Candlelighted close-ups	1/4 sec f/2	1/8 sec f/2	1/15 sec f/2	1/30 sec f/2
Indoor and outdoor holiday lighting at night, Christmas trees	1 sec f/4	1 sec f/5.6	1/15 sec f/2	1/30 sec f/2
OUTDOORS AT NIGHT				
Brightly lighted downtown street scenes (wet streets add interesting reflections)	1/30 sec f/2	1/30 sec f/2.8	1/60 sec f/2.8	1/60 sec f/4
Brightly lighted nightclub or theatre districts—Las Vegas or Times Square	1/30 sec f/2.8	1/30 sec f/4	1/60 sec f/4	1/125 sec f/4
Neon signs and other lighted signs	1/30 sec f/4	1/60 sec f/4	1/125 sec f/4	1/125 sec f/5.6
Floodlighted buildings, fountains, monuments	1 sec f/4	1/2 sec f/4	1/15 sec f/2	1/30 sec f/2
Skyline—distant view of buildings at night	4 sec f/2.8	1 sec f/2	1 sec f/2.8	1 sec f/4
Skyline—10 minutes after sunset	1/30 sec f/4	1/60 sec f/4	1/60 sec f/5.6	1/125 sec f/5.6
Fairs, amusement parks	1/15 sec f/2	1/30 sec f/2	1/30 sec f/2.8	1/60 sec f/2.8
Fireworks—displays on the ground	1/30 sec f/2.8	1/30 sec f/4	1/60 sec f/4	1/60 sec f/5.6
Fireworks—aerial displays (keep shutter open on Bulb for several bursts)	f/8	f/11	f/16	f/22
Burning buildings, campfires, bonfires	1/30 sec f/2.8	1/30 sec f/4	1/60 sec f/4	1/125 sec f/4
Night football, baseball, racetracks†	1/30 sec f/2.8	1/60 sec f/2.8	1/125 sec f/2.8	1/250 sec f/2.8
Niagara Falls				
White lights	15 sec f/5.6	8 sec f/5.6	4 sec f/5.6	4 sec f/8
Light-colored lights	30 sec f/5.6	15 sec f/5.6	8 sec f/5.6	4 sec f/5.6
Dark-colored lights	30 sec f/4	30 sec f/5.6	15 sec f/5.6	8 sec f/5.6
INDOORS IN PUBLIC PLACES				
Basketball, hockey, bowling	1/30 sec f/2	1/60 sec f/2	1/125 sec f/2	1/125 sec f/2.8
Stage shows				
Average	1/30 sec f/2	1/30 sec f/2.8	1/60 sec f/2.8	1/125 sec f/2.8
Bright	1/60 sec f/2.8	1/60 sec f/4	1/125 sec f/4	1/250 sec f/4
Circuses				
Floodlighted acts	1/30 sec f/2	1/30 sec f/2.8	1/60 sec f/2.8	1/125 sec f/2.8
Spotlighted acts (carbon-arc)	1/60 sec f/2.8	1/125 sec f/2.8	1/250 sec f/2.8	1/250 sec f/4
Ice shows				
Floodlighted acts	1/30 sec f/2	1/60 sec f/2.8	1/125 sec f/2.8	1/250 sec f/2.8
Spotlighted acts (carbon-arc)	1/60 sec f/2.8	1/125 sec f/2.8	1/250 sec f/2.8	1/250 sec f/4
Interiors with bright fluorescent light	1/30 sec f/2.8	1/30 sec f/4	1/60 sec f/4	1/60 sec f/5.6
School—stage and auditorium	—	1/15 sec f/2	1/30 sec f/2	1/30 sec f/2.8
Church interiors—tungsten light	1 sec f/5.6	1/15 sec f/2	1/30 sec f/2	1/30 sec f/2.8
Stained-glass windows, daytime—photographed from inside	Use 3 stops more exposure than for the outdoor lighting conditions.			

* With ISO 25-32 film increase exposure by 2 stops

† When lighting is provided by tungsten lamps and you want color slides, use tungsten films.

†† KODAK EKTACHROME 400 Film (Daylight) may be rated at ISO 800 when push processed. Merely decrease suggested exposure in this column by one stop.

KODAK BLACK-AND-WHITE FILMS FOR 35 mm CAMERAS

KODAK Film	Description	ISO Film Speed
PANATOMIC-X	An extremely fine-grain panchromatic film with very high sharpness for big enlargements	32
T-MAX 100 Professional	A medium-speed panchromatic film with finer grain than KODAK PANATOMIC-X Film and nearly the same speed as KODAK PLUS-X Pan Film. Particularly good for detailed subjects, this film features extremely high sharpness, extremely fine grain, and very high resolving power, and allows a high degree of enlargement.	EI 100
PLUS-X Pan	An excellent general-purpose panchromatic film that offers medium speed and extremely fine grain.	125
TRI-X Pan	A high-speed panchromatic film especially useful for photographing existing light subjects, fast action, subjects requiring good depth of field and high shutter speeds, and for extending the flash-distance range. This film has fine grain and excellent quality for such a high speed.	400
T-MAX 400 Professional	A panchromatic film that offers the same film speed as KODAK TRI-X Pan Film and finer grain than KODAK PLUS-X Pan Film. Especially useful for photographing subjects in low light, stopping action, or expanding depth of field, this film allows a high degree of enlargement. It can be exposed at speeds of EI 800 and EI 1600 with very acceptable results.	EI 400
KODAK T-MAX P3200 Professional Film	An extremely high speed panchromatic film that can be rated up to EI 25,000 with push processing in T-MAX Developer. Ideal for night sports and photojournalism, law enforcement and surveillance photography, and any photography done in very dim light.	EI 3200
Recording 2475	A very high speed panchromatic film for use in situations where the highest film speed is essential and fine grain is not important to you, such as for taking action photographs where the light is extremely poor. The film has extended red sensitivity and coarse grain.	EI 1000
High Speed Infrared 2481	An infrared-sensitive film which produces striking and unusual results. With a red filter, blue sky photographs almost black and clouds look white. With this film and filter, live grass and trees will appear as though they are covered by snow. This film has fine grain.	EI 125 tungsten*
Technical Pan 2415	A panchromatic film with extremely fine grain and extremely high resolving power that gives large-format performance with 35 mm convenience. Great enlargeability is possible. It is suitable for a wide number of general and scientific applications, such as photomicrography, precision copying, titling, and pictorial photography, depending on the exposure and processing used.	EI 25**

* Use this speed as a basis for determining your exposures with tungsten light when you expose the film through a No. 25 filter. In daylight, follow the exposure suggestions on the film instruction sheet.

** Use this speed for daylight pictorial photography only when processed in KODAK TECHNIDOL Developer, or the equivalent. Other speeds for different applications require alternative developers and give appropriate results. See the instructions packaged with the film.

Note: Panchromatic means that the film is sensitive to all visible colors.

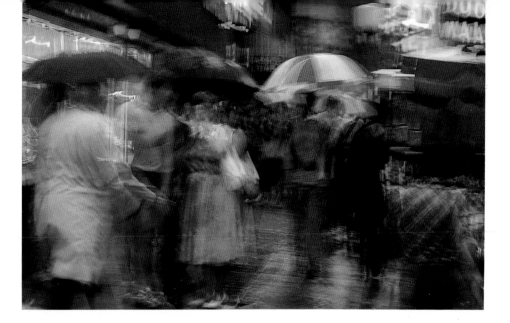

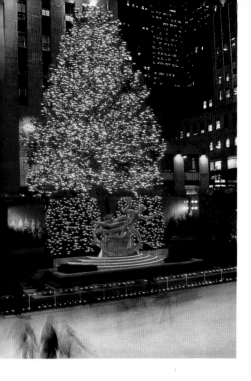

In the view of the Christmas tree at Rockefeller Center in New York, humanity is just hinted at in the blurred skaters at the lower corner. This small element in the composition adds to the overall feeling the photograph conveys. With its complete blur and shake movement, the sidewalk image presents the classic impression of New York City. The slow shutter speed allowed for enough subject detail to reveal the identity of the place while simultaneously conveying an impression of motion and urgency.

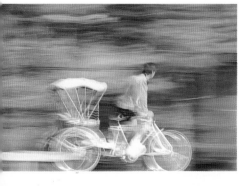

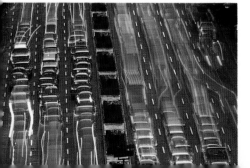

scene. In this way, even though the meter readings may be initially correct, the photographer has covered the possible contingencies of inaccuracy of the camera shutter or lens aperture, or even improper processing of the film.

Generally, exposures are made at half-stop intervals up to two full f-stops above and below the meter indications, but one f-stop in each direction is usually enough. It is well worth the extra three or four frames of film to ensure that a photograph will turn out properly exposed.

EXPOSURE EFFECTS

Shutter speeds and aperture settings have separate, and very different, effects upon the final outcome of the photograph.

Shutter speed is a time-based factor and affects the way in which any motion is recorded within a particular scene. Subjects that are moving can either be rendered sharply, in a sense "frozen," with only implied motion or action, by using high shutter speeds; or be recorded with a certain degree of blur or smearing of their image, at lower shutter speeds.

The degree to which a subject can be blurred depends upon many factors - not only its speed but also its direction relative to the camera, and also the way in which the camera is supported while the shutter is open: whether it is being held steady or tracking the subject in a technique the filmmakers call panning. In panning to freeze the motion of a subject against a blurred background, very accurate tracking of the subject by the camera is required, along with moderately high shutter speeds. The success of this technique, too, depends upon the direction of the subject's movement relative to the camera position and the speed at which the shutter is to operate.

In both these circumstances, either the complete blurring or the freezing of a subject in motion, the proper exposure for the light must be determined first, and then the shutter-speed–lens-aperture relationship balanced to provide proper exposure.

In both these photographs transportation is the theme and there are certain similarities in interpretation. In the traffic picture, a longer exposure time coupled with a fixed camera position creates an interesting combination of motion and stillness. Several of the cars did not move while the exposure was made, and those that did move left ghost images or light trails to show their path. The tricycle photograph also used a long exposure, but, with the camera moving along with the subject, the background has completely vanished into a streaked tapestry of color.

When photographing people, a telephoto lens of short-to-medium focal length is useful. These lenses not only provide a greater distance between the camera and a person but also have shallow depth of field when used at the larger apertures. This limited depth of field can be used to emphasize the person and reduce any distractions in the background by rendering that part of the image out of focus. The degree to which the background appears out of focus depends upon the focal length of the lens and the aperture used for the exposure.

USING THE DEPTH-OF-FIELD SCALE

The depth-of-field scale can guide you to the most efficient use of depth of field. For example, this scale can indicate how to show a flower bed sharp from front to

10 ft from camera

7 ft from camera

back using the largest aperture possible. Here's how to do it.

First focus on the farthest flowers. Note the indicated distance on the distance scale (green numbers at top). Here it is 10 ft (3 m).

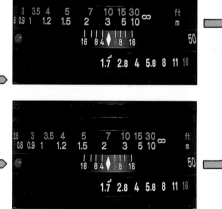

Focus on the nearest flowers and note their distance. Here it is 7 ft (2 m).

Adjust the focusing collar until you find the aperture marks for the largest aperture that completely encloses the near and far distances of 7 and 10 ft (2 and 3 m). As shown here that aperture is f/8.

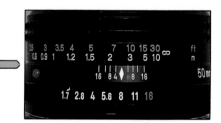

Set the aperture ring to f/8. You have now focused the lens for overall sharpness of the flower bed. You have also chosen the largest aperture giving the required depth of field.

DEPTH OF FIELD

Aperture setting is, in most circumstances, a more significant picture-controlling mechanism than shutter speed, except in cases where motion is a primary element. The term "depth of field" refers to the zone of acceptable sharpness that extends from in front of to behind the exact point on which the lens is focused, and its exact extent is a function of the aperture setting combined with the focal length of the lens and the subject-to-camera distance.

When most lenses are wide open at lower aperture numbers, the depth of field is quite shallow at near-to-moderate subject distance. This is advantageous for focusing on a specific point. If the widest aperture is used for the exposure, the photograph will appear exactly as it is seen in the viewfinder. The very shallow zone of sharpness obtained can separate the subject from the background and create a strong center of interest at the plane of focus. This phenomenon is called selective focus and is useful with normal and long lenses for minimizing the distraction caused by backgrounds with many separate elements. The technique is favored by portrait and fashion photographers who wish to emphasize a person or clothing and merely use the out of focus background as a smooth surface of light and color supporting the subject. Selective focus is not a practical technique with wide-angle lenses because they inherently have a large depth of field and even objects in the distance will not be thrown far enough out of focus to make them indistinguishable.

With smaller apertures (higher f-stop numbers) in use, the depth of field increases and more of the scene in front of and behind the point of focus will be acceptably sharp. The amount that depth of field can increase is directly proportional not only to the f-stop that is used but also to the focal length of the lens. Wide-angle and normal lenses can render everything sharp, from two or three feet in front of the lens to infinity, when they are set to very high f-numbers. Telephoto lenses have proportionally less depth of field as their focal length increases, to the point where a 400 mm lens at $f/32$ focused at 50 feet will have a depth field of only 9 feet. At a wide-open aperture of $f/5.6$, with the same conditions, the sharpness will extend only about 1 foot.

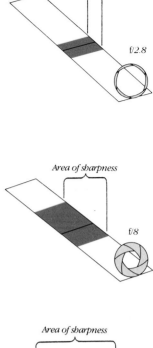

The use of telephoto lenses does not always require the background to be completely blurred for the subject to be given prominence. Often the background

can be reduced in sharpness and yet still provide some detail as to the place or environment the subject occupies.

With this lens focused at 10 ft. the depth of field at f/16 will be from 7 to 15 ft, a depth of 8 ft. At f/8, the depth is from about 9 ft to 12 ft, totaling only 3 ft.

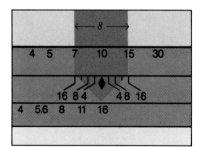

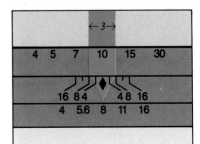

HYPERFOCAL FOCUSING

Most lenses of 50 mm and shorter have pairs of auxiliary focusing marks at each side of the principal focus mark. These indicate the approximate extent of the depth of field at specific f-stops. For instance, if a 28 mm lens is set to an aperture of $f/11$,

and the infinity focus mark (∞) is set to one of the corresponding pair of markers for $f/11$, the other marker will be opposite the 4-foot setting on the focusing ring. This means that the zone of sharpness will extend from 4 feet to infinity at $f/11$, even though the lens is shown to be precisely focused at 8 feet. This is termed the hyperfocal distance. For each aperture-setting indication on the focusing scale, the corresponding maximum zone of sharpness can be found by setting the infinity focus mark to the specific f-number marker; then, by reading the same f-number marker on the close-focus side, the extent of the depth of field at that aperture can be known: The hyperfocal distance for that f-stop will be lined up with the normal focusing mark on the lens barrel.

By the use of hyperfocal distance settings, the maximum amount of the scene, from near limit to infinity, will be in focus at the chosen aperture setting. This is especially convenient when there is no time to focus precisely, as with moving subjects or when very quick "grab shots" are wanted. By keeping the lens set at the proper hyperfocal distance, with the infinity mark at the setting for the aperture in use, everything between the two marks will always be in focus. It is only necessary to make certain that the shutter speed is fast enough to stop the motion of the subject.

AUTOMATIC-EXPOSURE CAMERAS

The introduction of sophisticated electronics and microprocessor chips into the design of many cameras has created technically complex cameras but at the same time eased their operation for the photographer. Now various modes of automatic exposure determination and automatic setting of both shutter speed and lens aperture can reduce the complexity of accurate exposure. Three types of automatic exposure modes are commonly available: aperture-priority, shutter-priority, and program.

Aperture priority is an automatic exposure mode that lets the photographer set the desired lens aperture manually. Using this method, the photographer decides on the appropriate depth of field and the camera's exposure meter and control circuitry determine and set the shutter speed proper for the selected aperture. In most cameras, pressing down lightly on the shutter release activates the meter circuits and permits the camera to set the shutter speed. Most of the newer cameras have audible "beep-tone" warnings when the shutter speed needed for a proper exposure is below $1/30$ second, in which case camera shake could ruin the photograph. Aperture priority is useful where the photographer wants some creative control over the exposure of the film and also when special lenses that have fixed apertures are in use; it is also helpful with telescope photography.

Shutter priority is the reverse of the aperture-priority mode and requires the photographer to set the shutter speed manually, either high, for stopping motion, or low, to create intentional blur of a moving subject. Once the shutter speed is set, the camera's control circuits will measure the light and automatically set the aperture for a proper exposure. This mode is useful when the subject's motion is of primary concern and depth of field is less important to the final photograph, as in sports photography, for instance.

Programmed automatic exposure modes require essentially no input by the photographer, as the camera's microprocessor circuitry controls all exposure functions of both the shutter and the lens aperture. Several SLRs and all the fully automatic lens-shutter cameras employ this type of exposure system. Although the photographer has no control of exposure, the camera's program responds instantly to changing lighting conditions, allowing exposures to be made very rapidly with a high degree of accuracy under conditions where there might be no time for making adjustments either to the shutter speed or to the aperture setting.

Several SLR cameras have additional variations on the basic program mode that take into account the type of lens being used with the camera and allow some

biasing of the exposure program to account for the lens or for the photographer's preference. A high-speed or telephoto program, for instance, may either be selected manually or engaged automatically when lenses of 135 mm or longer are attached to some of these cameras; this varies with both the manufacturer and the specific camera model. The high-speed program selects faster shutter speeds rather than increasing aperture values so as to reduce the chances of camera shake when longer lenses are in use. This, of course, means there is less depth of field than there would be with the standard exposure program, but it does ensure sharp photographs with most telephoto lenses in hand-held situations.

Another variation in program mode is a depth or wide-angle program. With this, the aperture is closed down further at specific light levels to provide greater depth of field and yet maintain shutter speed at values that will permit the camera to be hand held. These programs are most useful with wide-angle lenses and in landscape photography, where great depth of field is often desired.

One difficulty that does arise with automatic-exposure cameras is inherent in the design of their light-metering systems, specifically the pattern of light sensitivity in the camera's viewfinder. Most concentrate sensitivity at the center of the frame, where the subject is generally assumed to be in the majority of situations. If the main subject is not seen within this zone of maximum sensitivity, or has a brightness higher or lower than what the meter measures as "average" or midtone, the exposure is likely to be inaccurate. Examples of subjects that cause erroneous automatic exposures are snow scenes, where the predominantly white image causes the camera meter to see too much light and overcompensate, producing an underexposed photograph, or when the subject is backlighted and the meter may read the darker shadow area that fills the center of the viewfinder and, overcompensating in the other direction, increases the exposure until all other detail is lost through overexposure.

To deal with these situations in using center-weighted exposure systems, exposure-compensation dials or buttons provide for proper exposure.

The button version of this control generally adds exposure to the light reading and is intended for backlighted situations when proper exposure of the shadow area is more important than the surroundings, or when the subject is brighter than midtone values, as in the case of a person wearing a white coat standing near a white wall. This button is not used with darker subjects because it would overexpose the scene further.

The dial version is usually marked in plus and minus values on each side of a zero. The maximum value on each side of the dial is generally two stops, and the dial is usually divided into half-stop or third-stop segments. The exposure will be increased when the dial is set to the plus (+) side and decreased when set to the minus (-) side. So in snow, where there is a substantial amount of white area and the built-in meter is indicating less exposure for the excessive brightness, the exposure-compensation dial must be set at the plus (+) side to provide more exposure and make the snow look white. In the case of a darker-than-midtone subject, the meter wants to provide overexposure to make the subject appear as midtone; so the exposure compensation dial must be set to the minus (-) side to decrease the exposure and make the subject look darker than midtone in the final photograph.

This is a rapidly evolving field. Now becoming more widely used in automatic-exposure SLR cameras are meters that actually divide the frame into as many as six separate sections and read each independently. A computer within the camera analyzes the brightness differences among each of the metered segments and sets an optimum overall exposure that is based on data in its memory. In use, this system effectively replaces exposure-compensation controls, as the computer can actually evaluate the position of the brighter portions in a scene and provide the required compensation. This system provides the fastest and most accurate metering when the light is changing rapidly, or when a photograph is required in a rapidly changing situation.

The gentle colors of a slightly overcast sunset convey a sense of passive relaxation at the end of a day. Careful attention to exposure of the film is required during such a moment. Exposure based on a meter reading of the scene, with the sun included, would cause underexposure of foreground objects, and they would be silhouetted. If foreground detail is desired, do not include the sun or sky in the area read by the meter. "Correct" exposure of sunset scenes is highly subjective. The results of experimenting with a bracket of one stop over and one stop under the meter reading will often prove rewarding.

KODAK COLOR FILMS FOR 35 mm CAMERAS

KODAK Film	Description	To Produce	Use with	ISO Film Speed
Color Negative Films				
KODACOLOR GOLD 100	This film features very high sharpness and extremely fine grain to allow for a high degree of enlargement and wide exposure latitude. It is an excellent film for use in general lighting conditions where maximum image quality is desired for big enlargements.	Color prints	Daylight, Electronic Flash, or Blue Flash	100
KODACOLOR GOLD 200	With the same extremely fine grain and nearly as high sharpness as KODACOLOR GOLD 100 Film, this film provides twice the speed. It is a good choice for general lighting conditions when higher shutter speeds for capturing action or smaller apertures for increased depth of field are desired.	Color prints	Daylight, Electronic Flash, or Blue Flash	200
KODACOLOR GOLD 400	A high-speed film for existing-light situations, fast action, great depth of field, and extended flash-distance ranges. Medium sharpness and extremely fine grain offer good quality for a moderate degree of enlargement.	Color prints	Existing Light, Daylight, Electronic Flash, or Blue Flash	400
KODACOLOR VR 1000 (CF)	The very high speed of this medium-sharpness, very-fine-grain film suits it for use in low-light conditions when fast shutter speeds, small apertures, or telephoto lenses are required.	Color prints	Existing Light, Daylight, Electronic Flash, or Blue Flash	1000
Color Slide Films				
KODACHROME 25 (Daylight) (KM)	A popular film noted for excellent color and high sharpness. It has extremely fine grain and good exposure latitude.	Color slides	Daylight, Electronic Flash, or Blue Flash	25
KODACHROME 64 (Daylight) (KR)	A medium-speed, general-purpose film. Exhibits remarkable sharpness and freedom from graininess. Color rendition of this film is excellent.	Color slides	Daylight, Electronic Flash, or Blue Flash	64
KODACHROME 200 Professional (Daylight) (PKL)	This film features very high sharpness and fine grain while achieving higher speed. It allows the faster shutter speeds necessary for hand-holding longer lenses, smaller lens openings for increased depth of field, and use in low-light situations.	Color slides	Daylight, Electronic Flash, Blue Flash, or Existing Daylight	200
EKTACHROME 100 (Daylight) (EN)	A medium-speed film for general all-around use. It has sufficient speed to let you use higher shutter speeds or smaller lens openings in normal lighting or to let you take pictures when the lighting is somewhat subdued. This film produces vivid color rendition and excellent sharpness and graininess characteristics.	Color slides	Daylight, Electronic Flash, or Blue Flash	100
EKTACHROME 200 (Daylight) (ED)	A medium-speed film for existing light, fast action, subjects requiring good depth of field or high shutter speeds, and for extending the flash-distance range. It has very fine grain and excellent sharpness. This film can be push-processed to double the speed.	Color slides	Daylight, Electronic Flash, Blue Flash, or Existing Daylight	200 400 ‡
EKTACHROME 160 (Tungsten) (ET)	A medium-speed film for use with 3200 K tungsten lamps and existing tungsten light. It features the same very fine grain and excellent sharpness as the 200-speed Daylight film. This film can be push-processed to double the speed.	Color slides	Tungsten Lamps 3200 K or Existing Tungsten Light	100 No. 85B 200 ‡ No. 85B
EKTACHROME 400 (Daylight) (EL)	A high-speed film for existing light, fast action, subjects requiring good depth of field and high shutter speeds, and for extending the flash-distance range. It has fine grain and good sharpness and can be push-processed to double the speed.	Color slides	Daylight, Electronic Flash, Blue Flash, or Existing Daylight	400 800‡
EKTACHROME P800/1600 Professional Film (Daylight) (EES)	A very high-speed film for existing light, fast action, and subjects requiring good depth of field and high shutter speeds. This film exposed at EI 800 or EI 1600 provides good results in adverse lighting conditions. It can be push-processed as high as EI 3200 for extremely dim situations with some loss in quality. You can also expose the film at EI 400, which requires a CC10Y†.	Color slides	Existing Daylight, Daylight, Electronic Flash, or Blue Flash	EI 800 § EI 1600*

†KODAK Color Compensating Filter, CC10Y, sold by photo dealers.

‡Use these speed settings to expose these films when you send your film for push processing in Process E-6P, Push 1

§ Use this speed setting to expose EKTACHROME P800/1600 Film for push processing in Process E-6P, Push 1

* Use this speed setting to expose EKTACHROME P800/1600 Film for push processing in Process E-6P, Push 2.

SOME CONSIDERATIONS OF FILM CHOICE

The choice of popular 35 mm films depends upon the end use for which the photographer is aiming. Most amateur photographers whose ultimate aim is a small print make use of color negative films with speeds of ISO 100, 200, or 400 such as Kodacolor Gold films. These films have a wide exposure latitude and can produce acceptably good prints from a stop-and-a-half underexposure to three stops of overexposure. The drawback in using these films is that the exact colors of a scene can vary according to the system or individual who is producing the final prints from the negative, since many labs by necessity use averaging systems for color printing.

Many professional portrait, wedding, and school photographers also use negative color materials. Especially favored here is Vericolor III film.

The choice of most professional photographers whose images are intended for magazines and advertising is a reversal film that produces color transparencies. In 35 mm format they are often referred to as "slides." These are also popular for audiovisual educational, corporate, and industrial or training purposes. In this process, the only change from colors in the actual scene is the result of the particular bias introduced by the type and brand of film used. Kodachrome 25, 64, and 200 films and Ektachrome 64 and 100 films are general favorites.

Transparency films in general require very tight control of exposure and will provide vibrantly saturated colors when they are underexposed by a minimal amount, usually about half a stop or less. They do not tolerate overexposure very

A fine-grained, high-speed film can greatly simplify the life of a photojournalist or anyone else who often shoots in dim light. To make this dark classroom seem like a bright stage, the photographer used KODAK T-MAX P3200 Professional Film rated at EI 3200. Exposure was 1/30 sec, f/5.6 with a 35 mm lens.

well and tend to lose detail quickly in the brighter portions of a scene even at a half-stop of overexposure.

New film types are announced on a regular basis, and it is advisable to try these new types and compare them directly with a favorite film. Each type and brand of color film tends to have its own distinct way of recording colors and contrast, and so the final appearance of a scene in color can, in most cases, be tailored specifically to the light and the predominant colors present by thoughtful selection of the appropriate film type.

Although contemporary films yield excellent color rendition under most circumstances, the care and handling of the film both before exposure and after processing can affect the final results obtained from any type of film. There are two classes of films, amateur and professional. These may have the same name and film speed rating and yet differ in recommended applications and in storage and handling.

In the shot of tourist shirts from Hawaii, the colors are vibrant and richly saturated, lending a pleasant, lively feeling to the image. In the photograph of the pond and farmhouse, the colors are pastel and muted, presenting an impression of serenity and of an unhurried life-style.

Because of their complex emulsions, all color films will shift slightly in color balance as they age. This shifting can be minimized by storing the film at 55°F or lower, exposing it soon after taking it from storage, and processing it immediately. Professional photographers and their suppliers adhere to these standards, so professional class films are manufactured at as close to ideal color balances as possible.

Amateur photographers cannot always follow professional procedures. Films may be kept under warm conditions, exposed over a relatively long period of time, or not processed immediately. To provide the best results for a wide range of use, amateur class films are manufactured with a slight color bias opposite to their normal color shift tendency. In this way, any shift that occurs will be in the direction of ideal color balance, or at most only slightly beyond. This manufacturing precaution insures excellent color in millions of amateur color pictures each year.

In all cases, regardless of the film type, exposure to excessive heat must be avoided, most especially that classic case of leaving film in a locked car in warm weather. All color film that is to be kept for a long time before use should be kept under refrigeration and, when required for use, allowed to warm up slowly to ambient room temperatures before being loaded into the camera.

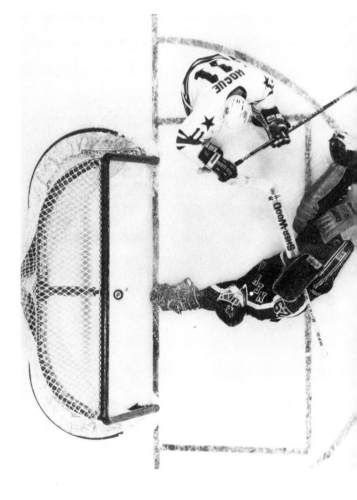

KODAK T-MAX 100 Professional Film offers extremely fine grain that gives you excellent results with even the 35 mm format used to take this photo.

The high speed and extremely fine grain of KODAK T-MAX 400 Professional Film makes it a versatile, all-purpose film that enables you to shoot sports and still lifes on the same roll.

WHAT'S NEW IN BLACK AND WHITE FILM

Black-and-white photography provides a medium for graphic rendition of subjects and eliminates the emotional overtones of color from the viewer's interpretation of a scene. Black-and-white images depend more upon the subject matter and composition for creating a visual interpretation than images in color do. They are less open to differing impressions created by the emotional impact of color. Many photojournalists use only black and white for these reasons; they seek to present facts and document events without leaving room for a viewer's differing response to the color content of the images.

For black-and-white photography, Kodak offers a wide selection of conventional film emulsions as well as the exceptional T-Max film. These T-Max emulsions are available in three speeds: 100, 400, and 3200. Advances in film-structure technology provide these materials with a level of fine grain and image resolution that was previously impossible to achieve at these speeds. The 100 version of this film has the grain structure and image resolution of conventional black-and-white films in the 25 to 50 film speed range, while the T-Max 400 film compares with conventional 100 speed black-and-white films.

These films also offer exceptional exposure latitude and processing compatiblity with special T-Max developer or conventional developer chemicals, and so they are useful in all situations, from normal daylight to very dim environments where the use of supplemental lighting is not practical or may not be permitted.

STORAGE CONSIDERATIONS

After processing, both slides and negatives should be stored in polyethylene file sleeves. These are readily available both for mounted slides and for strips of processed negatives. They should be stored in a dark area that does not suffer from extremes of either humidity or temperature. Slides can also be stored in projector trays, but care must be taken, as with all film storage, to keep the trays in a dry and dust-free area.

Color prints are best stored under dark conditions, but this is not always practical when display of the prints is desired. Photo albums provide a nice compromise, as they keep the prints in the dark and yet readily accessible for viewing. Prints mounted for wall display will fade over time, as will all photographic dyes when exposed to a continuous source of light. The only solution is to store the original negative properly, so that additional prints can be made to replace those that have reached an unacceptable appearance after fading.

Besides magnifying a scene and bringing distant objects closer to the camera, a telephoto lens can reduce the apparent distance between objects within a scene. In this classic shot of San Francisco, just such a lens was used to reduce the perceived distance between the turn-of-the-century homes and the modern downtown buildings. The effect is that the new skyscrapers appear to be only several blocks away from the small wooden homes, when in fact they are about two miles apart.

The focal length of a normal lens approximates the diagonal of the film format. The diagonal of a 35 mm frame is approximately 43 mm.

④ LENSES

Next to film processing, lenses are the crucial element in the photographic process. They are the devices through which the energy of light is accumulated and channeled to bring an image into focus at the surface of the film. Although many types of glass are used in making lenses, and there are many different lens formulas, all lenses work on the basic principle of refraction, or bending of light rays. Lens construction is related to the differences in the way each specific type of glass refracts the various wavelengths of light. The refractive index of a particular glass determines how uniformly the three primary colors of light are bent and altered to provide the various fields of view for each of the lenses.

The lenses currently manufactured for 35 mm cameras are the most sophisticated and refined of all consumer-market commercial optics. Because of its universal acceptance and wide use, the single-lens-reflex camera has the largest variety of lenses, ranging from the 6 mm "fisheye," which, with an angle of view of 220 degrees, actually sees behind itself, to 2,000-mm supertelephotos with a 1 degree angle of view, which magnify the scene forty times over that seen through a normal 50 mm lens.

There are four basic types of lenses made for 35 mm single-lens-reflex (SLR) cameras: normal, wide-angle, telephoto, and special-purpose. For the 35 mm format, the focal length of the lens, generally given in millimeters (mm), determines the angle of view and the relative subject magnification. Size of the maximum aperture in proportion to focal length determines the lens "speed," a term that is used interchangeably with "maximum aperture". A high-speed, or "fast" lens has a relatively large maximum aperture, whereas a lens that is considered "slow" has a maximum aperture that is small in relation to its focal length.

The term "zoom lens," as applied to 35 mm still photography, is really a misnomer. These are lenses that can provide many different focal lengths in a single lens package, offering great freedom in composition without requiring a change of position. Another advantage is that lens changes are reduced, and so the ability to respond to changing situations can be faster. Unless the special technique of changing focal length, or "zooming," during the actual exposure is employed, it is best to think of these lenses as a collection of infinitely variable focal lengths within the specific range of the zoom lens.

ANGLE OF VIEW

How much do you want to fit in your shot? The angle of view of the lens determines how wide or narrow a space will be included in the picture.

The focal length of a normal camera lens is the distance from the approximate center of the lens to the film plane when the lens is focused on infinity. With telephoto lenses, the focal length is often the distance from the film plane to a point in front of the lens.

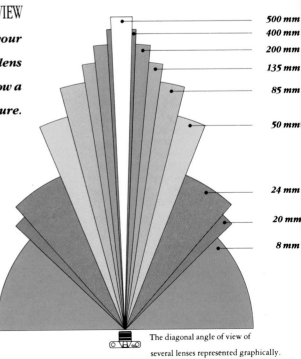

500 mm
400 mm
200 mm
135 mm
85 mm
50 mm
24 mm
20 mm
8 mm

The diagonal angle of view of several lenses represented graphically.

39

THE NORMAL LENS

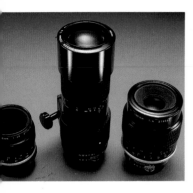

For any photographic format, the normal, or standard, lens usually has a focal length that is equivalent to the length of the diagonal of the image size. For 35 mm cameras, this diagonal distance is 43 mm, but the 50 mm lens has become the standard focal length. Normal lenses have an angle of view that most closely approximates the perspective, but not the magnification, seen with the human eye.

The normal lens has the fastest lens speed of all those made for the format, and in 35 mm is usually around f/1.4. There are some specially designed normal lenses that have maximum apertures of f/1.2, but these are very expensive and so are used only in situations where existing-light photographs must be made in low light.

The normal lens, although presenting a rather ordinary perspective, can also be the most versatile, having very limited depth of field at wide apertures and extensive depth of field at minimum aperture.

CARING FOR YOUR LENS

Placing a drop of cleaning fluid directly on the lens element could be risky. You must be careful not to let the liquid run down into the lens where it could cause fogging or rust. A safer procedure is to place the drop of fluid on the tissue first. But in either case, be sure to brush any grit off the lens before using tissue on it. Otherwise you may unwittingly scratch the surface as you try to clean it.

THE WIDE-ANGLE LENS

Wide-angle lenses for 35 mm cameras are those with focal lengths shorter than 50 mm. When these lenses are used at the same distance as a normal lens, they produce a smaller subject image and consequently take in a much larger field of view.

Of all lens types, wide-angle lenses have the greatest ability to transform the perspective of a scene. They increase the apparent distance between foreground and background subjects, and this effect becomes even more noticeable with the shorter focal lengths. As a result, subjects appear larger when they are placed in the foreground of the composition, and objects in the background diminish in size. A wide-angle lens is also useful when it is necessary to show a subject in its environment because it will include considerably more background; so a subject placed in the foreground can be given prominence, and yet a large portion of the

The use of wide-angle lenses is not limited strictly to including more information in the 35 mm frame. In this photograph of a Buddhist temple in Bangkok, a wide-angle lens has distorted perspective on purpose, giving prominence to the foreground yet still including enough of the background and environment to show the nature of the temple's extensive decorations. The added sense of depth created by the lens also serves to show the texture and intricacy of the decorations by permitting front and side views from one vantage point.

surroundings can be shown in the background.

Normal rectilinear wide-angle lenses in focal lengths from 13 mm to 35 mm do not distort straight lines, but those wide-angle lenses that are classified as fisheye lenses produce excessive barrel distortion, causing severe curvature of any straight lines that are outside the center of the picture frame.

It is important to think of wide-angle lenses not simply as tools for including more area at a given distance but also as optics that can distort perspective by altering the foreground-background relationship, creating an immense sense of depth.

Wide-angle lenses can create powerful leading lines within a photograph by their ability to extend and distort perspective. In these two photographs, the lines in the road and in the desert are used to bring the viewer's eye into the center of the image and so heighten the sense of distance. The vertical composition has a stronger feel of this extra depth because the lens "sees" more from top to bottom and so includes more foreground details.

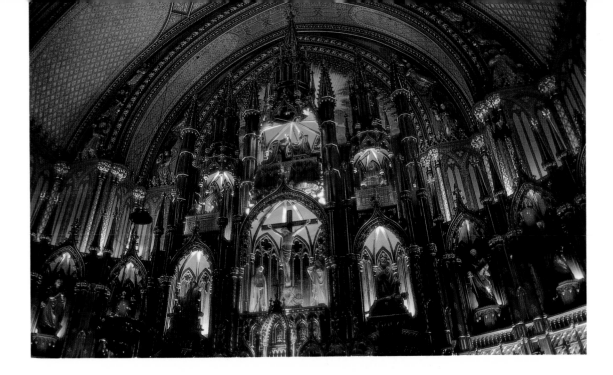

These three photographs use the unique ability of wide-angle lenses to both include more subject area and provide increased depth perspective of interior architectural subjects. The horizontal view of the home living room exemplifies a more normal wide-angle view, where the lens presents more subject information and really does not have much perspective distortion. The vertical view of the high-ceilinged living room is more typical of wide-angle lenses when used to increase the apparent depth and space relationships within a scene. The slight convergence of the vertical lines, caused by not having the axis of the lens perfectly aligned with the vertical members, introduces a feeling of distance and of increased area within the room. Similarly, by pointing a wide-angle lens upward, the photographer of the cathedral interior has increased the impression of great height by exaggerating the converging vertical lines while again including more subject detail than would be seen by a normal lens.

THE TELEPHOTO LENS

At the other end of the scale from wide-angle lenses are the telephotos. These are lenses with focal lengths and subject magnification greater than the 50 mm lens's. One characteristic is a much narrower angle of view than the normal lens. As their focal lengths increase, the depth of field decreases sharply. Another characteristic is that these lenses reduce the apparent distance between the foreground and the background in a particular scene, causing an effect known as compression.

There are several classes of telephoto lenses: short, which are generally 75 mm to 105 mm; medium, from 135 mm to 200 mm; long, in the range from 250 mm to 400 mm; and supertelephotos that extend from 500 mm to 2,000 mm. In the supertelephoto class, there are several mirror lenses. These use a system of mirrors to create folded-optic lenses with fixed apertures. They are much smaller than refractive lenses of equivalent focal length and provide long focal lengths in very portable packages. One disadvantage is their single, fixed aperture, which is generally *f*/8 or less. Another is their characteristic doughnut effect: out-of-focus highlights rendered in a doughnut-like shape by a secondary mirror in the front element.

The 85 mm short telephoto lens has a magnification closely matching that of the human eye. It records facial features quite naturally without any serious distortion and is used extensively for portraits.

One significant ability of the super telephoto lens is its extremely shallow depth of field when used at wide apertures. This has the effect of separating the main subject from the background by causing the latter to blend into an out-of-focus blur. It is almost like using an intricate tapestry as a background material, reducing the visual clutter that could otherwise be most distracting.

In other applications, the compressive characteristic of telephotos can make objects appear to stack up with a minimum of distance between them. This effect can be used to create the impression of congestion, of tightly packed objects where in reality a separation exists between them. For this effect to occur, a lens of 200 mm or more is required.

The compression effect of telephoto lenses can also remove or minimize depth perspective of many subjects and result in strong, graphic designs. In the area of fashion photography, the inherent characteristics of telephoto lenses can create striking graphic images that place visual emphasis on the model and the clothes, exhibited against an out-of-focus background.

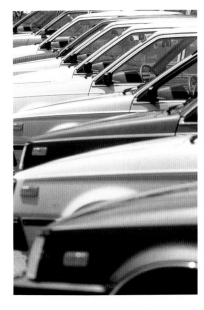

The sense of perspective compression is very evident in this photograph of parked cars. Even though several feet separate the cars, the telephoto lens has reduced this distance and gives the impression that the cars are only inches apart.

The limited depth of field characteristic of telephoto lenses, especially at wide apertures, permits very selective focusing to be used to separate the subject from the background. The mountains in the background here are rendered out of focus and magnified so that they provide a backdrop for the woman hiking. The difference between the sharp focus of the woman and the blur of the mountains causes the eye to rest on her.

The whole idea of variable-focal-length (zoom) lenses is wonderful. One lens can take the place of several, with the added advantage of in-between focal lengths. It sounds great and, in many cases, it is. But zoom lenses are not for every photographer and every situation. In deciding whether or not to buy a zoom lens, you should consider all the pluses and minuses.

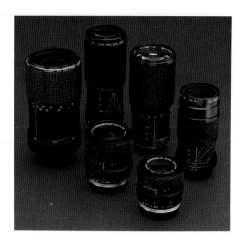

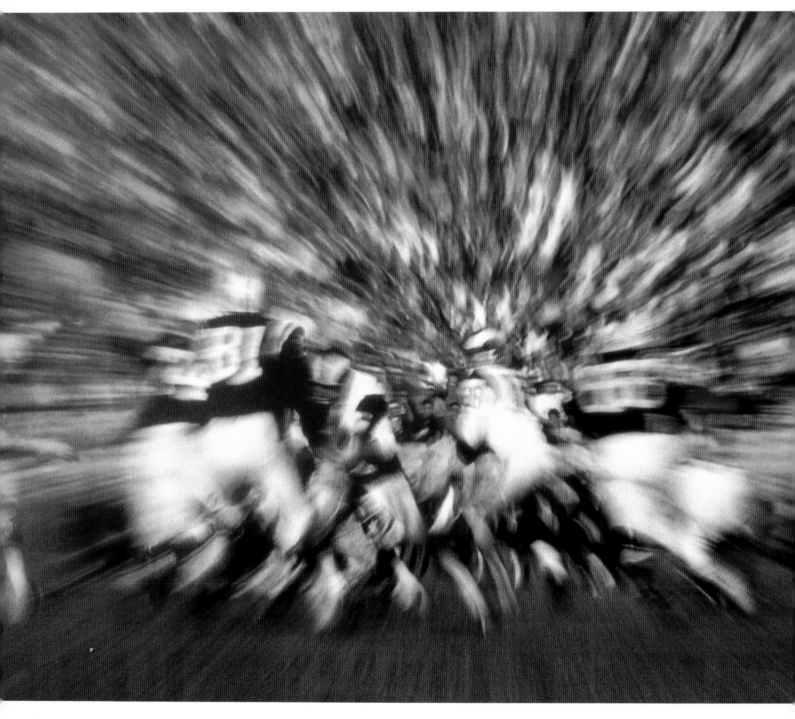

ZOOM LENSES

The increasing popularity of zoom lenses has been attributed to their multi-focal-length abilities and to their relatively low cost, as compared to the cost of the group of fixed-focal-length lenses that would be needed to cover the equivalent range of one zoom lens. The zoom lens is also substantially lighter and more compact to carry than the three or four fixed-focal-length lenses they can replace.

Some of the more popular ranges in zoom lenses are the 80 mm–200 mm and the 70 mm–210 mm telephoto zooms; the 35 mm–105 mm and 28 mm–85 mm wide-angle to moderate-telephoto zooms; and the newest breed of extended ranges that includes the 35 mm–200 mm and the 28 mm–200 mm zoom ranges. Some shorter zooms that are also popular are the 35 mm–70 mm and the 28 mm–50 mm, which cover the area around the normal lens focal length.

The disadvantage of zoom lenses is primarily in the area of maximum f-stop, where the largest apertures are around f/3.5. This somewhat limits their use in low light and in hand-held photography. With increasing development in lens design, there are now several telephoto zooms with maximum apertures of f/2.8; but these are very large when compared to their slower counterparts and reflect only about a one f-stop increase over them. For most outdoor and flash photography, the slower zoom lens is not considered a handicap beside the faster lenses of fixed focal lengths.

Zoom lenses can function as an infinite variety of single-focal-length lenses combined into a single

package, but one of their unique abilities is to be able to change focal length while the exposure is in progress.

The effect on the image is smears and streaks that produce a sense of motion. These two photographs typify this technique.

A longer exposure was used during the football game and the focal length of the zoom was changed during exposure.

For the abstract space shot, the streaking of several point light sources evokes a spatial depth.

When this technique is used, the lines always tend to converge at a single point.

MACRO LENSES

Macro lenses are specially equipped to provide very short minimum focusing distances. They are ideal for close-ups of small objects. These two views present objects of very different scale, machinery gears and a microchip circuit on a silicon wafer, but macro lenses were invaluable in achieving the proper magnification of each subject.

While most lenses are specifically designed to provide optimum optical performance in magnifications up to 1:10 (one-tenth of life size), macro lenses are designed with the additional capability for making close-up images. Most macro lenses will focus from infinity to a point where the subject will appear on film to be half its normal size; that is, magnified in a 1:2 ratio. (The slide, of course, remains its own $1 \times 1\frac{1}{2}$ inches in size.) Because of this extended focusing range, these lenses have special helicoids that have a more severe pitch than most lenses and that allow them to focus more rapidly in the non-close-up range.

Two fundamental types of macro lenses are available: standard, having focal lengths from 50 mm to 60 mm; and telephoto macro lenses, with focal lengths of 90 mm to 200 mm. The normal types of macro lenses have had extensive development and incorporate several complex optical designs, including floating elements that give them excellent optical performance over their entire focusing

range, to the extent that they can be used in place of regular normal lenses without sacrificing image quality at more distant focus settings.

The telephoto macro lenses, particularly in the 90 mm to 105 mm focal lengths, also have a high degree of correction over their focusing range, with the added advantage of producing the same image magnification, 1:2 or half life size, at nearly twice the lens-to-subject distance possible with the normal macro lenses. This is quite useful in situations where it is not possible to come very close to the subject with the lens, as when photographing insects, or where the lens-to-subject distance with a normal macro is too small to permit the insertion of lighting for the subject Telephoto macro lenses of around 200 mm provide even better distance from the subject, but they become physically larger and have significantly less depth of field for given camera-to-subject distance than their counterparts of shorter focal lengths.

Macro lenses are also suitable for higher magnifications, which are achieved by increasing the distance between the lens and the film plane. This can be accomplished either by inserting fixed extension tubes, which generally preserve the automatic function of the lens diaphragm, or by inserting a variable-extension bellows between the camera and the lens. In general, the extension tubes provide magnifications up to life size (1:1) whereas the bellows units are used for magnifications of 2:1 and greater, with the upper limit in 35 mm photography being about 20:1 (twenty times life size).

At magnifications of 1.5:1 and greater, it is recommended that the lens be reversed, as this places the larger image on the imaging side of the lens and better optical performance can be obtained because this follows the lens design more closely.

Most macro lenses are also excellent for copying documents and other flat objects because their curvature of field, the arc of optimum focus at a specific distance, has been reduced to such a point that they can be considered essentially flat-field lenses. This reduces the out-of-focus zones near the edges of the frame and minimizes any distortion that would be caused by a curved-field lens.

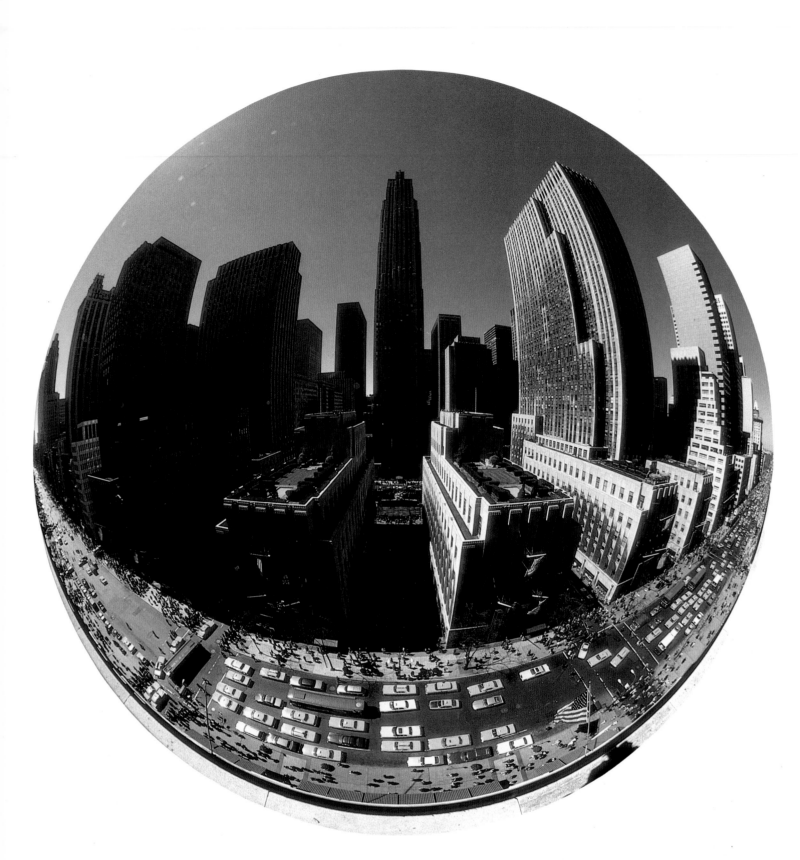

In this photograph of Rockefeller Center in New York City, a circular fisheye lens was used to provide a view of 180 degrees in all directions. The extreme line-curvature distortion created by this lens is clearly evident in the buildings and street close to the edges of the field of view. Lenses of this type have diminished in popularity because of their inability to fill the entire 35 mm frame with an image, although when used with discretion, they can create stunningly different images of common scenes.

SPECIAL LENSES

This category includes several diverse types of lenses: fisheyes, which are really ultra-wide-angle lenses, with their uncorrected distortion; perspective control (PC), which provide limited lens movements similar to those of view cameras; and extended-spectrum lenses, which are designed for photography in the near-visible ultraviolet and infrared regions of the spectrum.

Fisheye lenses, with focal lengths from 6 mm to 8 mm are called circular fisheyes because the image they make on the 35 mm film frame is a circle in the center of the film, covering 180 or more degrees in all directions. The circular fisheyes are not used widely because of the limitation of their circular image, although they do have application in astrophotography for star trails and in other scientific applications.

The full-frame fisheye, which is used more often, sees 180 degrees only in the diagonal direction of the format, but it fills the entire 35 mm frame with a rectangular image. These lenses have much wider usefulness than the circular types because the image can be made to appear with almost no distortion, provided the lens is aligned carefully with the scene. This means they can be used as an ultra-wide-angle lens with a diagonal field of view that is 62 degrees greater than that of the shortest focal length rectilinear lens.

Perspective-control lenses generally can be, with one exception, called shift lenses. They provide a means for displacing the central axis of the lens elements, parallel to the film plane, to control the convergence of horizontal or vertical parallel lines within the frame of a photograph. Useful for architectural photography, they can reduce or eliminate the convergence of parallel lines when photographing buildings and other tall structures from ground or near-ground level.

Other capabilities include removing foreground objects from a scene without altering the position of the camera and still retaining an undistorted perspective of the subject. In some cases, they can be used to introduce distorted perspective or to provide additional depth within a photograph. Ranging in focal lengths from 24 mm to 35 mm, depending upon the manufacturer, they have manually operated aperture mechanisms and require stop-down metering when being used.

One manufacturer makes a 35 mm lens that incorporates shift and tilt that can operate simultaneously; it is designated TS for "tilt and shift." The advantage of this lens is its ability not only to correct for converging parallel lines but also tilt for obtaining an increase in depth of field at specific apertures.

Extended-spectrum lenses are designed for photography that uses light in wavelengths in the near-ultraviolet and infrared regions of the bandwidth of film response, and for special-purpose films, such as infrared. They are highly corrected for all wavelengths of light and employ special glass and fluorite crystals to achieve excellent transmission properties. These lenses are priced well beyond the range of the normal optics of the same focal length.

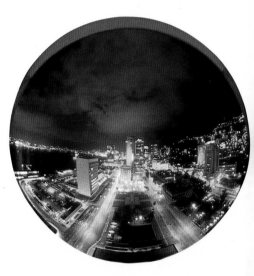

This evening shot of central Hong Kong was made with a circular fisheye lens that covers an angle of view of 180 degrees in all directions.

THE CARE AND CLEANING OF LENSES

Most modern 35-mm lenses have special antireflection coatings applied to the exterior surfaces of the lens elements. Even though these coatings can be quite hard, they are still susceptible to scratching from improper cleaning procedures. Care must be taken to remove most of the abrasive dust particles from the lens surface before using lens tissue and fluid. Use compressed air to blow the dust off the surface of the lens, after checking the lens instructions (the propellant in compressed air may damage certain types of lens coatings). The airflow must be gentle, because static charges can be built up with very strong air bursts, making the dust particles adhere more tightly to the lens surface.

Once the majority of the dust has been removed, apply a small amount of lens

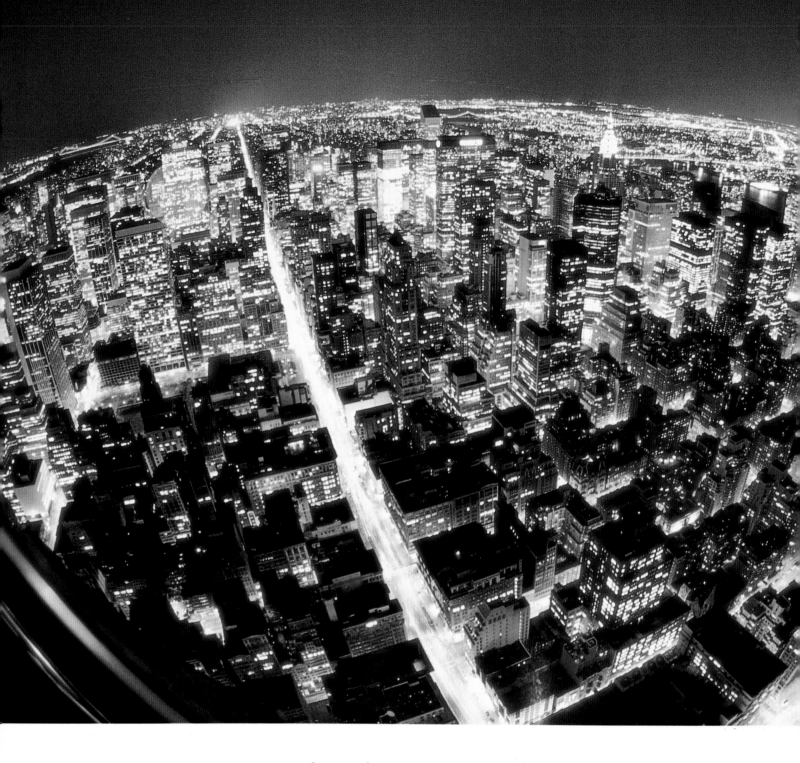

cleaning solution, one or two drops, to lens tissue or photo chamois and wipe the surface gently to remove any oily deposits. Cleaning solutions for eyeglasses, or those containing silicone or antifogging or antistatic ingredients, are never to be used on the lens surface. These additives can leave a residue on the glass that will cause flare and diffusion of the image. After wiping with lens fluid, wipe a second time with a dry tissue to remove any streaking. Breathing lightly on the lens at this point will cause a fine condensation of moisture on the lens, and this will help in removing any streaking that may be left. The final step is to blow off the lens once again with compressed air to remove any residual lint from the lens tissue.

If there is an excessive buildup of dust particles within the lens itself, give it to a qualified service center for a more thorough internal cleaning. Since most 35-mm lenses are no longer sealed, this procedure should be performed every three to five years, depending upon how much the lens is used.

Most modern 35-mm lenses are quite sturdy and can handle the majority of average shocks, from wall bumps to short drops, fairly well. Any lens that has been dropped from more than four feet, however, should be checked for optical

performance and mechanical function. The most common damage from these short falls is either a bent lens hood (if used) or bent filter-mounting ring, in which case professional repair is required.

Periodic checks should also be made to ensure that the aperture mechanism functions smoothly at all aperture settings. Because the mechanism for this operation varies greatly among camera manufacturers, this should be carried out at an authorized or approved service center for the specific make of camera.

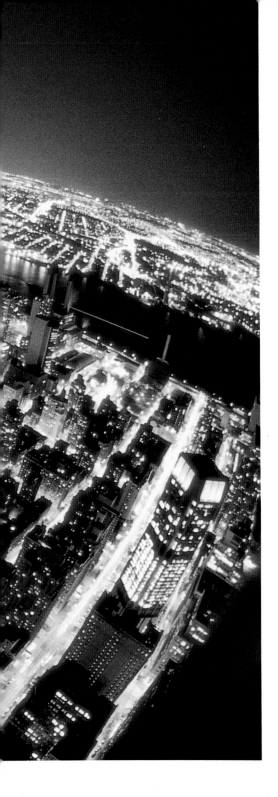

The full-frame fisheye lens presents a view that sees 180 degrees only in the direction of the frame diagonal, and so it fills the 35-mm frame completely. These four photographs show the distortion of straight lines and the unusual perspective it can provide. Fisheye lenses are not for every situation, but, when used with imagination, can create unusual images from ordinary subjects.

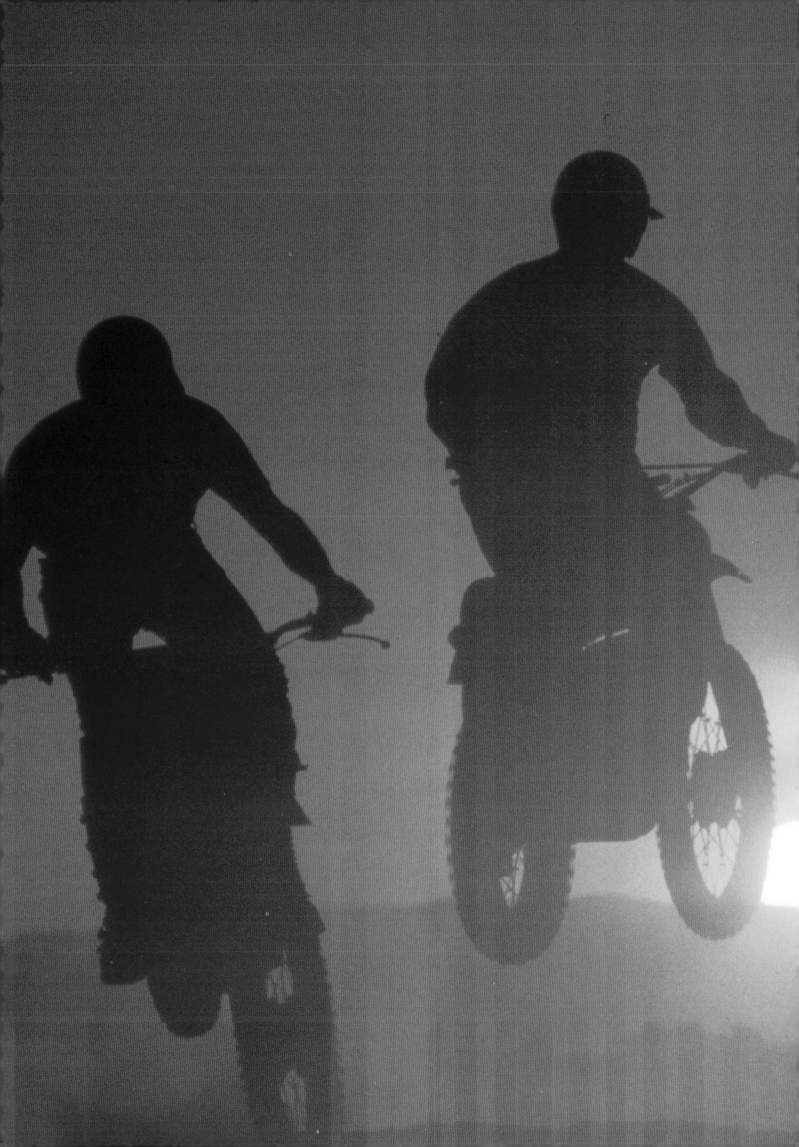

❺ PHOTOGRAPHIC FILTERS

Since the beginning of photography, filters have been used to modify the light received through the lens. A century ago, most black-and-white films were sensitive only to blue light. To balance the tones of a scene, filters were used to absorb some of the blue light, helping to balance the response to yellow, green, and red in the subjects. One of the earliest methods for achieving a color photograph, around 1900, used three color filters in red, green, and blue primaries in an additive process. So filters have been an integral part of the photographic process since its very beginnings.

Most filters reduce or block certain wavelengths of light from the spectrum that can be recorded by the particular film in use. For this reason, when a filter is placed in the optical path there is always a reduction in the amount of light reaching the film; therefore an exposure increase is usually required. The amount of exposure increase is specific to each filter type and is also dependent upon the light source. This information is supplied with each filter, in an instruction sheet or engraved on the filter mounting ring, if the filter has one.

Exposure meters that measure light through the camera lens, like those built into most SLRs, automatically compensate for the reduction of light caused by placement of any filters over the lens, so that the exposure factor is automatically accounted for when light readings are made with these meters. Some meters have slight problems with deep red filters used for black-and-white films, and in those cases the filter factor must be applied to a meter reading taken without the filter in place. Usually, if this is necessary the filter or camera manufacturer will note it in the instruction manual or filter fact sheet.

Filters have many uses in all types of photography. Those intended for black-and-white film have much stronger colors than those used with color materials. For color photography, several classes of filters are available: ultraviolet (UV) and skylight; color-correcting; color-compensating; and special effects.

An ever increasing variety of optical materials is joining the variety of filter types. Three primary materials are used in the manufacture of filters: gelatin, optical glass, and optical plastic. The first type is also the oldest. Gels are used where extremely critical filtration and repeatability of color are required. Optical glass filters are probably the most widely used type in the commercial market. The introduction and acceptance of certain types of optical plastics have allowed several filter manufacturers to create not only the normal type of filters but also entirely new series of special-effects filters that were impossible to manufacture in glass or gelatin.

The deep orange filter used to enhance the color of sunset provides a monochrome backdrop for the motorcycle riders and lends a very graphic nature to the image. Without the filter, there might have been more variation of color within the scene, but the visual impact of the riders would probably have been reduced. The orange monochrome has placed more visual emphasis on the figures while still keeping the feeling of a warm sunset.

HOW POLARIZING FILTERS WORK

To understand how polarizing filters work, you need to know a few things about light. Light rays travel in straight lines. They also vibrate as they travel in straight lines, rather like a person on a pogo stick following the stripe down the center of a road: The person moves forward in a straight line but does so in an up-and-down motion. Each light ray vibrates in only one plane of direction (left and right, up and down, and so on). In normal light, all the rays vibrate in random directions. In polarized light, the rays vibrate in the same direction (for example, left and right).

Light becomes polarized as it is scattered from the blue sky and reflected from shiny nonmetallic objects. Selective sorting of individual rays causes the polarization. Selective sorting doesn't mean there's an assembly-line worker choosing and rejecting light rays. It means that more of those light rays vibrating along a certain plane are scattered or reflected than are light rays vibrating in others planes.

Think of yourself on the ground looking at the sky. Fifteen light rays are about to make a mad dash into the atmosphere. Five of them are vibrating up and down, five left and right, and five diagonally. In other words, they show random vibration before entering the atmosphere. Upon entering the atmosphere, they are knocked

ULTRAVIOLET (UV) AND SKYLIGHT FILTERS

Film is sensitive to some wavelengths of light the eye does not see, especially in the far blue and ultraviolet region of the spectrum. Ultraviolet light can be perceived as the bluish haze that is present in landscape photographs taken over long distances on humid days. It reduces the clarity of objects in the distance and in some cases gives the impression of atmospheric pollution. On film, ultraviolet light can be recorded on film as an overall blue cast that affects all colors within the scene and creates a most unnatural appearance. Ultraviolet light can also cause detrimental blue color shifts in film exposed in shadow areas on sunny days.

To correct these problems, ultraviolet (UV) or haze filters can be placed in the optical path to block those shorter wavelengths that cause this blue cast. Most modern lenses block UV radiation, and so ultraviolet filters are not generally needed. And yet, because most UV filters are mild enough not to produce a serious shift in the overall color, many photographers use these filters as a protection for the front lens element.

Some commonly used types of UV filters are designated UV 0, Haze 1A, or L37c. These are the mildest of the UV filters available and really do not have an effect visible to the human eye looking through the lens. For a stronger effect, there are UV filters that have more blue cutoff and begin to affect visibly the recording of blue within the scene. These filters are generally slightly yellow in appearance and are designated as Haze 2A, Aero 1 or 2, UV 16 or 17. As the "aero" designation implies, these filters are intended for aerial photography, where an extreme reduction of blue is required to increase the color saturation and contrast to an acceptable level. This does not prevent these filters from being useful in normal ground-level work, and they are quite effective when used with long telephoto lenses, generally 300 mm and up, over long distances on hazy days. The one drawback is that they may tend to shift the blue tones toward green in the final photograph or slide, since the UV-absorbing dyes do have a strong yellow cast.

The skylight filter can be distinguished from the UV filter by its inherent pink color cast. This is actually caused by a slight cutoff in the green part of the spectrum, and the filter can be closely related to a red color-correction filter. There is a common misconception that a skylight filter can be used interchangeably with a UV filter. Whereas the UV filter is generally clear and affects the mostly invisible area of the spectrum, the skylight filter warms the scene slightly with red. In many cases, the added red does not eliminate the blue cast but shifts it toward magenta. This can often render a blue sky in a somewhat inappropriate hue. The skylight filter is not strong enough, in most cases, to eliminate blue from the shadow areas of a sunlit scene. For these reasons, most professionals use the UV or Wratten series of filters, as opposed to the skylight filter, when such warming is needed.

about and only a few reach your eyes. Of those transmitted to you, only two vibrate up and down, only one left and right, but four vibrate diagonally. No longer do we have random vibration. These four

make the light partially polarized. So polarization occurs when there's an abundance of light rays vibrating along any one plane. It's that simple. Depending on your viewing angle, the

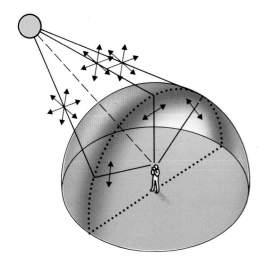

To find the part of the sky that can be most darkened with a polarizing filter, point your shoulder at the sun. The sky directly in front and behind you can be most darkened. If the sun is near the horizon, the sky overhead can also be darkened.

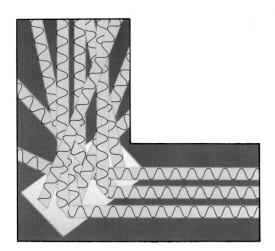

POLARIZING FILTERS

For color photography, the polarizing filter, or polarizer, is probably the most useful of all filters. While essentially neutral, it does not affect the overall color cast of a photograph and can be used in many ways to create extremely vibrant color photographs.

Light is an energy that vibrates along its path, like a vibration traveling along a stretched length of wire. Its vibrations occur at all angles to the direction of motion, however; they are unpolarized. The polarizing filter acts like a screen, permitting only those light waves that are vibrating parallel to the orientation of the polarizer to pass. As an analogy, consider the polarizing filter as a picket fence with openings oriented in only one direction. If a rope were to be stretched through the fence and shaken, only those motions that were aligned with the openings of the fence would pass through.

Polarizers are primarily used to reduce the glare from nonmetallic objects and glass panels. (The glare from metallic objects, however, is more of a direct reflection and is not affected by the polarizing filter.) The maximum effect is seen when the reflection is viewed at an angle of approximately 37 degrees from the surface of the reflecting object.

Another use of the polarizer is to darken clear blue skies. Since the atmosphere contains microscopic particles of dust and moisture that are reflecting and scattering light, the polarizer can eliminate most of this reflected light at specific angles to the sun. There is a polarized band in the clear blue sky that is always at right angles to the sun. To find the band, one simply needs to extend the thumb and forefinger at a 90-degree angle and point the index finger toward the sun. The thumb, as it rotates around the axis formed by the index finger, will automatically indicate the area of sky that can be affected by the polarizing filter. This benefits the photographer by giving control over the darkening of the sky, which increases as the filter is rotated from its minimal-effect position.

Another use of the polarizer is in photographing landscapes or cityscapes, to reduce the haze that is present at the horizon and on which a UV filter will have no effect. In many cases, there is a yellow or brownish haze around cities that is due to atmospheric pollutants. The use of a yellowish UV filter will only accentuate this problem, not reduce it. Since most of this haze layer is composed of particulate matter, however, and it reflects light, the polarizer can help eliminate a portion of the objectionably colored reflected light. Unfortunately, in the modern world this problem is one that must be accepted.

proportion of polarized light may increase or decrease. Nearly all reflected light has both polarized and unpolarized light, though at times the polarized portion may be a miniscule amount.

A polarizing filter works by blocking light that vibrates along the same plane (polarized light). Embedded in the polarizing filter are minute crystals. These crystals all have the same orientation. For

a brief time you might think of them as forming a tennis racket with only vertical strings. Now think of the light rays as paper plates. If the plates are polarized, they'll all be lined up in the same direction. The polarized plates will pass through the vertical strings of the tennis racket only when the strings are aligned with the narrow edge of the plates. You have but to rotate the racket and the polarized plates will be blocked, darkening the blue sky or

reducing reflections. Pass the plates and the blue sky will be light again and reflections will reappear. The darkening of blue sky or reduction of reflections depends solely on the blocking of polarized light. If there isn't much polarized light present, the effect will be weak. When the polarizing filter is passing polarized light, you see no effect on reflections or the sky. By rotating the filter 90 degrees, it will block any polarized light.

Some subjects, such as paved roads and vegetation, tend to have a fairly large degree of glare and can be made to appear darker and more true to the color perceived by the eye when photographed with a polarizer. Green plants and grass appear to be somewhat more bluish in a photograph than our eyes tend to see them. This is caused by the reflection of the blue sky upon their shiny surfaces. Using a polarizer when photographing these subjects will help to intensify the green color by reducing the reflected blue.

A polarizer can be used to darken blue skies when the camera's view includes that portion of sky that is affected by the filter. A polarizer is not always necessary, but it can provide more color saturation and greater contrast between subject and sky and so achieve dramatic effects. Here, the polarizer emphasizes the white house, giving the brightly lighted side even greater prominence by enriching the sky color. (In some cases, if the subject is very light or white, the polarizer can make the sky appear black on film.) The degree of saturation depends upon the clarity of the day, the relative position of the sun, and the extent to which the polarizing filter is rotated between minimum- and maximum-effect positions.

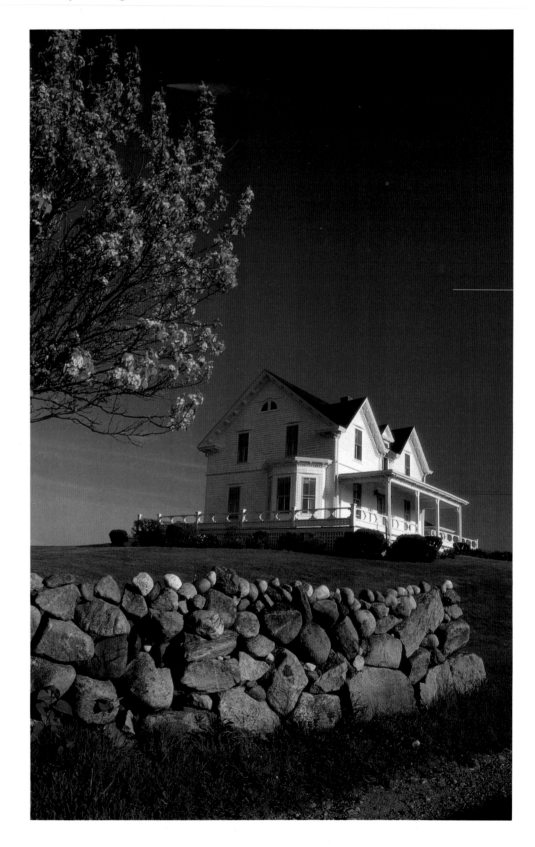

COLOR-CORRECTING FILTERS

These filters are used to balance the light source to match more closely the color balance of the film being used. These filters, usually designated by a Kodak Wratten number, are divided into those that "warm" the appearance of the scene by lowering its color temperature toward the more reddish side of the spectrum and those that "cool" the overall appearance of the picture toward the blue end of the spectrum by raising the color temperature of the scene. (See chapter 6)

Although there is a broad range of these filters, the primary types are used to convert daylight-balanced films to either the 3200 K (Type B) or 3400 K (Type A) tungsten incandescent light sources or to convert either of the tungsten-balanced films to a daylight balance of 5500 K.

On the warming side of the group are the 81 and 85 filters; the cooling filter group bears the 82 and 80 number designations. Of these types, the 81 and 82 series are weaker and lend themselves to more subtle effects and color alterations. The 85 and 80 series are quite strong and contain the filters for balancing the various film types to the differing light sources. Each of the numbered filters has a letter following the Wratten designation number; the letter indicates the relative strength and temperature shift of the filter. The filters are generally available in A through E or EF values, increasing in density and color-temperature shift from A to EF for the 81 and 82 groups, and decreasing in density in the 85 and 80 series when going from A through D.

Subtle color changes can be made with the weaker types of Wratten filters to compensate for a film's response to specific lighting conditions or to improve the appearance of the subject matter. One of the best examples is the wide use of the 81A, 81B, or 81C filter to improve the appearance of skin tone in portraits. These filters are not exceptionally strong and cause only a slight warming shift in the pastel tones of a scene, as in skin tones. By filtering out some of the blue light, they lower the color temperature by approximately 100 K. The effect in portraits is to give skin tone a more even, a warmer, or a tanned appearance without seeming unnatural.

On overcast days, when the color temperature is extremely high, in the range of 8,000–10,000 K, and photographs show a blue cast, the 81A or 81B filter can restore

Conversion Filters for KODAK Color Films				
		Filter and *f*-Stop Change		
KODAK Color Films	**Balanced for**	**Daylight**	**Photolamp (3400 K)**	**Tungsten (3200 K)**
All KODACOLOR Films	Daylight, Blue Flash, or Electronic Flash	No filter	*No. 80B + 1⅔ stops	*No. 80A + 2 stops
KODACHROME 25 (Daylight)			No. 80B + 1⅔ stops	No. 80A + 2 stops
KODACHROME 40-5070 (Type A)	Photolamps (3400 K)	No. 85 + ⅔ stop	No filter	No. 82A + ⅓ stop
KODACHROME 64 (Daylight) and EKTACHROME 64 (Daylight)	Daylight, Blue Flash, or Electronic Flash	No Filter	No. 80B + 1⅔ stops	No. 80A + 2 stops
KODACHROME 200 Professional (Daylight) EKTACHROME 200 (Daylight)				
EKTACHROME 400 (Daylight)				
EKTACHROME 160 (Tungsten)	Tungsten (3200 K)	No. 85B + ⅔ stop	No. 81A + ⅓ stop	No filter

Note: Increase exposure by the amount shown in the table. If your camera has a built-in exposure meter that can make a reading through a filter used over the lens, see your camera manual for instructions on exposure with filters.

* For critical use.

the color temperature to the more pleasing 5500 K level, which is normal for daylight-balanced film.

The stronger 85 series of filters can be used to add more color to sunsets and twilight, reducing the blue tones that are sometimes prevalent in the part of the sky away from the setting sun. Also they can be used during midday to simulate the warmth of the light that occurs at dawn or sunset.

For the most part, the Wratten 80 and 82 cooling filters are used less than the warming filters. These are mostly employed to correct incandescent tungsten light to daylight-balanced film. Without such correction, colors will look excessively reddish or gold. Sometimes these filters are used at sunset to reduce an orange cast on subjects lighted by the setting sun.

A color correcting filter can also be used to create a different mood. The use of a warm-toned filter can create the impression of early morning or late afternoon light.

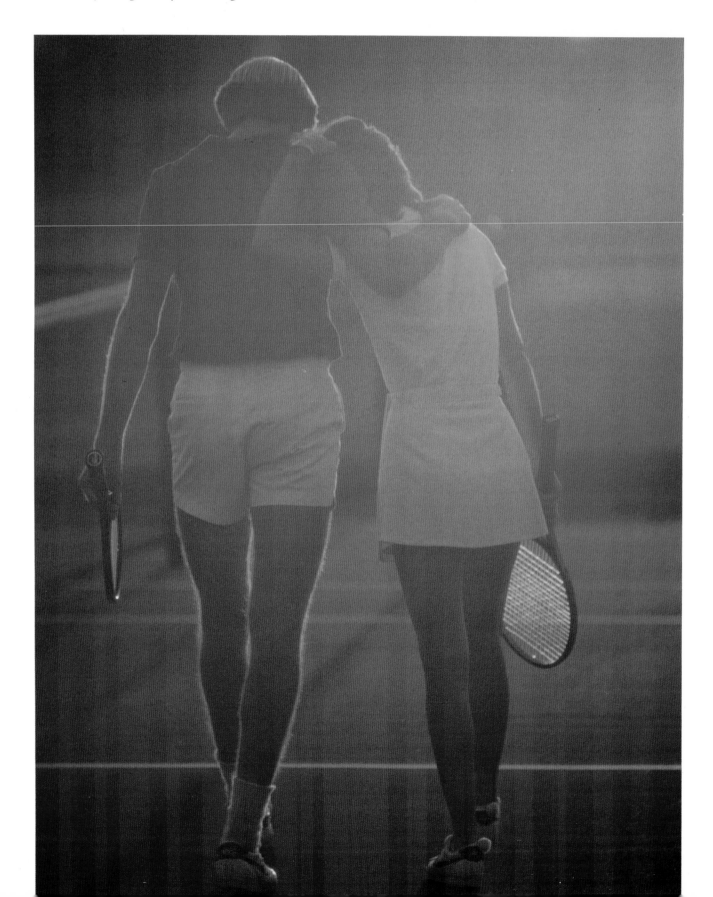

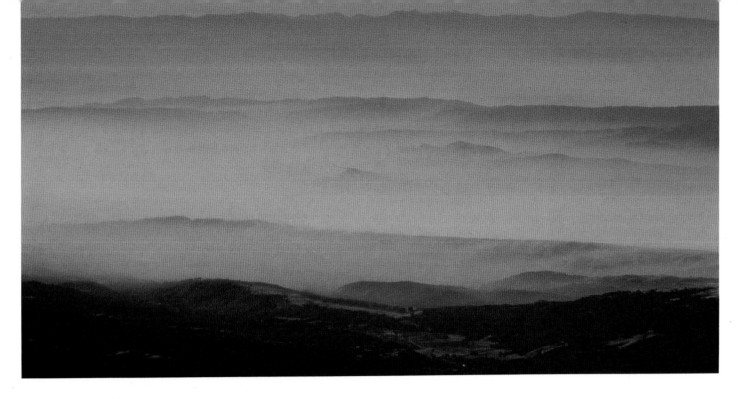

COLOR-COMPENSATING FILTERS

These filters are most often used in critical color work, where the subject is so well known that small color changes will be noticed in the final photographic result. Since color negative films can be manipulated easily in the printing stages, color-compensating filters are generally used only with color transparency films where critical color balance is required during exposure.

Color-compensating filters are supplied primarily as gelatin squares and used in special holders mounted in front of the lens. Until now, it has been difficult to manufacture filters in the close tolerances required for color accuracy in any other medium except gelatin. Because of their fragile nature, color-compensating filters are not generally used outdoors. Handling them requires utmost care to avoid scratching and fingerprints. Unlike glass filters, gelatin filters cannot be cleaned by ordinary means. The best that can be accomplished is to blow off any dust with a gentle stream of compressed air and not brush or touch the surface in any other way. Even with normal handling, these filters have a rather limited life span and they can be quite expensive when replacement time comes.

The normal use for color-compensating filters is for critical changes in the fundamental color balance of the entire scene and to correct for unusual lighting sources, such as fluorescent tubes. These filters generally are supplied in red, green, blue, cyan, magenta, and yellow, and in densities from 0.025 to 0.50 CC. The designation CC stands for *color compensating* and the numerical unit is the density of the filter in logarithmic expression, without the decimal point. For example, a CC30M filter is a *color-compensating* filter of 0.30 density and magenta hue.

Color-compensating filters can help remove certain overall color casts that occur with nonstandard lighting sources. Fluorescent lamps, for instance, generally give a green cast to most daylight-balanced color films. For most fluorescent lighting, a CC30M (magenta) filter is required, along with one or two other CC filters, to remove this green cast. A combination that works particularly well for most types of fluorescent lighting (except warm white deluxe bulbs) is CC40M plus CC05Y. This combination of medium magenta and pale yellow removes both the green cast and a small amount of the residual blue that most fluorescent lighting appears to produce on daylight-balanced film. This combination will not work with tungsten-balanced films, which require further additional correction to achieve proper color. For this reason, daylight-balanced film is more convenient to use unless supplementary tungsten lighting is to be added. The initial color-filter pack is simpler, and proper color balance is easier to achieve.

A most unusual application of a magenta color-compensating filter is presented in this view of the Sierra Nevada range in the western United States. These filters can be used for very subtle fine-tuning of color balance, or can have sufficient color density to cause an overall color cast. Here, the magenta filtration blends harmoniously with the deep blue of the mountain peaks and accentuates the presence of fog in the valley areas.

NEUTRAL DENSITY FILTERS

The neutral density (ND) filters are used to reduce uniformly the light intensity passing through the lens and do not impart any color bias to the photograph. These filters come in a variety of densities that absorb proportional amounts of all wavelengths of light. The most widely used are the 0.3, 0.6, and 0.9 densities which correspond to one, two, or three f-stops of light reduction, respectively.

They are useful when it is preferable to reduce the shutter speed rather than closing down the aperture and increasing the depth of field. For example, with a neutral density filter in place, a wide aperture can be used in bright light to emphasize the subject by selective focusing, or a slow shutter speed can be used to create a feeling of motion through subject blur.

One effect that can be obtained by using extremely strong neutral density filters, around a density of 4.0, is the elimination of all moving subjects from a scene, even in the middle of the day, by making long time exposures—up to several minutes. By exposing for such a long time, only stationary objects will appear in the final photograph. People walking and cars in motion will not remain in the scene long enough for their images to be recorded on the film.

Another application of ND filters is to reduce the depth of field when using an electronic flash with sunlight outdoors. Although more and more 35-mm cameras have higher shutter synchronization speeds, some up to $1/250$ second, there are many that still only function with flash at $1/60$ second. With ISO 100 film, the aperture required for this shutter speed is around $f/16$ to $f/22$. This might provide too much depth of field for the particular photograph, and an aperture setting of $f/8$ would be more desirable. By placing a ND filter of 0.6 density over the lens and leaving the flash set for the original $f/16$ exposure, the lens can be opened two full f-stops to yield proper film exposure. With cameras having through-the-lens (TTL) flash metering, it is only necessary to open the lens by the two f-stops, since the TTL flash system will automatically compensate for the neutral density filter.

DIFFUSING FILTERS

All filter manufacturers make their own interpretation of a diffusion filter. There is a confusion in terminology between "diffusion" and "soft-focus" filters. Often the former term is used when the latter is the real intention. To clarify the terminology: Diffusion filters cause the entire photograph to have no areas of distinct sharpness. Although this is often acceptable in portraits, where facial features thereby appear smoother and more uniform, it is often disconcerting to the viewer of the photograph because the general appearance is that the lens was not in focus at the moment of exposure.

Soft focus, on the other hand, is the controlled introduction of spherical aberration to the optical system. This makes the lens unable to focus the light rays from all portions of the scene equally. The result is a sharp image that is surrounded by an out-of-focus image of the same scene, causing the highlights to have a halolike surrounding field due to the superimposed out-of-focus image. This gives a softening effect to the image overall while retaining a degree of sharpness that is pleasing to the eye.

The most famous of the soft-focus filters are the Zeiss Softars, which have small domelike projections on their clear surface to create spherical aberrations. Other filter manufacturers achieve the same effect by depositing a silver flake material on clear optical glass.

Smearing small amounts of petroleum jelly onto a clear glass filter in a very controlled manner can also provide a soft-focus effect, but the petroleum jelly can

ruin a good filter and not produce repeatable results over a long period of time, as the material flows readily on warm days.

Some photographers have successfully used fine mesh material stretched across the front of the lens to achieve the same type of soft focus. Stocking material is ideal for this, but care must be taken in the choice of the material because its color affects the final color balance of the photograph. Black nylon stockings have an almost neutral effect when used in this manner, but the material does not create the flaring highlights the other types of filters produce.

SPECIAL-EFFECTS FILTERS

Over the last decade, several new optical polycarbonates (plastics) have come into acceptance for critical optical applications, primarily as filter materials. These new plastics have allowed the designers of filters to create new and unusual filter types; in some cases, entirely new filter systems have been introduced to the marketplace.

However attractive special-effect filters may appear in the marketing claims, many of these new types of filters tend to be mere gimmicks unless good judgment is used in applying them to the photographic situation. In many cases, it may be the effect of the filter, rather than the photograph, that commands attention.

There are many ways of achieving soft-focus effects with filters, and some photographers even make their own with various diffusing materials. Here, a smear of petroleum jelly on a clear filter created the soft-focus image with the streaking of light. Coupled with the granular effect of pushed high-speed film, the streaks and softening enhance this impressionistic image of a subject that might not have been as interesting had it been photographed "straight."

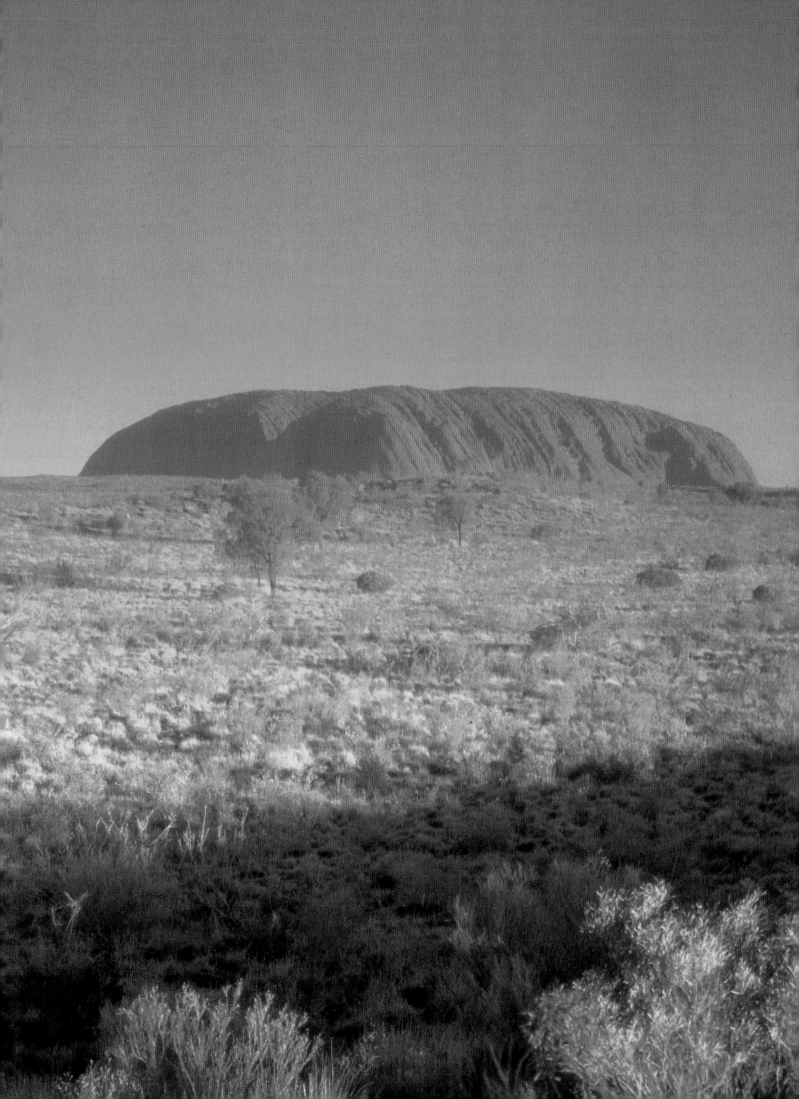

Several of the new filters, especially the graded neutral density or graded-color types, can add to the essence of a photograph by controlling an area that is likely to become overexposed otherwise. This calls for subtle technique. Of course, in many of the science-fiction and fantasy photographs we see today, the uses of special effects and special-effect filters are limited only by the imagination of the creator. The best practitioners of this type of photography use the filter effects as a means to an end in order to bring their personal visions to reality on film.

Fog filters have been around for a long time and are generally good, but there are improvements in the basic design. Some of the manufacturers that use the new optical plastics have developed graduated fog filters that give a more natural effect than those that are uniformly coated.

Color-graduated filters that are half clear and half color, or half neutral density, are often useful where the sky is rather bland or would wash out to white when you are exposing for a subject on the ground. A tobacco-colored graduated filter gives more color to the sky at Ayers Rock, (left), in

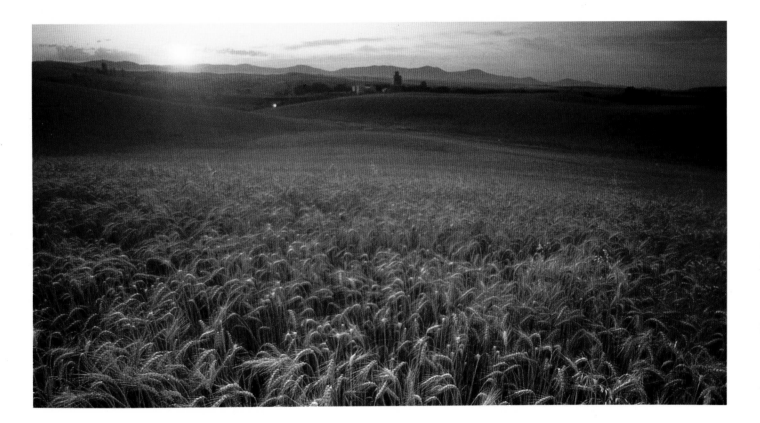

The starburst filters have been around for a long time, too. Their effect results from crosshatched lines engraved on clear glass. They are used to expand the glimmer of point light sources in nighttime cityscapes and in photographs of jewelry. Their over use in recent times has made them an obvious technique that draws attention away from the content of the photograph, and they are no longer used extensively in the ranks of professional photographers.

One of the ways to accent the bright pinpoints of light in night scenes without using a filter is to use a lens aperture of $f/8$ to $f/16$, which produces a diffraction starburst of approximately twelve points around each light source. The advantage of this is that the image diffusion present with a star filter is completely absent from the image with this technique. Also, the lens is being used at near optimum aperture for better sharpness and excellent depth of field.

The various multi-image and spectral-burst filters do have their place in science-fiction and fantasy photography; but, again, their visual effect draws attention to the technique and away from the content unless their use really does enhance the atmosphere of the final image.

Without a definite purpose for the use of special-effects filters, the optical phenomena they generate may become the entire essence of the photograph and diminish the true intent of the image and impact of the subject.

Australia. The clear portion of the filter was placed at the bottom of the frame so as not to affect the color of the immediate foreground. For the horizontal image, a red graduated filter enhances the sunset colors and reduces the brightness of the sky while maintaining the foreground exposure. When used in conjunction with the horizon or other lines of separation within the scene, these filters can provide an almost natural appearance and do not call attention to themselves.

Soft-focus filters, in contrast to simple diffusers, create a soft halo of light around the lighter portions of the image, softening the tonal contrast and smoothing areas of similar color and tone while still providing a reasonably sharp image. Each of these photographs uses soft focus to enhance feeling in a way that is most harmonious for the subject matter. The light source does not have to be soft for the filters to work well. In fact, in the photograph of the young ballerina a very directional lighting method has been used, yet it still works in harmony with the soft-focus effect.

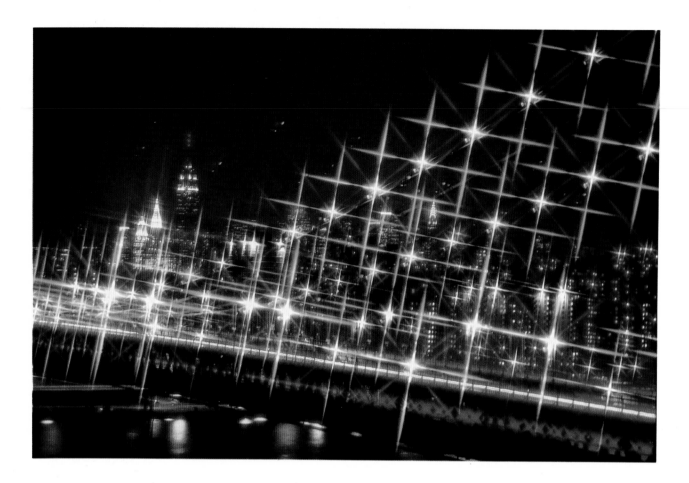

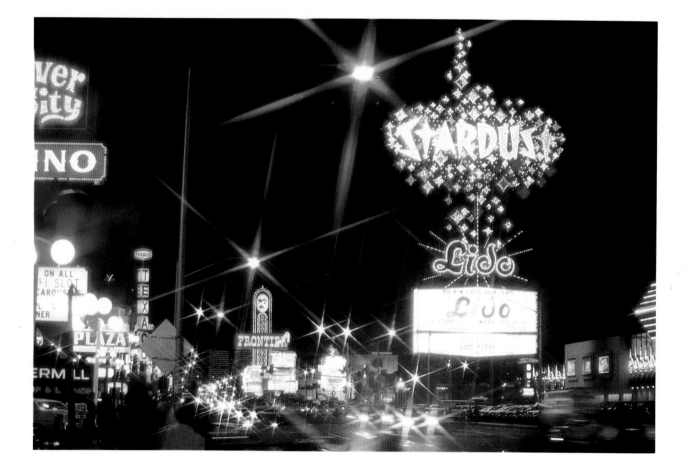

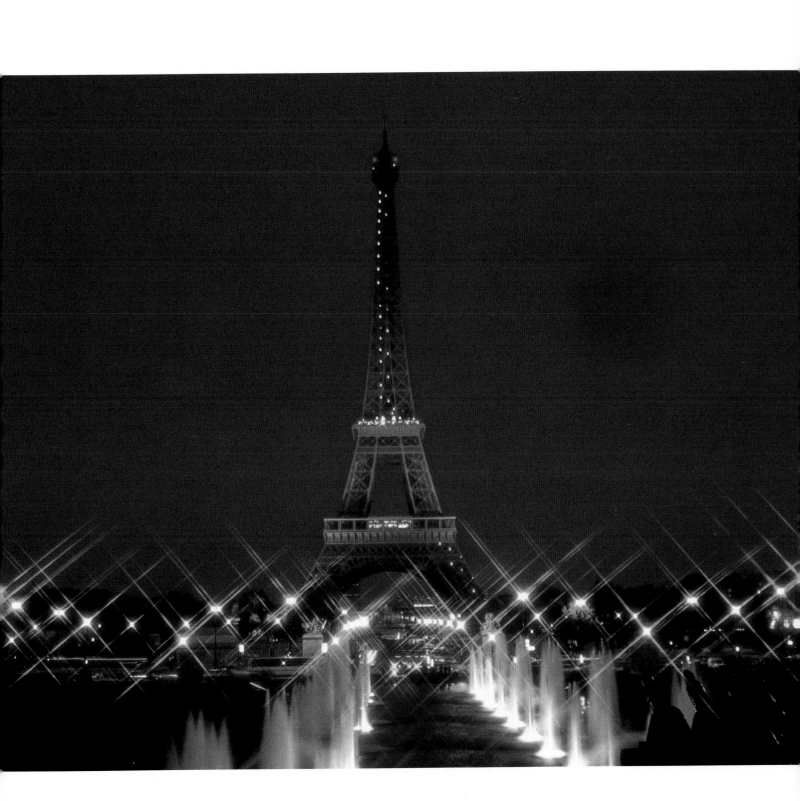

Star filters are often used excessively, and yet they can provide a proper accent when the subject matter and lighting require some extra attention. Sometimes the intensity of the stars makes them the real subject of the photograph. In some cities, lights or lighting can be as important as the landmarks of the city. In the view of Las Vegas, a six-point star filter enlivens a typical street scene, while in Paris a four-point star filter has provided an additional center of interest and a visual base to support the Eiffel Tower. The third view, of the Manhattan Bridge in New York, also uses a four-point star filter, but the intensity and brightness of the lights become the focus of attention, rather than the bridge, which is obscured by the stars. In this image the hint of New York provided by the buildings in the left portion supports the lights as the subject and enforces the feeling of New York as a brightly illuminated city.

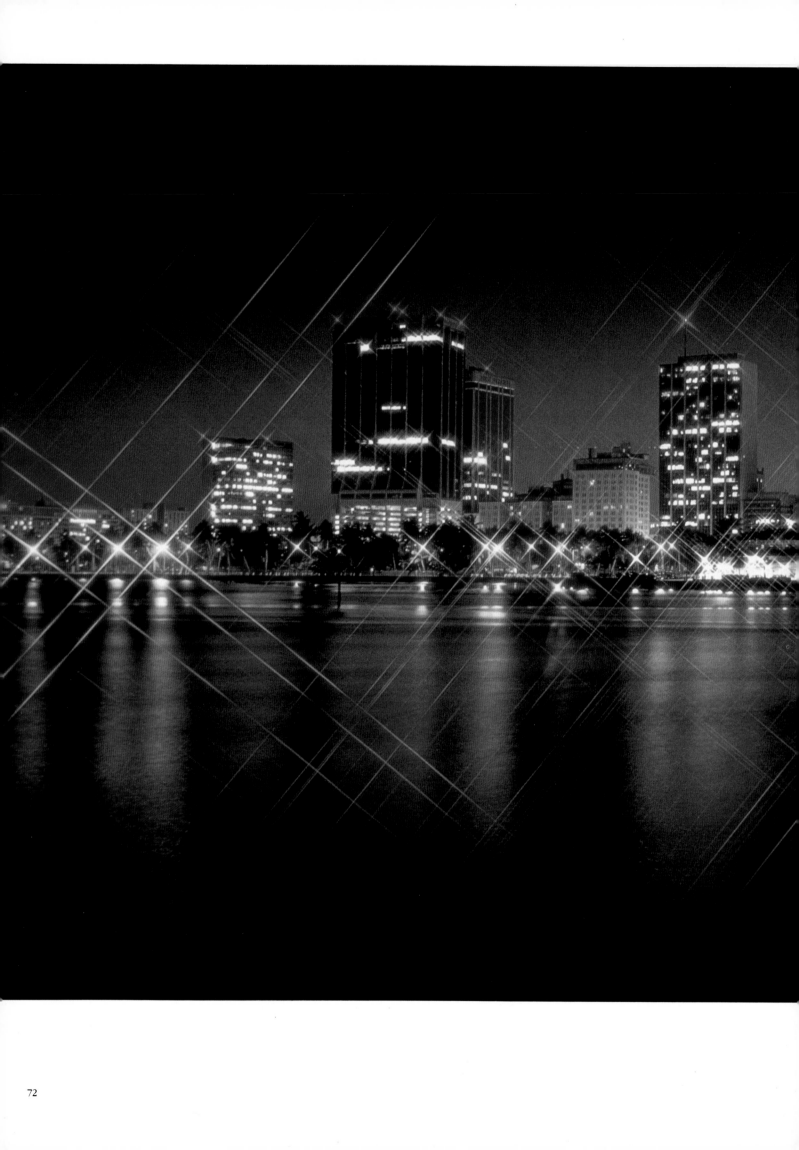

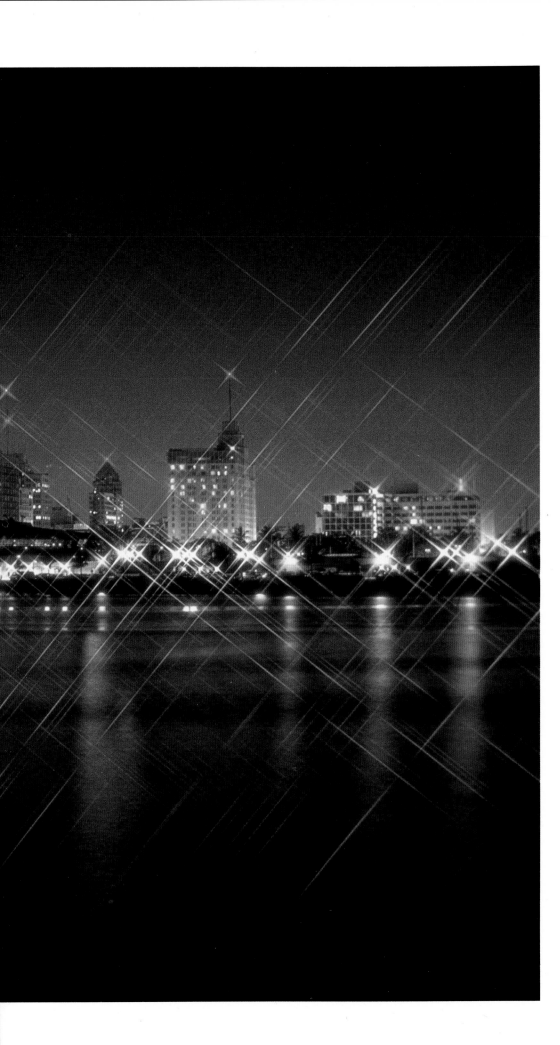

Star filters are varied in number of star points and in relative intensities or sizes of the generated stars. In these night views of Miami, different star effects were sought. An eight-point star filter provides a heightened awareness of the point light sources in the scene without letting them overpower the skyline. In the other version, a four-point star filter has created very large stars from the points of light, which almost become a screen through which the city is seen.

To alter the tonal rendition of the sky in black-and-white photography, use colored filters. The No. 8 yellow, No. 15 deep yellow, No. 58 green, and No. 25 red filters increasingly darken a blue sky, making the clouds stand out by contrast. A No. 47 blue filter lightens the sky.

No filter

No. 8 yellow filter

No. 15 deep yellow filter

No. 25 red filter

No. 47 blue filter

No. 58 green filter

FILTERS FOR BLACK-AND-WHITE FILMS

Normal black-and-white film, termed panchromatic, is sensitive to all colors and records them as various shades of gray in the final image, according to their relative brightness. The rendition and relationship of these shades of gray can be altered by strong filters.

The filters made for use with black-and-white films function by absorbing wavelengths of the spectrum that are complementary to their own color. For example, a deep red filter, No. 25, blocks most of the blue and green bands of the spectrum, allowing only yellow, orange, and red wavelengths to pass. The net result of this on film is the darkening of all objects that are blue or green and some lightening of those colored yellow, orange, and red. In outdoor scenes with clear blue skies, the red filter will turn the sky very dark, almost black in some cases, with very dramatic results.

Because of the large amount of blue light present in atmospheric haze in many outdoor scenes, an orange or red filter can be effective in reducing or even eliminating the appearance of this haze in the final photograph.

In brief, subjects that are the same color as the filter will be lightened, and those that have colors complementary to the filter color will be darkened. The degree of these tonal alterations can be controlled by the actual color of filter used. In the previous example, where the red filter reduced or removed the appearance of atmospheric haze, a deep blue No. 47 filter would have accentuated the haze effect by eliminating the red portion of the light.

For general photography, the effect becomes increasingly stronger in the blue and green areas when going from the yellow to orange to red filters, red having the strongest effect. In fact, for most general black-and-white photography outdoors, a No. 8 light yellow filter is recommended all the time, to reduce the amount of blue light reaching the film and to provide more normal rendition of tonal contrast. The use of these filters is not as tightly defined as that of color-film filters. They affect the contrast and tonal relationships among colors in a scene and the way in which those colors will appear on black-and-white film as a variety of gray tones. As a result, they can be used in many ways to achieve unusual as well as conventional effects in the final black-and-white image.

Filter Recommendations for Black-and-White Films in Daylight

Subject	Effect Desired	Suggested Filter	Exposure increase in stops
Blue Sky	Lightened	No. 47 Blue	2⅔
	Natural	No. 8 Yellow	1
	Darkened	No. 15 Deep Yellow No. 21 Orange Polarizing filter	1⅓ 2⅓ 1⅓
	Greatly darkened	No. 25 Red	3
	Almost black	No. 29 Deep Red	4
Marine scenes when sky is blue Sunsets	Natural	No. 8 Yellow	1
	Water dark	No 15 Deep Yellow	1⅔
	Natural	None or No. 8 Yellow	1
	Increased contrast	No. 15 Deep Yellow No. 25 Red	1⅓ 3
Distant landscapes	Increased haze effect	No 47 Blue	2⅔
	Natural	No. 8 Yellow	1
	Haze reduction	No. 15 Deep Yellow No. 21 Orange Polarizing filter	1⅓ 2 1⅓
	Greater haze reduction	No. 25 Red No. 29 Deep Red	3 4
Foliage	Natural	No. 8 Yellow No. 11 Yellowish-Green	1 2
	Light	No. 58 Green	2⅔
Outdoor portraits against sky	Natural	No. 11 Yellowish-Green No. 8 Yellow Polarizing filter	2 1 1⅓
Architectural stone, wood, sand, snow, when sunlit or under blue sky	Natural	No. 8 Yellow	1
	Enhanced texture rendering	No. 15 Deep Yellow or No. 25 Red	1⅔ 3

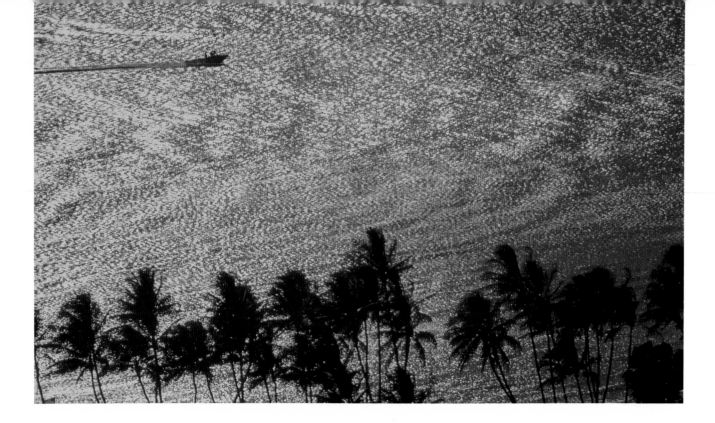

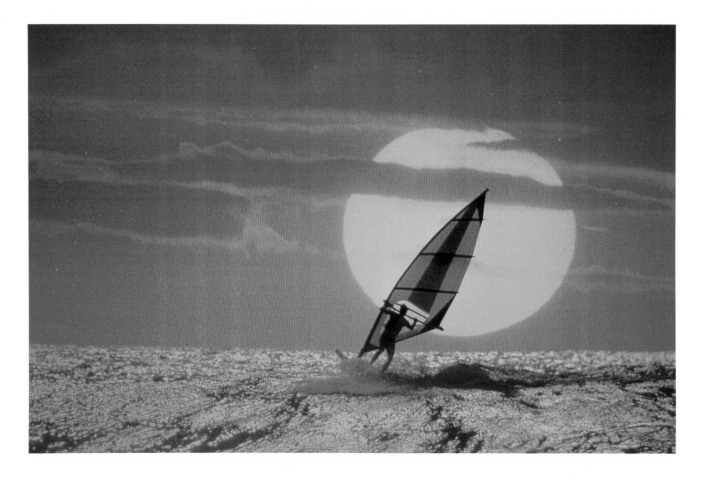

A deep orange filter, such as a Kodak Wratten No. 21, can be used to generate the golden glow of sunset. In each of these images, the orange filter provided extra color saturation or even altered the existing light to create the impression of dawn or late-day lighting. The additional warmth from this filter adds to the feeling of sunshine and pleasure within the image.

COLOR FILMS WITH BLACK-AND-WHITE FILTERS

The filters used for black-and-white film are much stronger than those used for color work. They are made in various degrees of primary colors: blue, red, yellow, orange, and green. These deep-color filters that are principally intended for black-and-white photography can also be applied to color photography situations where a strong overall color cast is desirable. One of the most used filters is for this is the No. 21 deep orange filter. When used for a sunset, it can impart an overall golden-orange cast to the photograph that, although it may not be realistic, tends to convey the impression of the ideal sunset.

The No. 25 red filter can also be applied to sunset situations, but it causes a further distortion of reality than the orange filter. If the impression of extreme heat and sunlight is the intention of the image, however, the No. 25 red should be considered.

There are other applications of black-and-white filters in color photography, such as using primary tricolor combinations of red, green, and blue (filter Nos. 29, 58, and 47, respectively) for multicolored motion photographs and other similar effects. Experimentation is the key to their use.

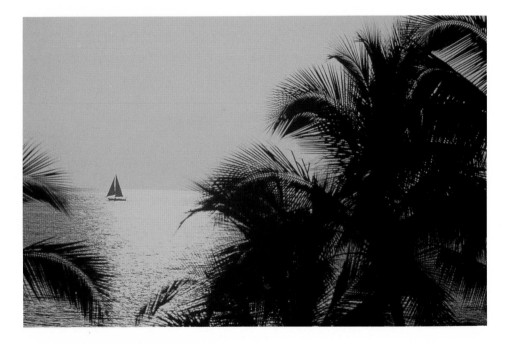

The use of a medium yellow filter that is primarily intended for black-and-white film has transformed these photographs into vibrant images that give the impression of an intense sunset. Although nature rarely provides monochromatic images, these can draw attention to the subject by their strong graphics and sheer intensity of color.

❻ WORKING WITH LIGHT, COLOR, AND FILM

Light is the essence of all photography. It is the generation and reflection of light that causes the image of objects to be perceived and images of them to be formed on light-sensitive materials. In strictly scientific interpretation, the true nature of light is not fully understood, but visible light is known to be a small segment of the electromagnetic radiation spectrum of wave energy. Light is also thought to consist of small subatomic particles called photons. It is this dual nature of light that leads to the uncertainty in attempting to explain fully its nature and properties.

Human eyes are sensitive to the small segment of the spectrum between ultraviolet and infrared energy known as "light." This visible band appears as white light when all the wavelengths are present in equal amounts and is thought of as normal daylight, the color of light that reaches the surface of the earth most days at midday. In actuality it consists of a multitude of color permutations that human beings can see. It has the appearance of a rainbow when it passes through a glass prism or of course when sun strikes rain or spray in the air, causing a real rainbow to appear.

When a large amount of haze or humidity is present in the atmosphere, it can largely alter the color temperature of a sunset. The cool, nearly monochromatic hue of this hazy sunset in Maine shows just what effect the atmosphere can have in changing the color temperature of light. On a clear day, this sunset would consist of brilliant orange tones; here, the light has been raised in color temperature to a moody bluish level.

When combined in equal proportions, red, green, and blue light form white light.
When combined in unequal proportions, they can form all the colors of the spectrum.

COLOR TEMPERATURE

An important method of defining the color quality of light is in terms of color temperature, usually expressed in degrees on the Kelvin scale of absolute temperature. If an object were to be heated to 2000 K, it would emit a certain amount of visible radiation that would be heavily biased to the orange-red region of visible light; that is, it would be glowing somewhat orange. If the same object were to be heated to 5500 K, it would appear to be glowing white, or white hot. At this temperature, the spectral output of the object's visible radiation would closely match the spectral characteristics of midday sunlight. If the object were heated further, to 10,000 K, it would then appear to be glowing blue, and its radiant energy output would extend into the ultraviolet wavelengths.

Over many years of research, film manufacturers have established that most film emulsions that are to be exposed in normal daylight should respond with normal color to a spectral color temperature of 5500 K. For this reason, this color temperature is considered the normal point for white light for photographic purposes.

COLOR TEMPERATURE CHART

Household Lightbulbs	"Type A" Film Balance	Tungsten Film Balance	Photographic Daylights	Daylight Film Balance	Blue Sky
2000°K	3200/3400°K		5500°K		9000°K

It is important to understand that color temperature does not mean that a measurement of heat is involved; it is simply a scientific manner in which to describe the particular color mixture of various types of light, including daylight. The color temperatures below 5500 K become increasingly yellow, then orange, then red as they approach 1000 K. Color temperatures above the 5500 K norm become increasingly bluish and are often termed "cool" because ice tends to have bluish tones.

Normal daylight is not always 5500 K, even at high noon. Absorption of blue light by the atmosphere occurs when the sun is near the horizon at dawn or sunset and light must travel through a great amount of air. For this reason, early morning and late afternoon light is reddish-orange and appears vibrant and warm on daylight film. On overcast or hazy days, there is a predominance of blue light as it is scattered more easily than red light by the particles of moisture in the air. Therefore, the color temperature of a heavily overcast day can be in the range of 15,000 K and appear bluish to daylight-balanced color film.

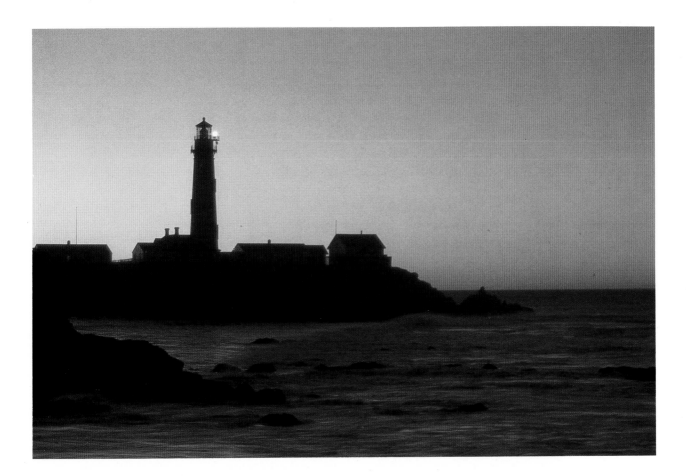

The richness of a twilight afterglow plus film's inability to record color accurately in long exposures produced the soft, unusual color combinations of these two photographs. At this time of day, the sky contains almost all the colors of the spectrum—from reds at the horizon to deep indigo in the uppermost portions. Exposure is critical in such lighting situations, and bracketing is imperative because film has a varying response to long exposure times. The softness of the light and the unusual natural sky coloration convey a feeling of calm and conclusion to the day.

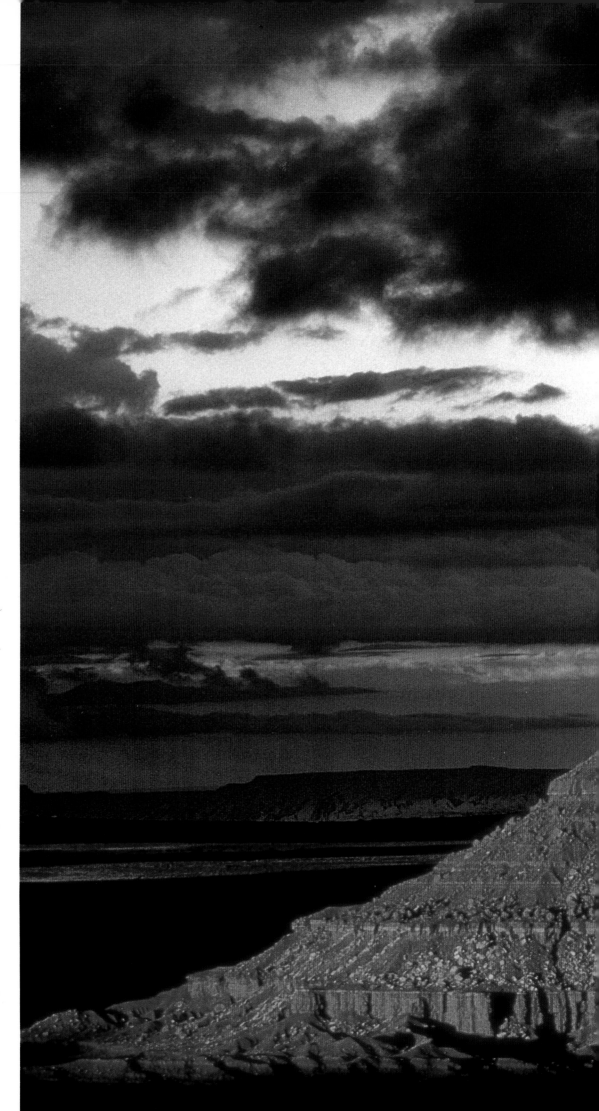

This image provides a striking contrast between the high color temperature of the clouds, which appear dark blue, and the late sunset light's very low color temperature, which is illuminating the rock formation. The effect of warmer colors is to make objects seem closer to the viewer whereas cool colors tend to feel more distant. The color contrast presented here helps to increase the feeling of separation between the rock formation and the sky.

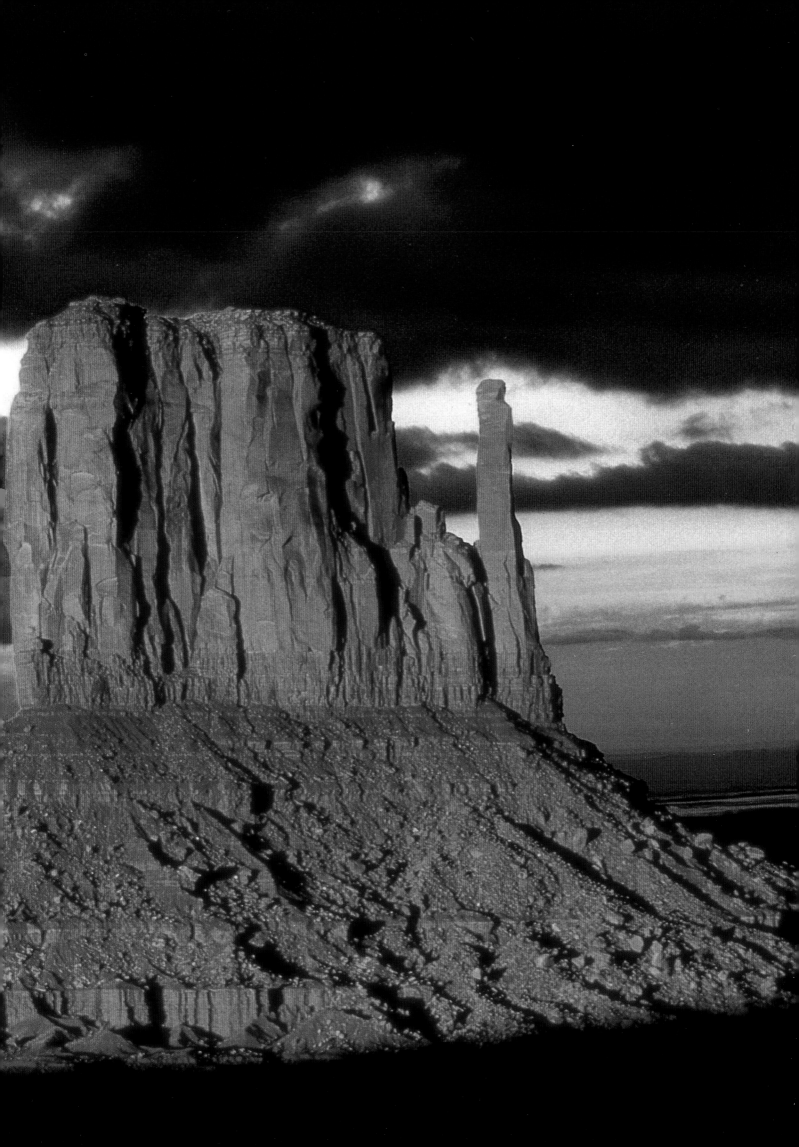

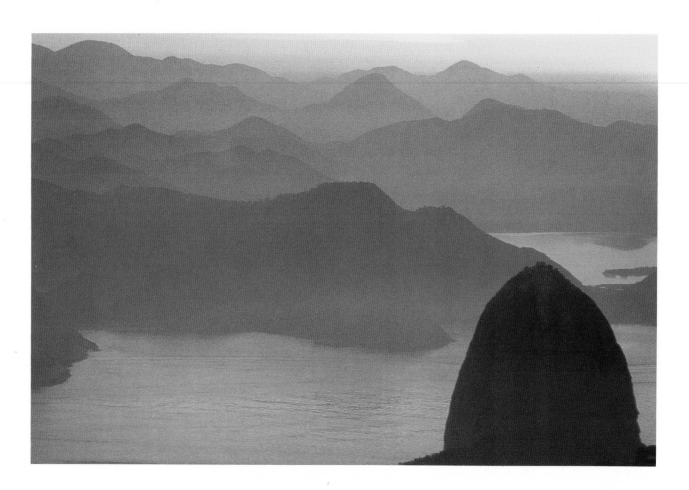

Photographs that include large distances can have a limited range of color tones, as in the photograph of Sugarloaf Mountain in Rio de Janeiro, where the color temperature of the light is fairly consistent and the tonal variation is caused primarily by atmospheric effects. In contrast to this, the photograph of misty mountains is almost a complete spectrum of hues from blue to red, representing a wide range of color temperatures in the light. The mood established by the color range in each of these images is different—and is in harmony with the subject matter presented in each.

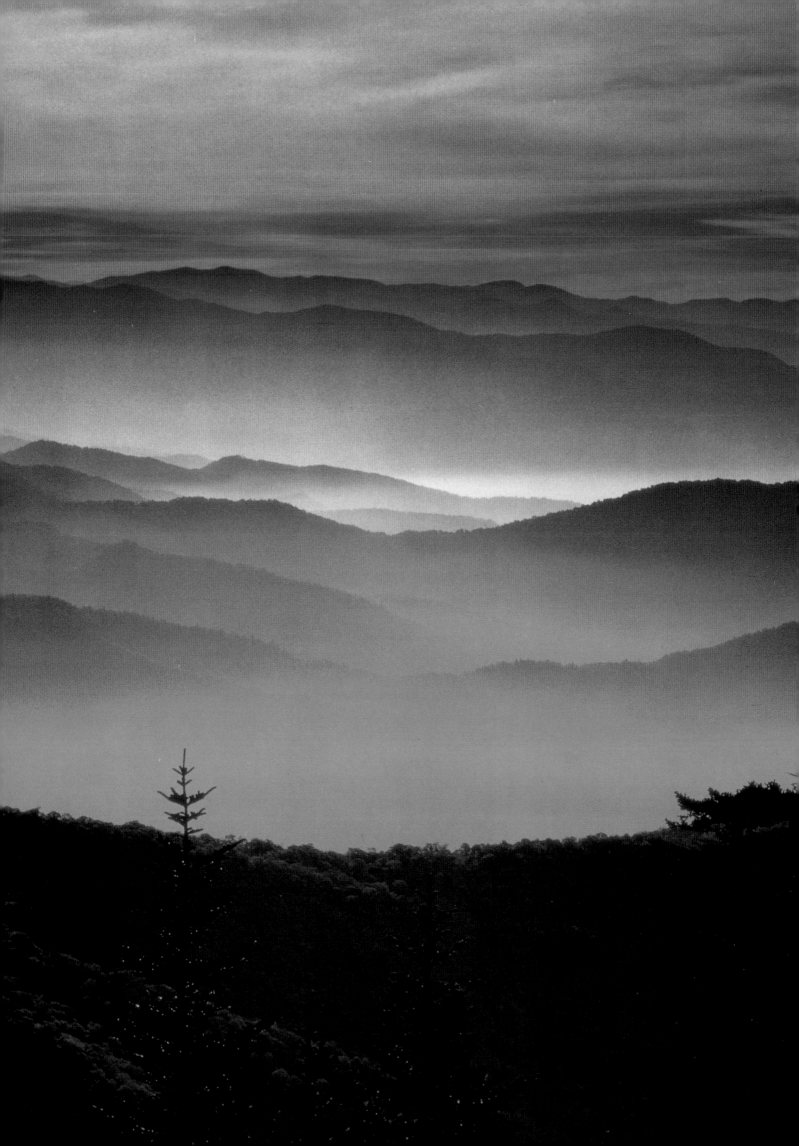

The cool, almost monochrome blues of these two landscapes create a feeling of mystery, as of an unknown presence lurking in the distance, along with a mood of isolation within the mist. This effect can be generated by using strong blue filters over the lens or by the intentional misapplication of film balanced for tungsten lighting but exposed under daylight. The emotionally expressive power of such colors is readily evident in these photographs.

MATCHING LIGHT SOURCES AND FILM TYPES

Artificial light sources such as lightbulbs use filaments made of tungsten metal that are heated by electrical current to the point of glowing, visible emissions. These filaments generally produce a color temperature of around 2800 K and appear reddish-orange when recorded on daylight-balanced color film. Manufacturers of lightbulbs decided several decades ago to standardize two types of tungsten-filament bulbs with two specific color-temperature spectrums for use in photography. These are called Type A, which has a color temperature of 3400 K, and Type B, with a 3200 K color temperature. These lamps have a fairly good degree of consistency, and film manufacturers produce color emulsions that record these light sources as white rather than the reddish-orange they would appear when recorded on daylight-balanced films. The Type B films are more widely manufactured because the lightbulbs that emit 3200 K have a much longer filament life.

For this reason, when planning exposures it is important to match the spectral balance of film to the color temperature of the prevalent light source. Since a degree of color correction can be done at the printing stage of color negative films, most concerns that are expressed with regard to color casts are stated in relation to color transparency films. The final transparency cannot be color-corrected after processing, although some correction can be made if it is to be printed.

When either of the tungsten-balanced films is used in normal daylight, it will have an overall blue color cast that in most cases will be quite objectionable. These films must therefore be used with a Wratten 85 or 85B color-correcting filter to lower the color temperature of daylight to the proper balance for the film. In the same way, using daylight-balanced film under tungsten illumination will yield very red-orange results unless a Wratten 80A or 80B filter is used to increase the color temperature of the light source. (See the table on page 61.)

In some cases, an exact match between color temperature and film type is not necessary; the strong color cast caused by intentional misapplication may intensify the mood of a photograph. One of the most common examples of this misapplication is the use of tungsten-balanced film without corrective filtration on

The overall blue cast of this simple composition adds to the atmosphere of the small boat resting in the water. The reclining position of the figure in the boat is supported by the restful monochromatic blue, creating a feeling of a carefree day on the water. This effect can be achieved either with a blue filter, such as a Kodak Wratten No. 80A or 80B; or by using tungsten-balanced film in daylight.

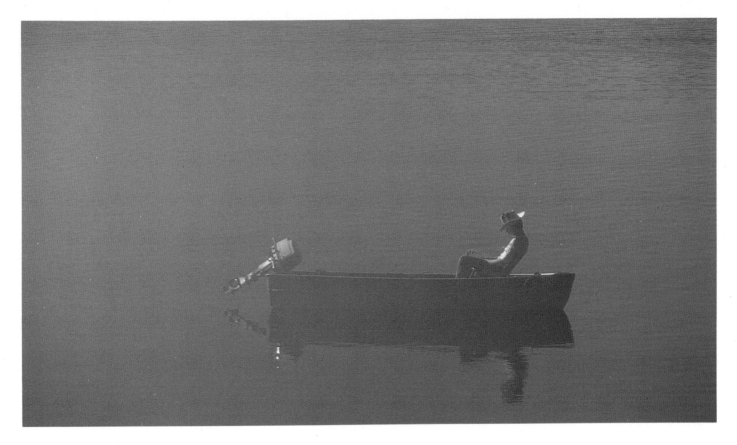

In this view of London's Parliament buildings, numerous light sources combine to create an interesting and harmonious mixture of colors that lends an air of contemporary appeal to an ancient structure. The slightly overcast sky has registered as a mixture of blue and magenta, while the fluorescent lighting underneath the bridge appears green. The remaining lights within the scene are primarily tungsten and would normally appear yellowish, but a slight overexposure has caused them to appear more white. The reflection of the lights in the river Thames adds multiple accent points of both white and colors that echo the color scheme of the upper portion of the frame.

The color of dawn differs slightly from that of sunset; it seems to hold the promise of the day yet to come. Although the basic color palette is similar to sunset's, the presence of more yellow conveys a lighter feeling than is usually experienced at sunset. In the first misty sunrise picture here, the feeling is that the sun will eventually overcome the fragile mist. The soft backlighting of a different early morning mist creates a gentle backdrop for the woman on horseback. And a backlighted hickory tree causes distinct shadow streaks through the mist in the foreground, almost becoming the actual subject of the photograph. In another mood, mist subdues the intensity of the sun in the Everglades photograph.

foggy or overcast days: The resulting strong blue cast enhances the feeling of overcast or of oppressive gloom. Another instance is a twilight photograph of a cityscape or other artificially lighted area at night, when the remaining glow in the sky turns intensely blue while many of the artificial lights in the scene are rendered more accurately than they would have been on daylight film.

Light from many ordinary lightbulbs appears to the human eye to be white rather than the reddish cast recorded on color film. The reason is that human vision, being so closely linked to the brain, is very much affected by the brain's desire to have things appear "normal." Thus, the brain has a built-in compensation factor that can, over a reasonably wide color-temperature range, "correct" the color spectrum to appear as white even though it deviates from the normal spectral content of daylight. This can be tested by exposing the eyes to normal daylight of a very intense brightness and then quickly moving into an area that is illuminated solely by light from tungsten-filament bulbs. The overall color cast of the room will appear to be orange at first and gradually become white as the brain begins to compensate for the lower color temperature.

It is not always necessary to include the actual light source in a photograph to describe the time of day. In both these photos, the impression of sunset is gained through the reflection of sunset light in the bodies of water that form important compositional elements within each frame. The photograph of the people fishing has had the yellow enhanced through the use of a yellow filter intended primarily for black-and-white photography, while the runner on the beach is pictured in the strong natural color of sunset that occurs near the ocean.

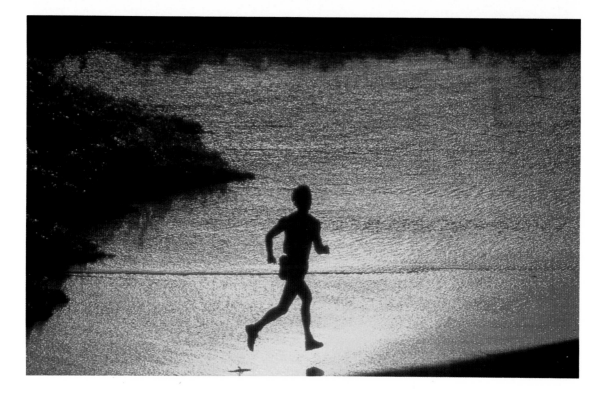

THE DIRECTION AND QUALITY OF LIGHT

The quality of light is one of the most significant factors in establishing the mood of a photograph. Even though composition, color content, and subject matter establish and define an image, the mood and emotions are evoked by the quality of the illumination that is present. The image of a forest in bright sunlight, with rays of light streaming through its trees, creates a totally different impression from the same scene taken on an overcast day, when tones are muted and brightness is lacking. The former may prompt feelings of happiness and relaxation, whereas the latter may evoke mystery, gloom, or even a sense of threat with its darker tonal range. Even though the subject is the same, the light has caused the viewer to receive a different impression.

Three characteristics of light determine the perception of a particular image and the viewer's response to it. Brightness is the intensity of light, color is the overall cast, and quality is the manner in which light illuminates the objects within the scene.

There are two fundamental types of light quality: direct, which is very harsh and can be created by a small point source similar to the sun on a very clear day, such as a single small lightbulb; and soft, much like the shadowless, diffused light of an overcast day.

Direct light creates harsh contrast, with deep shadows and intensely saturated colors. In combination with the shadow content of an image, direct light can be used to convey many different emotions, such as strength, mystery, or joy. Because of its ability to bring out the texture of surfaces, direct light must be used carefully when photographing faces. Many unflattering details can be emphasized by the harshness of the light. Direct light is bold and does not lend itself to rendering delicate tones.

Direct light can emanate from three principal directions within the photographic composition: the front, the side (either left or right), and the back of the subject. There are further variations of these three principal directions: The height of the light source relative to the subject can create either top or bottom lighting from any of the three directions. This directionality has a most profound effect on the final photograph and can completely alter the mood of the image.

Frontlighting tends to be the least interesting of all types of direct lighting because of the lack of shadows. It tends to flatten the perspective of a scene, causing the subject to blend into the background. If the subject is lighter in tone than the surrounding area, however, frontal lighting can lead to an exciting separation of the subject from its environment. Frontlighting also places more attention upon the specific composition of a photograph because the viewer's interest in relationships between highlight and shadow areas is somewhat diminished.

Sidelighting creates the most interesting combination of highlights and shadows within a photograph and can introduce an extra sense of depth. Textures tend to be brought out strongly and become a part of the visual construction of the image. The

Sidelighting is excellent for bringing out the texture and emphasizing shapes, as is shown here. The shadows created in this way help to define the background and highlight the runner's face and towel, while still keeping some shadow areas present for the eye to explore. The saturation of the colors in this image also provides complementary contrast and helps to offset the intensity of the shadow areas.

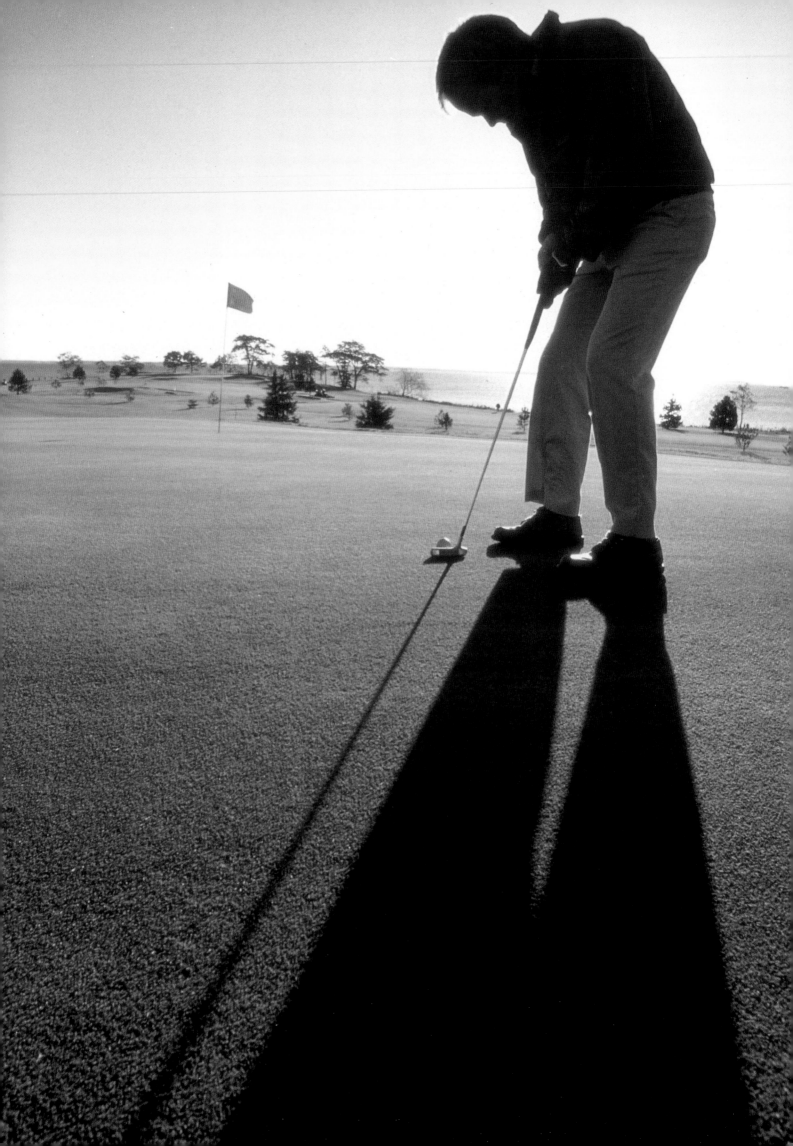

Although basically there are only two colors within this photograph, the tree is given more weight as the center of interest by the shadow that runs parallel to the ridge line and counter to the band of clouds in the background. Sidelighting here is subtle, and is really only defined by the shadow of the tree.

Backlighting creates very intense relationships between the foreground and background through placement of the shadows generated from subjects within the frame. Use of a wide-angle lens has lengthened the shadows of the golfer's legs and intensified perspective, providing a good lead-in from the bottom edge of the frame by creating two arrowlike wedges of darkness for the eye to explore.

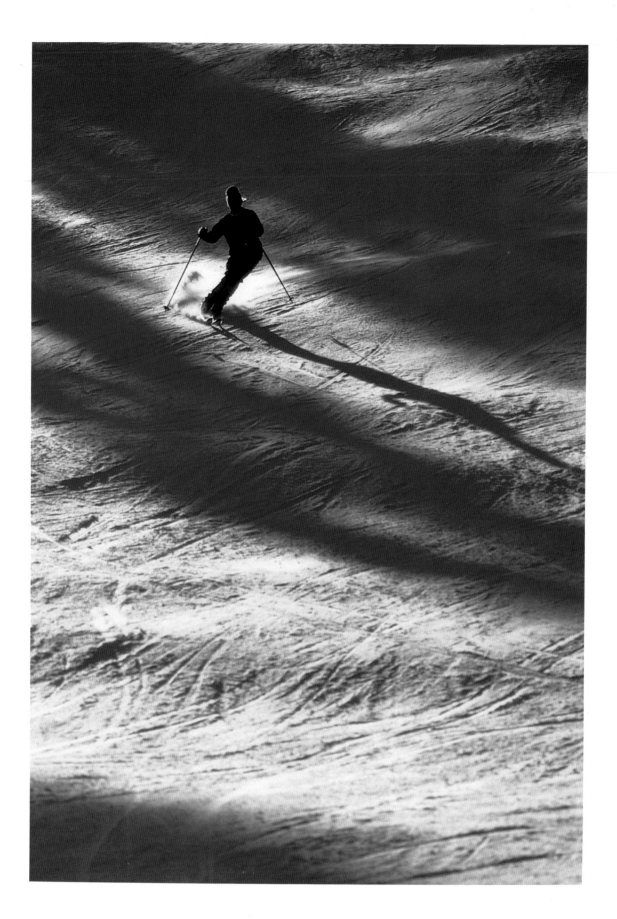

Late afternoon sunlight coming from an oblique backlighting position creates shadows that emphasize the texture of the snow and diminish the scale of the skier in this photograph. The silhouette of the skier, separated from the background shadows by the small amount of rim lighting on the left side of the figure, becomes a strong symbolic image.

interplay between the light and shadow areas can emphasize the more significant parts of the composition, and even become compositional elements in themselves. The key to effective use of sidelighting is to be quite deliberate in composing the photograph, limiting the number of elements so that the subject is properly emphasized without an overabundance of distracting lines, shapes, and tones.

Finally, backlighting is the most exciting of the light-source positions, and also the most challenging from the point of view of proper exposure for the interpretation of the subject. Backlighting creates both a strong sense of depth, through the way shadows lead toward the lens, and a very harsh delineation of forms, through the highlights along the rims of objects. The images created with backlighting can be dramatic and extremely graphic when there is a proper balance between highlights and shadow detail. In some cases it is advisable to include some fill light, either by using flash or by reflecting some of the main light back toward the front of the subject, in order to preserve some detail in the shadow. This is due to the limited ability of any film to record contrast differences beyond four or five f-stops.

The qualities of soft, indirect lighting are quite different from the qualities of direct light. The most diffuse form of soft lighting has no direction and therefore no shadow areas. There are many ways to achieve soft lighting effects. Light can become difused by passing through clouds on an overcast day, by bouncing off a large reflecting surface, or, if the source is a flash unit, by bouncing off a ceiling or wall. Soft lighting can bring out subtle tonal variations, and a more continuous range of tones can be recorded.

Soft lighting can also be directional, with the same three fundamental positions as direct light and yet with more subdued impact at each of the positions than direct lighting would produce. Directional soft lighting creates soft-edged, open shadows and more subtle highlights, and textures are de-emphasized and smoothed out. Diffused lighting is preferable for portraits of people because it has the ability to hide imperfections in the skin.

Soft lighting can establish moods of relaxation, of security and tranquillity, or of fantasy. These are personal feelings, and the color that accompanies the diffused light can evoke various degrees of each. Slight overexposure of a scene with very diffuse lighting can convey a sense of lightness and well-being, and so create a visual tapestry that transcends the subject to create a very emotional atmosphere.

Twilight, just after sunset, is one of the most powerful soft-light situations. Various sections of the entire sky are emitting light in wavelengths from blue to orange. As different sides of a subject are illuminated from the various portions of the sky, they take on extra dimensions of color that no other lighting can create. The passivity of the blues, the subtle tinges of orange and magenta, can lead to many different personal interpretations; but the overall visual effect can be stunning.

The same effect may also be experienced at dawn, but it seems that the

Strong direct backlighting has reflected from water droplets to create a tapestry-like effect around the runner, reducing his image to silhouette. The slight highlight on the right shoulder of the figure provides some separation and keeps the image from being strictly two-dimensional.

Frontlighting can serve to separate the subject from the background and reduce the shadow content of the image. It also has the effect of flattening, or reducing, textures and perspective. And it can also help to clean up an image by eliminating certain unwanted textures and lines. The frontal lighting used in this portrait is very direct and still causes some shadow areas to appear, but it helps to separate the person from the darker background.

Sidelighting is very effective in outdoor portraits of people. It can also provide separation from backgrounds by contrast in brightness, keeping the visual interest on the subject. The late afternoon sun is often the best source for sidelighting both because the color is warm and because the subject can be placed to minimize the shadow areas around the eyes. With this direction of lighting it is important to watch how surface textures are rendered, however, particularly when the subject is a face. It can be used intentionally to bring out character lines.

In this aerial photograph of crop harvesting in California, direct light from a very low angle places emphasis on the texture of the furrows, creating graphic lines that play against the solid rectangles of the vehicles. Direct light leaves harsh shadows, and, unless they are relieved by the addition of fill lights—which in some cases, as here, is impossible—the resulting shadows must play an important role in the planning of the composition.

atmosphere at dawn is always cleaner and brighter, and the light tends to be harsher just before sunup. The end of the day seems softer. Perhaps the moisture and dust particles stirred up at sunset from the daily activity of the population diffuse the light more than at dawn, when the night has settled much of this material.

The light from flash units or from continuous incandescent (tungsten) lamps can be modified in many different ways to achieve both direct and soft lighting effects. The simplest way to soften the light from a single point source is to bounce it off a large reflecting surface and onto the subject while shielding the subject from the

Often backlighting can appear simply as a reflection from an object or area and yet produce a striking image. In this photograph, the reflection of sunset light from the road surface and power lines creates a graphic interpretation of

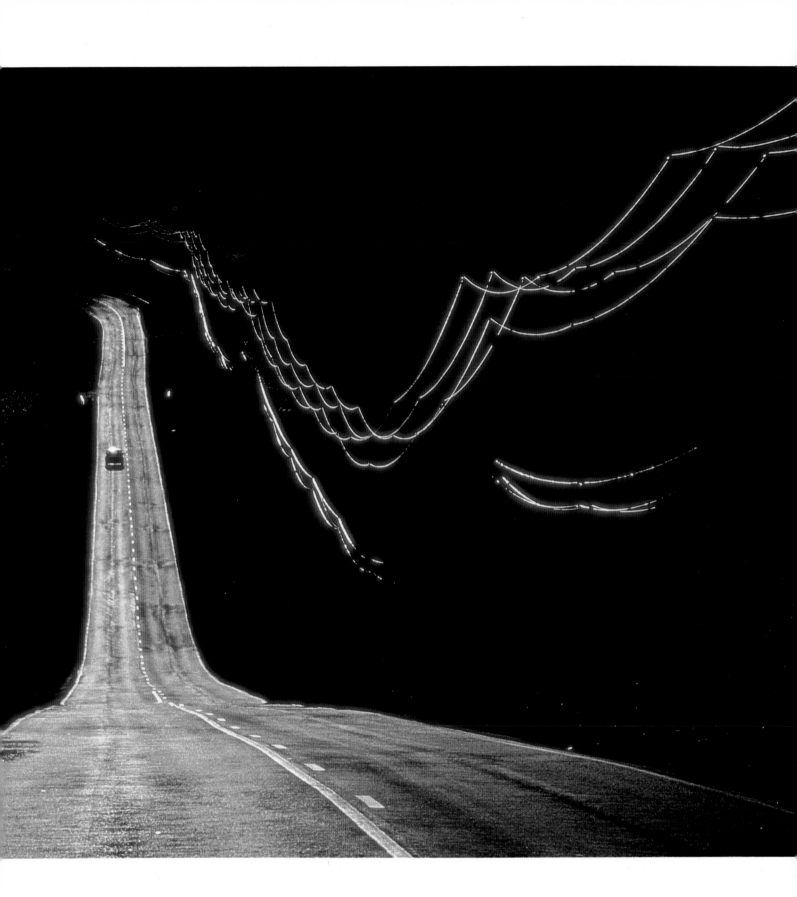

direct light. This causes a reduction in the harsh shadows and flattens the contrast within the illuminated area.

In the realm of photographic control color temperature, light intensity and direction, and light quality all contribute to the final appearance of a photograph and the message that it can convey. It is in the eye and mind of the individual photographer to choose and manipulate these controllable factors effectively to create and convey feelings or emotions about the subject matter. This is the true essence of a good photograph.

⑦ ILLUMINATION AND FLASH EQUIPMENT

The area of artificial illumination for photography has become almost exclusively the realm of the electronic flash unit. For its size, power output, and power requirements, the flash has no equal. The light quality and consistency of its output can be matched by no other light source, including the sun, which varies from day to day.

Early in the 1930s, Dr. Harold Edgerton of the Massachusetts Institute of Technology made one of the most significant developments of this century in artificial lighting. He developed the high-speed pulsed, stroboscopic light that has evolved into the photographic flash. The concept of a short-duration high-intensity light source had existed since the early days of photography but had evolved only just beyond the flash-powder bar to the flashbulb. There was no fully consistent and repeatable method of using these light sources.

The electronic flash consists of a glass tube filled with inert xenon gas, with electrodes placed at opposite ends. It uses a high-voltage pulse of electrical current to excite the xenon atoms, causing them to radiate visible energy (light) with a color balance very close to that of daylight. The extremely short duration of this light pulse has the ability to "freeze" subject motion.

The continuing development of electronic flash technology and the means to modify its intensity, quality, and appearance on film has improved its use to simulate natural sunlight for indoor photographic situations. In addition, it can be mixed very effectively with natural sunlight to reduce the intensity of shadow areas and to diminish natural contrast in outdoor photographic situations, especially portraits.

Electronic flash has come to be more accepted among photographers than tungsten lights, which require immense power and generate large amounts of heat to equal the illumination from a moderate-sized electronic flash unit. Since electronic flash can be interchangeable with daylight, there is no need to carry different films to match the color balance of daylight and of artificial light when photographing both outdoors and indoors.

There are two basic divisions of flash units: the small, on-camera types that run off small alkaline or rechargeable batteries and the larger, AC-powered studio flash systems that generate enormous lighting power.

These photographs represent two variations of basic studio lighting. In each of the portraits, a main front light has been placed either above the camera position or (in the case of the man's portrait) slightly to the right of the camera. In each, a reflector was used—under the woman's chin and to the man's left side—to reduce the intensity of the shadows away from the main light source. In the man's photograph, a second light source was placed directly behind his head to produce a rim-lighting effect and separate his dark hair from the black background. An alternative to this would be to place a spotlight above his head to give a shine to the hair, with the same result of separating him from the black background. In the portrait of the woman, very soft, even lighting was used to illuminate the white background, while a soft-focus filter on the lens added to the effect. These two portraits present almost a classic rendition of "masculine" and "feminine" portrait lighting.

PORTABLE FLASH

The on-camera flash unit provides exceptional versatility for both outdoor and indoor photographic situations. These units are generally powered by four AA batteries and can deliver substantial amounts of light, depending upon the size of the unit. Several types are available and should be chosen for compatibility with the camera system in use. The first and most prevalent type is the auto-thyristor. Incorporated into the body of the flash unit is a light sensor that will quench the flash when the proper amount of light has been reflected back from the subject after the flash is triggered. A range of three to four *f*-stops can be attained with most of these units. The camera lens must be set to the proper *f*-stop for the distance from the subject. These flashes have integrated scales that link subject distance to a particular selection of *f*-stops.

AUTOMATIC FLASH UNITS

Some advanced electronic flash units have the ability to vary and control the duration of light output. These units automatically adjust their flash duration for proper exposure. Automatic units have a sensor that measures the intensity of flash reflecting from the subject. When the light is bright enough to produce an acceptable exposure on the film for a preselected f-stop, the unit will halt its flow of light.

DEDICATED FLASH

Other automatic units—dedicated flash—work in conjunction with specific cameras to produce acceptable exposure. Although dedicated camera/flash outfits vary, a sophisticated system would work this way: When the shutter is released, the flash fires. A sensor, positioned in the camera behind the lens, determines the light necessary for correct exposure, sends the information back through the camera to the flash unit, and turns off the flash.

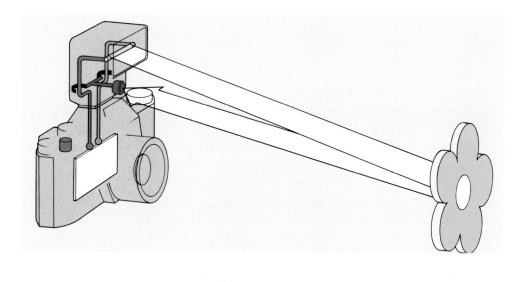

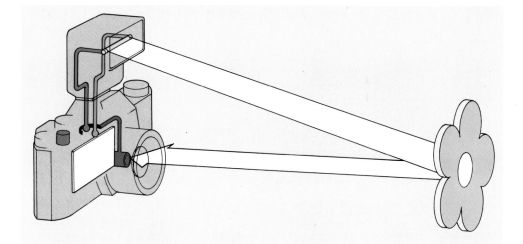

| $^1/_{1000}$ *second* | $^1/_{500}$ *second* | $^1/_{250}$ *second* | $^1/_{125}$ *second* | $^1/_{60}$ *second* |

The lens aperture that can be used with a flash unit of a specific power is related to how far the subject is from the flash unit. At a specific distance, for example, 10 feet, the flash might be capable of producing correct exposure at f/11. If the subject is moved to a point 15 feet away from the flash, the amount of light required for proper exposure will be twice the amount of the previous distance because there is now twice the area to be illuminated by the same flash output. The illumination required varies as the square of the distance from the flash, because that defines the area that must receive the illumination. So, for the same flash unit moved from 10 feet ($10^2 = 100$) to 15 feet ($15^2 = 225$), the f-stop must be changed from f/11 to f/8, for correct exposure.

To make life easier for photographers, most small flash units come equipped with a scale or dial that links the factors of film ISO speed, subject distance, and the maximum f-stop available under the given conditions. The auto-thyristor dials express these scales in a minimum/maximum distance range for each of the f-stop settings available at a specific film speed. The flash will provide a proper reflected-light exposure for subjects of average reflectance within this distance range.

The second type of automatic-exposure flash is termed "dedicated" because these units are designed to be used with specific cameras. Specialized hot-shoe contacts and circuitry control flash output internally from the camera body and also, when activated, automatically set the camera's shutter to the proper speed for flash exposure. The operation of these units differs from that of auto-thyristor units because a sensor within the camera body measures the light reflected from the surface of the film during the actual exposure. These systems are also called TTL flash, since they read the flash exposure through the actual imaging lens.

The TTL flash systems have the same restrictions on subject distance and maximum usable f-stop that other types of flash units have, but usually they permit a wider range of f-stop settings to be used at given subject distances and film speeds. They also have greater exposure accuracy because they see the exact angle of view the imaging lens sees and are therefore able to integrate exposure for the entire area covered by the lens. The sensors for auto-thyristor flash units, on the other hand, may take in an area approximately equal to that covered by a 35 mm lens only, and this can lead to inaccurate exposure with very wide or very long lenses. TTL flash units have proven to be quite accurate and useful, not only in indoor photography when used as the principal source of illumination but also outdoors, for filling in the shadow areas of a scene with a proper amount of light.

The basic problem with using on-camera flash as a primary source of illumination in a photograph is that it creates flat frontlighting, with a lack of shadows and dimension in the subject and a harsh, direct light quality. This is an unflattering

Single-lens-reflex 35 mm cameras have a recommended flash synchronization speed—usually $^1/_{60}$ or $^1/_{125}$ second. Operation at speeds faster than recommended may give partial images. The sequence above illustrates the shutter set at speeds faster than recommended. The two shutter curtains do not expose the entire film frame to the flash burst. Only at a slower speed (far right) do the curtains fully open when the flash fires, to reveal all of the frame.

illumination for many subjects, especially people. One of the most effective ways to approach this problem is to soften the direct light from the flash, usually by bouncing its main output off a ceiling or wall to broaden it and so create more subtle lighting effects. Several on-camera flash units have heads that permit the flash reflector to be moved vertically for bounce lighting or swiveled for increased versatility in such situations.

Other methods to achieve softer light from these flash units involve accessory attachments, such as supplementary reflectors or soft-boxes; the latter are large reflectors with cloth diffusion fronts. All these are quite effective in altering the light quality from hard and direct to anything from fully diffused and shadowless to soft light with a directional appearance.

There remains only one problem to solve, and that is the position of the flash in relation to the subject and to the camera. The on-camera position, even with bounce lighting for soft effects, is still a frontlighting position and not very conducive to interesting effects. There are cables that permit auto-thyristor flash units to be used up to 3 meters (about 10 feet) from the hot-shoe coupling of the camera. For dedicated TTL flash units, the manufacturer of either the camera or the flash unit offers cables that retain all operations and functions that are available when the flash is mounted on the camera. Using the flash at either side of the subject provides more definition and contrast and a greater sense of depth. This, of course, does not have a great effect when the flash is bounced off a ceiling, because this tends to spread the light evenly in many directions, flattening the contrast.

Another approach to achieving a more interesting lighting situation with portable flash is to use several units placed at key points around the subject, such as the side and top, and operate them by means of photoelectric "slave" triggers. These inexpensive slave units sense the light from the main flash on the camera and simultaneously fire the flash connected to them. Using these additional flash units for background light, hair light, and fill light can enable studio-quality portraits to be made with relatively inexpensive lighting equipment.

OFF-CAMERA FLASH

While on-camera flash is fast and convenient, considerable improvement in modeling—subject shape, texture, and general appearance created by the light—frequently occurs when you position the flash away from the camera. The goal is to have the light falling on the subject more from the side, top, or even bottom than directly from the front. Flash on-camera tends to give flat lighting with no relief for the form of the subject, (left). Placing the flash off to one side and somewhat higher than the camera gives interesting shadows that develop a three-dimensional appearance, (right).

PROCEDURE FOR ON-CAMERA AUTOMATIC ELECTRONIC FLASH UNITS

AUTO-THYRISTOR FLASH UNITS	DEDICATED NON-TTL FLASH UNITS	DEDICATED TTL FLASH UNITS
1. Set the film speed on the flash unit's exposure calculator dial or scale to the same setting as the film speed set on the camera.	1. Set the film speed on the flash unit's exposure calculator dial or scale to the same setting as the film speed set on the camera. (Some flash units of this type do not require this, as they receive film-speed information automatically from the camera body when they are turned on.)	1. Set the flash unit's exposure calculator dial to the same film speed as set on the camera
2. Set the highest shutter speed on the camera that can be used with electronic flash. This is generally 1/60 second.	2. Find the distance to the subject from the camera position. Choose an aperture setting with this distance range from the exposure calculator dial or scale.	2. Determine the subject distance and find the maximum usable aperture setting for that distance.
3. Find the distance to the subject and, using the exposure calculator on the flash unit, choose the aperture setting for the distance range that will provide the desired depth of field.	3. Set the flash unit's selector to the aperture setting determined in step 2.	3. Set the lens aperture to any value up to the maximum aperture setting, as determined in step 2.
4. Set the camera lens to the aperture setting determined in step 3.	4. Set the camera to the automatic (A) or program (P) mode.	4. Set the flash unit's selector switch to the TTL mode.
5. Set the flash unit's automatic sensor switch or dial to the same aperture setting, either by number or by coordinated color, from the calculator dial as determined in step 3.	5 Turn on the flash unit and wait for the ready light to come on. This will automatically set the camera to the correct shutter speed for use with electronic flash and the lens aperture to the proper setting.	5. Set the camera to the automatic (A) or program (P) mode.
6. Turn the flash unit on and wait for the ready light to come on.	6. Take the picture.	6. Turn on the flash and wait for the ready light to come on. This automatically sets the correct maximum shutter speed for use with electronic flash.
7. Take the picture		7. Take the picture.

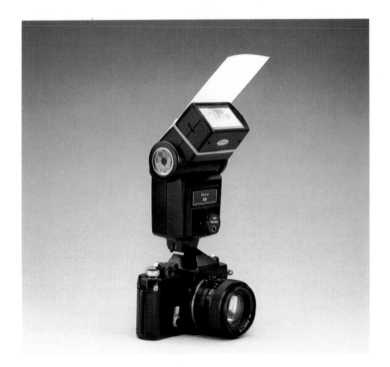

To lighten shadows under your subject's eyes, tape a piece of white cardboard (an index card) to the flash so it extends about 2 inches beyond the flash head. Some of the light from the flash will be bounced off the card directly at the subject's eyes.

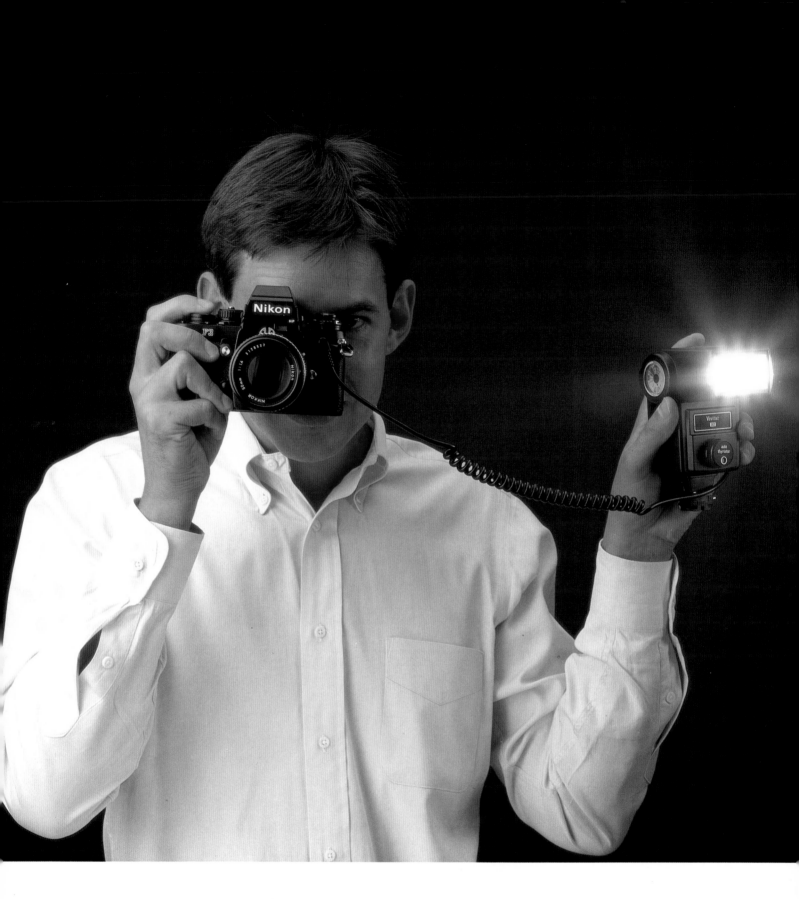

Needing a bounce angle beyond the capabilities of the flash tilt axis, you can hold the flash in one hand, the camera in the other, and connect the two with the appropriate cord for automatic or dedicated operation. The sensor must face the subject on automatic (sensor-on-flash) systems. Or set the flash to manual. The flash will freeze any camera motion, even though your one-handed camera support may feel somewhat wobbly.

Flash units come in many sizes and shapes. Generally, the bigger the flash unit, the more powerful it is.

When photographed with direct flash (above) this scene displays characteristic direct-flash problems: harsh, flat lighting and uneven exposure from foreground to background. The same scene, (right) photographed with bounce flash is far superior. Exposure is much more uniform and the quality of light is more natural and flattering.

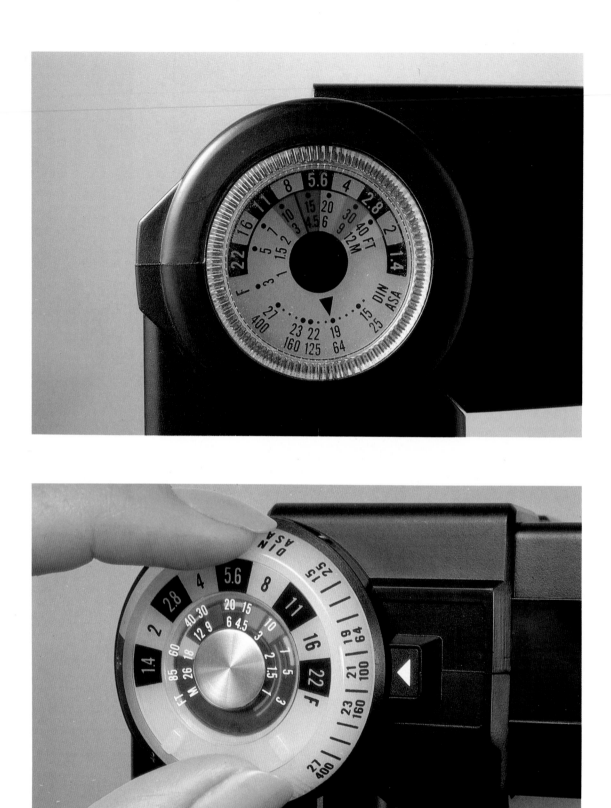

Different flash units use different methods of providing you with information.

BUILT-IN FLASH

Many of the newer SLR cameras and lens-shutter 35 mm cameras have automatic electronic flash built into their bodies. The electronic flash is powered by the internal batteries of the camera and can be used both as a solitary source of light and also as a secondary or fill-light source in many situations, especially outdoors, where it will reduce harsh shadows.

On many of these cameras, the flash is activated automatically when the camera's built-in exposure meter reads a low light level, while on others it must be manually activated. In cases where some flash fill is desirable but the camera does not activate the flash automatically because the light level is high enough without it, it is possible to fool the camera by holding a hand over the light sensor (which is either in a separate opening or in the lens) and pressing the shutter release down lightly to activate the exposure meter before taking the picture. The meter will sense the false low reading caused by the hand and activate the flash. The picture can then be taken normally, with the flash unit contributing enough light to reduce the harsh shadows.

Some models of lens-shutter cameras have flash controls that either activate the flash or provide a fill-flash mode for outdoor situations. When using these cameras, it is only necessary to activate the fill-flash mode, and then the camera's electronics will automatically establish the correct exposure for the existing light and provide a balanced amount of flash illumination to even out the shadow areas.

Electronic flash can be used to simulate natural light and can be controlled quite fully to provide a range of different lighting styles. In the uppermost photograph, very soft, nearly shadowless lighting was provided by the use of softening diffusers over the flash heads. Lighting such as this keeps contrast to a minimum and reduces shadow areas, creating a flattening effect. In the portrait directly above, very direct light from a flash head was used without any softening attachments. The location of the light, slightly lower than the subject and off to the left of camera, has created very deep shadows and sparkling catchlights in the eyes.

STUDIO FLASH

Large, powerful studio flash systems are highly versatile but require AC power for their operation. One or two of the major manufacturers of these systems make battery-powered versions with medium-low output levels, but the majority require high-amperage lines. These flashes consist of two parts: a power supply, or generator box, which contains the capacitors and controls for the light, and one or more fan-cooled flash heads, which hold the actual flashtube and also continuous-light sources called modeling lights.

The modeling light is usually a tungsten bulb placed near the flashtube to provide an idea of how light from the flash, when it is fired, will strike the subject. These bulbs are of limited intensity, around 250 watts to 750 watts, and can provide a limited view of how the lighting will appear on the film. Many professionals still rely upon making a preliminary exposure with instant-processing film to judge the exact contrast relationship between a number of light sources. Each flash generator can be fitted with up to six flash heads for exact placement and control of the light.

The flash heads themselves can be equipped with a multitude of light-modifying accessories, such as pan reflectors of various angles of coverage, soft-light reflectors, and soft-boxes, all of which have different effects on the way the subject will appear on film. The classic umbrella reflector now comes in a wide variety of types, some with white or silver interiors that can produce, respectively, very soft, diffuse light or a more specular but still soft lighting effect.

The studio flash can be connected to the camera either by a hard-wired cable running from the camera or by remote triggering devices that use either radio or infrared light pulses to trigger the flash. These devices have become almost indispensable because synchronization cables tend to wear rapidly, whereas the remote controls are reliable. The radio types are used more in nonstudio situations, as they have a range up to 1,000 yards. The infrared triggers are designed more for interior use and sometimes rely on bouncing of the light-pulse signal from walls or ceiling.

The most basic studio lighting is that used for portraits; it requires three light sources.

First, the main light is most often a soft-box about three feet square, or a large silver or white umbrella. This is placed in front of the subject, either elevated directly over the camera position or level with the camera at one side of the subject.

Next, a fill light (or reflector) is positioned to direct a lesser amount of light into the shadow areas that are created by the main light; it is set to provide light that is about one or two *f*-stops less than that from the main source. The fill-light source is also often a large soft-box, or white umbrella, or a flat reflector with a silver or white surface.

Soft lighting effects can be obtained simply by bouncing the flash into the white walls or ceiling of a room. This provides completely even, shadowless lighting. Adding a soft-focus filter over the camera lens further reduces color saturation and gives a romantic impression to the dancer's image.

The final light source can either be directed at the background, to separate it from the subject, or be a hair light—a direct spotlight pointed down from above the subject. The hair light provides highlights on the hair, creating a halo of light that keeps the subject's head from merging with the background. In some cases, both background and hair lights are used together to provide a dramatic separation between subject and background.

Most portrait lighting uses only variations of this basic setup. The exact placement of the lights within each of their areas, and the ratio of intensity between the light sources, determine the final appearance of the photograph. There are many permutations of the basic formula.

Sidelighting can be most dramatic with electronic flash, where its character can be controlled more readily than when it occurs in nature. In each of these photographs sidelighting was used to illuminate the subject; but the character of the light is different for each, and so each subject is rendered with different shadow characteristics. In the photograph of the formal couple, a soft-box diffuser over the flash head created sidelighting with soft-edged shadows. Although skin textures are readily visible, they are soft and do not show any specular highlights. In the portrait of the young woman in Hawaii, very direct sidelighting created sharp, deep shadows, along with very distinct skin textures and some specular highlights. Many accessories are available to control electronic studio and portable flash and provide the photographer with maximum control over the final appearance of the photograph, offering numerous choices of how the subject is to appear.

113

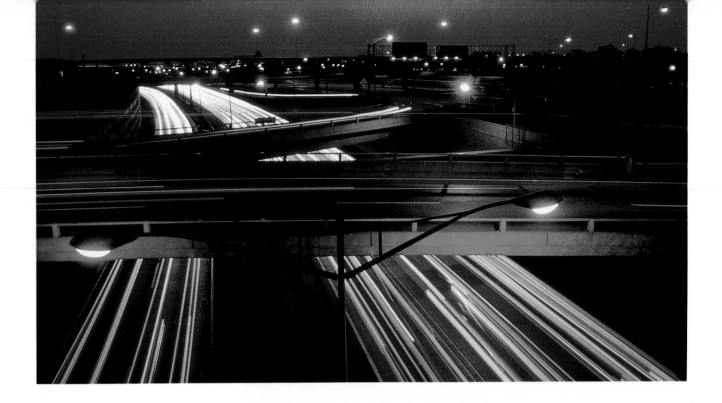

TRIPODS AND SUPPORT SYSTEMS

The purpose of a tripod is twofold. It supports the camera for steadiness, and it allows the photographer to monitor composition constantly without the variations encountered in hand-held work. There are many situations where the use of a tripod is not practical and others where it is an absolute necessity, such as long time exposures. Many photographers neglect tripods for average middle-of-the-day scenes; yet the extra support gained could free them to concentrate more on the composition of the photograph.

Most tripod manufacturers rate their tripods according to the amount of weight each will hold. The better models will not only carry the weight of camera and lens but also keep vibration to a minimum while the exposure is made. There are many expensive tripods on the market that, although they look sturdy, can shake substantially—for example, in a strong breeze.

The small, light cameras that became popular several years ago brought to light other problems not encountered with heavier cameras. The light-weight cameras have a higher level of vibration, caused by the shock of the SLR mirror as it rises during exposure. Because there is less mass in the camera body, there is less absorption of this mirror energy, and consequently photographs made with longer lenses show more evidence of camera shake. Many of the newer high-tech SLRs have no way to lock up the mirror prior to shutter release, and this gives even more reason to use a vibration-free, or vibration-absorbing, tripod.

There is a general rule that when a camera is used in the hand, the shutter speed should be equal to or higher than the reciprocal of the focal length of the lens being used. In other words, when a 135 mm telephoto lens is being hand-held, the shutter speed should be no less than $1/125$ second, (rounding out to the nearest standard setting) to ensure sharp photographs.

A proper tripod should be able to hold the camera at the eye level of the photographer without having to extend its legs fully or to use any center-column extension. The legs on most tripods grow thinner with each lower section, and so the number of leg sections should ideally be limited to four. Even the largest upper legs get quite small by this point. If they are round, these legs should start out at a diameter of 1 inch or greater. If a good tripod is still found to have some vibration problems, a supplementary weight hung from the center column can help dampen vibrations. This could be a jug of water or a bag of rocks that can be dumped out after completion of the photography.

Most tripods can be equipped with either a three-way pan head or a universal ball head that requires only one control to manipulate. While both are acceptable, and this is a personal choice, the head should have good support stability and be able to handle the weight of the largest camera and lens that is to be used, without drift or sag.

A quick-release system can help get the camera on and off the tripod rapidly. These devices can generally be trusted to hold the camera tighter than is possible with the constant tightening and loosening cycle of standard mounting screws. Quick releases consist of a plate that is semipermanently attached to the bottom of the camera and a matching plate-locking base attached to the head of the tripod. Either a spring-loaded mechanism or an auxiliary screw clamp secures the plate and the camera to the base. In general, the better models of quick releases are very sturdy and do not contribute to vibration problems. One point to remember is that, to be convenient, the plate should be left on the camera all the time; otherwise, its entire purpose becomes meaningless.

A tripod can be used in most photographic situations, from portraiture to close-ups or macrophotography. Since it does support the camera steadily, it permits very long exposure times; so it expands the capabilities of the photographer, even sometimes allowing invisible phenomena to be recorded. To accomplish these long exposures, a cable release, either the classic mechanical one or an electronic type, is needed to hold the shutter open at the "B" (for bulb) setting on the shutter-speed dial. (The type of cable release depends upon the electronics and/or motor-drive system of each particular camera. Many of the electronic models allow use of a mechanical type, which is less expensive.)

Another way of supporting a camera and still retaining some degree of mobility is to use a monopod, a single leg in place of the tripod's three. These are used by many sports photographers who employ large, high-speed telephoto lenses that can weigh as much as twenty pounds. The monopod can be attached to either the camera body or a tripod-mounting collar, if the lens has one. The monopod has the same adjustable height as tripod legs. It can have either a simple camera-mounting screw at the top or a full tripod head for added versatility. In fact, a tripod head is a must if the camera needs to be held in a vertical position.

A monopod will not be steady enough to hold a camera for exposures below 1/4 second with any lens, but it can extend the useful range of shutter speeds down about two steps from the recommended minimum for a particular focal length. It also provides more stability, and so can improve focusing and composition when longer lenses are used and the weight of the camera and lens could otherwise cause inherent shake.

CAMERA BAGS

Camera bags have changed radically in the last decade. What used to resemble a leather briefcase has assumed variations on a soft knapsack theme, and very elaborate "system" bags have changeable interiors and exceptional padding and protection for the camera equipment. The key to choosing a proper bag is to make sure it holds enough equipment to satisfy the shooting needs of a full day and yet not be so heavy that it cannot be carried for long periods of time.

Protection against random external bumps and interior contact between the individual pieces of equipment is also important. Most professionals have settled on a system of bags either of canvas or of more durable, and unfortunately, more conspicuous, special nylon weave. The nylon bags are more heavily padded and generally waterproof, but some photographers think their design limits access to the stored equipment, whereas the design of the canvas types does not. This is a personal choice and depends upon the amount of and type of use the bag will get and the amount of equipment it will have to carry at any one time.

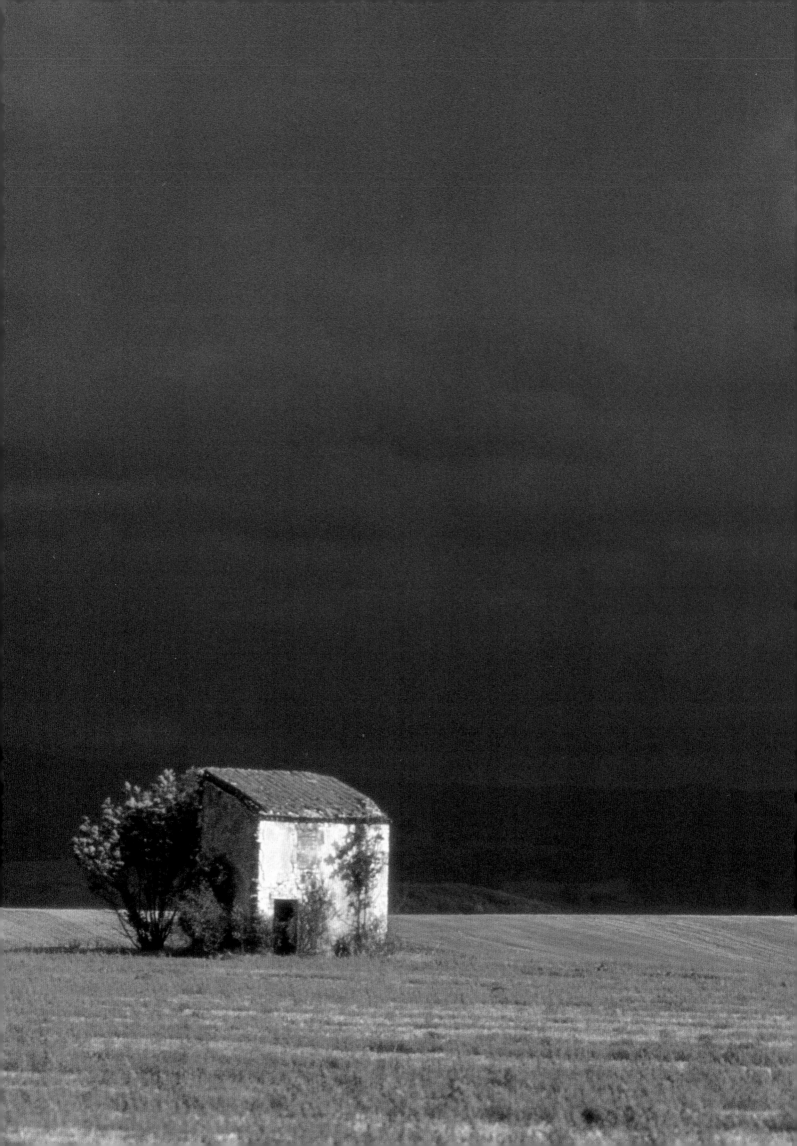

❽ PHOTOGRAPHIC COMPOSITION

Any discussion of photographic composition can be very esoteric at best because of the almost infinite variety of subject matter and specific interpretation that can become the content of a photograph. Photography has been called the universal language, and it is a powerful medium for evoking emotion and memory within the human mind. Each individual responds differently to a given set of colors and shapes within an image, and this response is based partly upon the experience of the individual and partly upon the fundamental meaning those colors and shapes may have within the particular society.

The composition of a photograph consists of the construction and organization of the elements of the subject and their interaction with the light (the content), along with the particular treatment and technique by which the individual photographer chooses to present this subject (the style).

Composition is a truly individual preference and, although there are many books and articles that present certain rules of composition, it is often the photographer's reaction to the subject that makes the final determination of the content of the subject and placement within the photographic frame. The photographer should ask the question, "How does this subject make me feel?" Of prime importance is the essence of balance within the picture content, the harmonious blending of the subject matter with interpretation in order to make a visual statement.

The reaction of the viewer should also be considered when making these choices. Because many people do not share the same level of experience, their perception of what is presented does not always match that of the creator. The brain also lends an interpretation to the visual input from the eyes and seeks to achieve a more natural order from the visual stimulus. This is why many people have difficulty in perceiving so-called optical illusions: Their brain refuses to accept the reality of facts that are presented visually. It is therefore extremely important to introduce some sort of structure in a photograph, to present the subject within the frame with clarity and a dynamic flow that allows the eye to move naturally within the framework of the composition. Yet often a photograph that is most memorable will make a strong initial impression but then leave some small part for the imagination of the viewer to fill in or to extrapolate.

Whereas painters and illustrators have the option of creating on a blank surface, photography is limited to what exists or to what can be defined by or created with light. It is a medium that can be manipulated, but it relies upon a reactive energy to define reality. The first choice must be whether to create a straight documentary record of the subject or to make a more personal interpretation. This choice, and the further choices of lighting, perspective, film response, and exposure, all

Contrast between dark clouds and sunlit ground creates a striking separation between the land and sky in this photograph. The weight of the bright ground is balanced by the larger area given to the dark sky. Placement of the small building at the one-third point within the frame provides visual interest and balances with the slightly lighter gray clouds present diagonally opposite in the upper sky.

determine the final outcome of an image and ultimately its success or failure. The photographer who chooses to make a universal statement by the symbolism of photography can often make a more lasting impression on the minds of the viewers by exposing them to a more personalized look at the world.

There are two approaches one can make toward design and composition within the photograph. The first is to follow generally accepted rules of graphic design that lend themselves to organization within the frame. The second is to let the subject and the photographer's emotions toward it dictate the placement of the elements. The choice between these approaches always rests solely with the photographer, and it is the photographer's discretion and experience that dictates the final appearance of a particular image.

These three photographs, although entirely different in subject matter, have very similar compositions. In each of them the subject is environment and light, but no specific point of reference is provided other than the small human element included by the photographer. In each of these photographs, try covering the human figure or the vehicle with a finger, and you will find that the pictures lose an important element that provides scale and counterpoint to the vastness of the landscape.

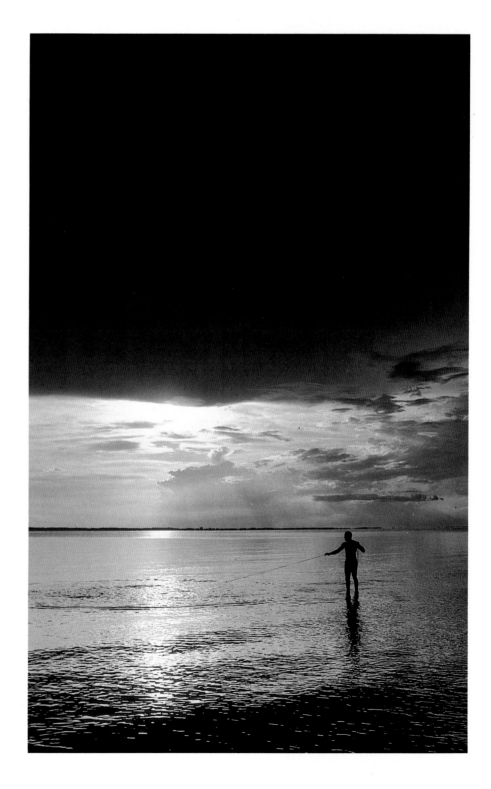

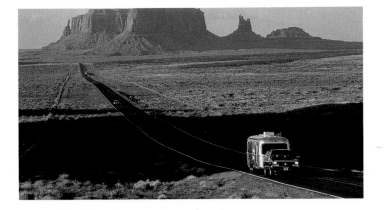

Color is an important aspect of composition. The use of bright colors played off against darker backgrounds can heighten interest in the main subject and draw more attention to the center of interest. The young boy sitting on the steps would have enough strength to exist alone in this image; but introduction of the rain-story elements, with their bright yellows and blues, creates a small environment around the child's face. This use of color immediately draws attention to the child and also separates him from the horizontal lines of the steps.

121

DIVIDING THE FRAME

One of the common tenets for composition is that subjects with the highest significance should be placed according to the rule of thirds. That is, the area of a photograph should be broken into three segments vertically and three segments horizontally. The four points where the lines between these sections intersect command the highest attention, and the viewer's eye is drawn strongly toward these points. Each of them is about a third of the way in from the nearest edge of the frame, and the one-third rule approximates the ancient artistic principle of the Golden Section, dividing each frame into proportions of 5:8.

Rules such as this can lead to repetitive compositions that, if viewed together, can tend to tire the eyes of the viewer. It is best to think of such rules as guidelines rather than laws. Nevertheless, there can be no denial that the most attention is gained by placing the significant portions of the subject at one of these intersections. In portraits, for example, very strong images are often found to have the eyes placed at one of these key points within the frame.

The angle of view of the lens used has a paramount effect upon composition. A wide-angle lens will alter perspective by emphasizing the foreground and reducing the relative size of the background; it thereby increases the apparent depth of the scene. A telephoto lens will decrease the perception of depth by compressing the distance between the subject and its background. On the other hand, exaggerated separation from the background can be achieved by using telephoto lenses wide open to reduce the background to an out-of-focus blur.

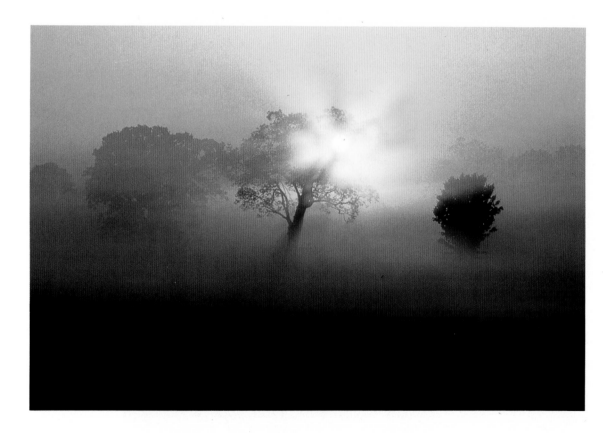

Often the compositional elements within a photograph can be separated by tones rather than by sharp lines of contrast or even color changes. The misty sunset shown here is just one instance where the lighter tones of the mist establish a false horizon line and provide a graded separation between the dark ground and the sky area. If the photographer had chosen a lower point of view, the mist would have blended into the sky more and the gradual tonal change would have been lost.

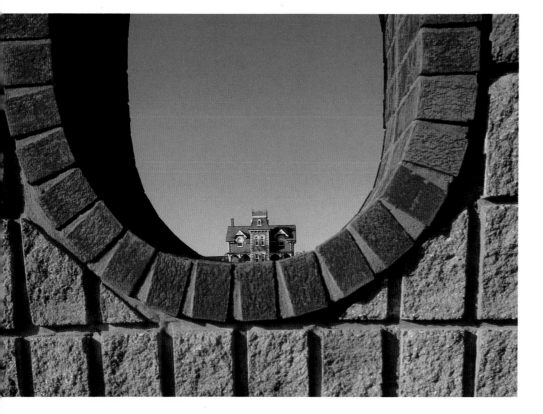

Composition does not really thrive on any hard-and-fast rules. It is often the imagination and creative thought of the individual photographer that determine the construction, however unconventional, of an image. Such is the case with this photograph of exterior architecture. In order to create an impression of this particular house, the photographer used an opening in a nearby brick wall as an unusual frame for it. Although the house itself occupies only a small portion of the frame, the attention is directed to it by the compositional element of the bricks. The unique shape in the opening creates an almost vessel-like quality, containing the image of the house and serving to keep the eye moving about the picture area even though the main subject is placed squarely in the center.

CENTERED SUBJECTS

Subjects that are centered can often be made to convey solidity and importance through the visual weight they carry by reason of their placement. Each photograph contains elements that are both static and dynamic, creating tension and also allowing a resting point for the eye.

Scientific studies have shown that the eye scans an image, searching for details and a resting point that provides a visual base. The dynamic elements of a photograph, whether they are lines, shadows, perspective, or asymmetry, move the eye through the frame. The more static elements provide a resting point. Often that point, by itself, can establish the subject.

Everything included within the frame should support the main subject, either by integrating the background environment into the view or by isolating the subject through limited depth of field.

Leading lines and perspective can be very strong compositional elements. The railings of the bridge at each side of the frame create a visual arrow that leads to the couple placed dead center within the frame. Also contributing to the dynamics of the image are the couple's reflection in the wet wood, which draw the viewer's eye up from the bottom of the frame. The use of sidelighting also helps to keep the photograph from being completely symmetrical, as the brighter railings on the left side balance the brighter illumination on the right side of the couple.

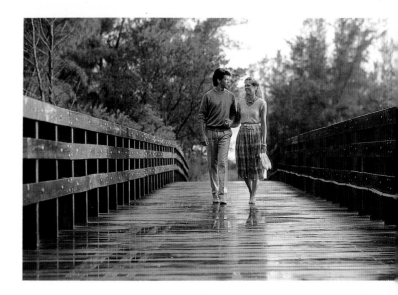

Subjects at the center of the frame are not necessarily boring when extra effort is given to the overall composition of an image. In this photograph of a woman going snorkeling, a full-frame fisheye lens was used to cause curvature of the horizon line and a reduction in the relative size of the background to give more prominence to the woman. The boats in the background are reduced in size, so that they provide some supporting information but do not detract from the presence of the solitary figure in the center of the frame.

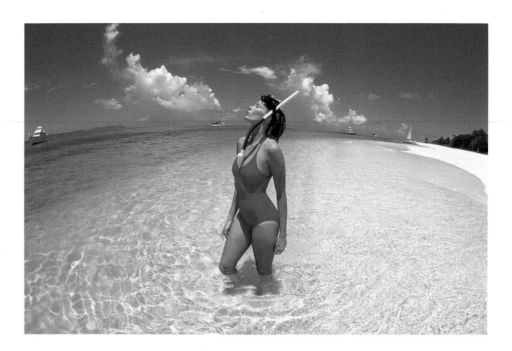

A most unusual composition for a landscape is to place the horizon line at the center of the frame. But is it really centered? In this photograph, the bright yellow stripe of flowers in the center actually divides the frame into very definite sections, with the sky occupying half the frame and the green vegetation occupying a little more than a third. Through the use of a very graphic approach to the scene, even without having a strictly defined subject the photographer has made a composition that transcends the literal interpretation of the landscape, presenting it as a balanced combination of color bands.

Even the simplest subjects take on a new dimension with the addition of color. The centering of the sign in this photograph has implied dynamics derived both from the colors and from the symbolism of the bi-directional sign. The intensity of the yellow, with its direct complementary color, blue, forces the eye to the sign. The lighter post supporting the sign both leads to the sign from the lower portion of the frame and provides a visual support for it. The arrow then provides the eye with two opposing directions to travel away from the center. With almost exact placement of the horizon line on the vertical center line of the frame and the sign on the lateral center line, the frame is divided into four sections of equal weight and balance.

OFF-CENTER SUBJECTS

Many photographs can be made far stronger by moving the main subject off center, generally to one of the rule-of-thirds positions, to create a visual tension within the frame. In landscapes, the inclusion of a tree or other object at one of these strong positions creates a point of interest and can provide the visual resting place in the scene while introducing a sense of scale or depth.

When people are the principal subjects, positioning them off to one side of the frame can help to set up a foreground-background relationship. Using a lens of shorter focal length then permits inclusion of the environment, supporting the impression or story surrounding the person.

A key to working with off-center subject placement is to determine the relative importance of the remainder of the frame away from the subject. If the nonsubject area can be cropped out without affecting the overall impact of the image, it probably is not required for the composition.

To test the success of having a subject off center, look at the flow and direction of

Color can help break up the monochromatic effect of certain subjects,

such as this mountain climber. The red of the climber's uniform

serves as a center of interest and a resting place for the viewer's eye.

The dark cracks in the snow divide the frame into thirds

vertically and support the subject's placement at the lower right location,

again one-third of the frame away from the right border.

lines. There should be a natural flow of the eye from one edge of the frame to the main subject and then to the remaining areas to gain more detail.

When looking through the viewfinder of a camera, it is important to see in a detached way, as if the image were being projected, and make a mental print of the photograph. In this way, the thought process for better composition can begin to develop a disciplined method. One thing many photographers fail to analyze prior to exposing their film is their distance from the subject, and they are often disappointed with the resulting image. One suggestion is that a photographer who feels close enough to his or her subject should move one step closer to tighten up the composition. Of course, if a sense of space is the intention of the photograph, this does not apply.

A good photograph is a bit like a well-planned meal: It should provide enough information to satisfy the eye initially, but also keep the eye wanting just a little more. A lack of complete information can retain the viewer's interest. Staring at a photograph and then closing the eyes and trying to remember the actual image, or portions of the image that carry the most impact, is an excellent way to judge the final impact an image may have.

Perspective can be presented in many ways, but converging lines evoke a sense of depth and distance very strongly. In this photograph of a road in Russia, the convergence of not only the road but also the trees on each side of the road lends a feeling of great distance to the image. The placement of the convergence point slightly to the right of center creates an asymmetry that keeps the composition from being static. The color contrast that is present creates a graphic image built of triangles. The snow-covered ground, the road, and the sky are all triangular and their apexes meet at a specific point that divides the frame into thirds.

*Three different treatments of the
same basic theme of couples are
presented in these photographs.
The couple on the balcony is not
only strategically placed within the
frame (at the one-third point) but
also highlighted by using a
telephoto lens at a wide aperture
and shooting through a group of
red flowers and foliage. The out-of-
focus color patches created by the
foliage create a vignette within the
composition, leading the eye to the
center of interest on the couple. On
the opposite page, a different
approach has a couple standing in
the same portion of the frame, but
a soft twilight afterglow creates a
sense of intimacy. Just enough
light falls on the front of the people
to keep them from becoming a
pure silhouette. If that were to
happen, their close placement
would instead be seen as an
indistinguishable mass. The third,
and most unusual, view of a couple
was taken from overhead. Again
the couple is in the righthand third
of the frame; but here the people
are treated almost symbolically,
given definition by the hats and the
hands. In these three pictures, the
same subject is placed in nearly
the same position within each
frame, but the subject matter is
presented in three totally different
manners. The first picture is a
quite literal view on the balcony,
the second is less literal and more
interpretive of the couple's
emotions, and the third employs*

UNUSUAL ANGLES

Too many photographs are taken with the camera held at the eye level of a photographer who is standing upright looking at the scene. Even though perspective and depth can be controlled by the various focal lengths available, the world as seen from the same height can be commonplace. Many professional photographers can be observed standing on small step ladders or crouching low to the ground while making an image. This additional effort can present entirely new points of view and interpretations of the same scene.

For example, that classic road scene, showing distant mountains and a road with converging lines, gives a sense of great depth and distance when photographed from a standing height. That same scene taken from a camera positioned within a few inches of the road surface places more importance on the road and its convergence from foreground to background.

Another cliché is the person standing either alone or in front of a background. Generally this is taken at eye level and, unless the photographer is exceptionally taller or shorter than the subject, the picture lacks dynamism because the eye-level view of a person is what the watcher experiences normally. The height of the subject can be manipulated by changing the camera position. A relatively natural view comes from lowering the camera until it is roughly at the height of the subject's waistline. The person can be given added height, to the point of distortion, by further lowering of the relative camera position. Conversely, a person can be made to appear shorter by raising the camera's relative position. The effect will be almost natural up to the eye level of the subject. Above this point, and depending upon the lens in use, a shortening effect begins to occur, and more emphasis is placed upon the face of the subject while the body is diminished.

The camera angle can also affect many other types of subjects. A normal building can be distorted into a threatening mass by being shot from a very low angle, from which point the convergence of its lines creates enormous distance and depth. The same building viewed from the roof of another building of equal or greater height will seem diminished.

The need to document or interpret a subject leads to an effectively communicating photograph. It is solely up to the photographer's discretion and ability to establish the impact and message the final image is to have. To illustrate awesome achievement or power, lower camera angles provide the strongest rendition and perspective. To diminish height and reduce proportions, a camera angle relatively higher than eye level is required. Both can provide dramatically different interpretations of the same subject.

mostly symbols to illustrate the theme. Composition, then, is more than the simple matter of subject placement within the frame. It is a combination of this with interpretation and approach and the way an individual photographer chooses to present the message in a photograph.

129

DEPTH OF FIELD AND PERSPECTIVE

No other factors are so critical to good composition as depth of field and perspective. Although these two are somewhat independent of each other, both are related to the lens' focal length.

Depth of field is primarily a function of the aperture setting used during exposure of the film and is related to the focal length of the lens in use. Wide-angle lenses tend to have greater apparent depth of field than do telephoto lenses at the same aperture and shooting distance.

With the wide-angle lens, the foreground-background relationship is altered and most of the scene is sharply rendered. The subject is set within the environment of the scene and the foreground is prominent. Combine this effect with the exceptional depth of field that can be obtained at smaller apertures, and the subject and its background environment can be rendered sharply. In addition, the inclusion of converging lines can create a powerful impression of distance and depth within the two-dimensional photograph.

A telephoto lens tends to increase the size of the background objects in relation to the main subject and render them out of focus. This reduces their apparent distance relationship and leaves the subject standing out quite sharply in relation to them. This selective focus can be powerful when the primary emphasis is upon the main subject in relation to its surroundings.

*A **wide-angle lens** has the power to change distance relationships and alter composition radically from what the eye may perceive from a fixed viewpoint, creating strong leading lines and rapidly diminishing the size of objects in the background. Here a wide-angle lens is used to accomplish just that, and the near-monochrome color content of the image is given dynamic motion by the strong perspective.*

Composition can employ very simple elements or, as in this case, combine many technical factors to create visual dynamism. The photographer combined a low viewpoint with a wide-angle lens and direct backlighting to create depth and symbolize the classic West Coast golf enthusiast. Long shadows created by backlighting through the palm trees are emphasized by the wide-angle lens, and the choice of a low angle of view introduces the additional element of texture from the grass, adding interest to the foreground.

WATCH THE BACKGROUND!

One of the most common errors in poorly composed photographs is the lack of attention paid to the background. Many times a photograph is ruined by having tree branches growing out of a person's body or head, stares coming from slightly-out-of-focus faces, or bright distractions in the background. This does not come from a simple lack of attention, even when using an SLR camera: In fact, the image that is presented on the focusing screen is not necessarily the one that will be obtained in the exposure. This is because all modern SLRs have automatic lenses that remain wide open for viewing and focusing and only close down to the taking aperture at the moment of exposure. The image that is seen while focusing therefore exhibits very shallow depth of field, unless a lens of very short focal length is in use. A background that appears to be out of focus and not discernible at focusing apertures will have a very different appearance in the final photograph if the lens is set to a smaller opening.

To overcome this, camera manufacturers include a control called a stop-down lever (or button) or depth-of-field-preview control. It permits the scene to be viewed at the aperture that will be used for making the exposure. When activated, this control closes the aperture blades down to the particular setting at which the film is to be exposed. Although the SLR viewfinder will darken proportionally with higher *f*-stop numbers, it is still possible to see just how much of the scene will be rendered in sharp focus in the final image. This control is therefore one of the most valuable tools on any camera, as it prevents major surprises when the final images are processed.

While composing photographs, even when hand-holding the camera, use the depth-of-field preview frequently to check for stray items in the background. This is critical with telephoto lenses, which have very limited depth of field when wide open. By making a habit of checking the background for focus, and for damaging elements, the eye will develop a more disciplined approach to composing photographs with an SLR.

Rangefinder cameras have a much different viewing system and cannot accurately show the depth of field attained at various *f*-stops. Since viewing is accomplished through a separate optical system, almost everything is presented as being in focus; so it becomes a matter of visual discipline to check all parts of the viewfinder and judge what effect the various background elements will have upon the final composition.

Two photographs using a similar compositional approach can result in very different implications about similar subjects. Although both these images take a wide-angle view from a low position, the depth of field of each image is different, and this makes the subjects look different. In the view of a field of flowers and a farmhouse, the building is rendered out of focus and the existence of the structure is only implied. The primary subject here is the daisies, with their foreground prominence. In the other picture, the photographer chose to create a strong line of entrance from the edge of the frame with the stairway up to the house. This, combined with an extensive depth of field, puts the house as the final goal of the dynamics of the image. Although viewpoint and lens selection are nearly identical in these two scenes, and the composition is similar, the simple variation in depth of field has created two images with entirely different centers of interest.

Often the subject of a color photograph is purely color itself, as in this example. There is really no formal structure to the photograph, and the eye is permitted to wander freely around the frame, taking in the vibrant colors presented in a lively confusion. The actual objects, parasols in Chile, are of secondary importance to their color.

❾ APPLYING PHOTOGRAPHY

PERSONAL PICTURES

Many photographers prefer to work early in the morning or late in the day to catch the often dramatic light and color that is present during those times. Bad weather also can make for interesting lighting conditions, however. These two photographs illustrate the difference in mood and appearance weather can create for similar subject matter. The impression of the lone windsurfer in the warm sunset light is of calm, peaceful enjoyment. The sailboat on the mauve-colored sea, the heavy clouds and only breakthrough, streaming sunlight, create a more ominous look, as if a storm impends, and there is a sense of urgency to find a safe harbor. The color and the conditions under which a photograph is made can greatly affect the final impression given by the particular image. ❻ ❽

KEY TO REFERENCE SYMBOLS:

❸ Chapter Three, Basic Photography

❹ Chapter Four, Lenses

❺ Chapter Five, Photographic Filters

❻ Chapter Six, Working with Light, Color, and Film

❼ Chapter Seven, Flash Equipment

❽ Chapter Eight, Photographic Composition

SPORTS PHOTOGRAPHY

For every situation, interpretive variations are limitless. In these two photographs of fishing, two completely different themes are presented: one literal and active, the other more symbolic and passive. The frontally lighted shot of a trout fisherman wading in a stream has a sense of dynamic action created by the saturated colors and the vibrant lighting contrast between the subject and the background. The other image shows a more symbolic side of fishing by using backlighting to silhouette an elderly gentleman, identified by his pipe and eyeglasses, sitting at the end of a dock. Both photographs say "fishing," but one exhibits a more active side while the other makes a generalized statement about the relaxing properties of the sport. ❸ ⑥

VACATION PHOTOGRAPHY

One subject can have many visual appearances, depending upon the factors under which it is photographed. A high vantage point shows the lights and traffic that surround the Eiffel Tower during the evening hours. A very different view of Paris is given from ground level in the midday view of the same landmark. Both approaches are valid. It is up to the photographer to choose one that best expresses an individual impression of the subject. ❸ ⓺ ❽

VACATION PHOTOGRAPHY

Sometimes the best impressions of traveling to a different place or city are obtained from the smaller details encountered, rather than wide-angle views of the streets or even cityscape overviews. New Orleans is often thought of in terms of the old French Quarter and the famous Bourbon Street, here symbolized by the street sign and lamp that together say "New Orleans." In a similar manner, London, or more specifically, the Tower of London, is denoted memorably by the portrait of one of the tower guards known as Beefeaters. Such specific symbols may characterize a place more thoroughly than wide-expanse views. ❹ ❽

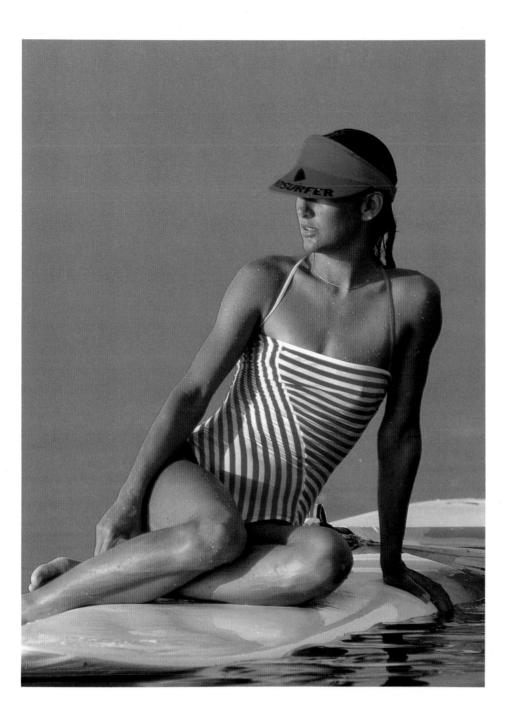

PHOTOGRAPHING WOMEN

Classic beach/bathing suit photographs of women are always more popular, but a more balanced image is presented in photographs of their activities within the business community and at home. There is a strength and vitality to the modern woman, and any image of her should reflect that fact. These five photographs present different aspects of the contemporary woman, from the soft-focus view of the mother to the corporate executive, from the sophisticated elegance and graphics of a red-striped swimsuit to a simple, straightforward portrait. Throughout the history of art, women have been the subject of the artist's vision, whether as the classic nude form or as the historical heroine or to symbolize abstract values. ❹ ❺ ❼ ❽

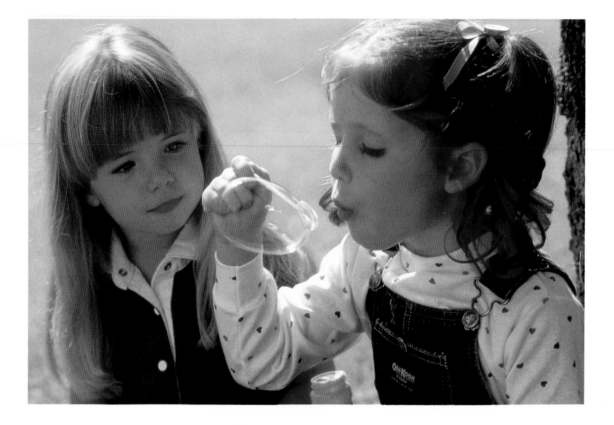

PHOTOGRAPHING CHILDREN

Children are the most often photographed subject for the amateur photographer with a family. Photographs provide a record of their growth and development, as well as of the special times in their lives. Making good pictures of children can also be one of the most frustrating experiences the photographer can face because of the subject's inattention and constant activity—usually away from the camera. The photographer who sets out to make good pictures of children must have inexhaustible patience and a fundamental understanding of children. A good supply of toys to capture and hold interest also helps. The photographic approach to children must be consistent with their lives. In each of these three photographs, the children have been shown as they truly are, without benefit of sophisticated lighting or elaborate technique. Occasionally, the addition of a soft-focus filter can help to extend the mood, but the approach should still be kept simple. ❹ ❻ ❽

PERSONAL PICTURES

Photographs are a great way to preserve events, and for personal memories they beat videotapes since they can be carried around and viewed with much greater ease. Something as simple as a birthday party presents a great opportunity, whether to make pictures for personal use or for photographic practice. In any case, the results will be looked at for years to come and always be accompanied by memories of the day. As with photographing children, the technique should be simple and straightforward, presenting the subject as naturally as possible. If electronic flash is required, as it is in most such situations indoors, the effect can be made more natural by bouncing the light off a white ceiling or wall to soften it. ❸ ❹ ❼

PHOTOGRAPHING EVENTS

Holidays and special events give you wonderful excuses to make photographs. Some are yearly celebrations; others occur only once in a lifetime. For those yearly events, why not try to make images that are a departure from the usual routines? Here the haunting vision of a scarecrow and jack-o'-lanterns at twilight beautifully combines all the elements of a classic view of Halloween. Next, a time exposure, with the camera on a tripod, shows the fireworks and evening lights of buildings in Washington, D.C. The same technique was used by another photographer to capture the street scene and fireworks of the World Cup celebration at Aspen, Colorado.

Fireworks are a very popular subject, but difficult to photograph well. They call for a good tripod and a cable release to permit long time exposures: It takes several seconds and more than one burst for a truly effective rendition. Parades are also a favorite subject. Here, sometimes the essence of the event can be captured in just a small portion of the total activity. For instance, just a cowboy hat and an American flag illustrate the Fourth of July celebration in Steamboat Springs, Colorado. The viewer would almost certainly attach these symbols to something truly American in nature, and make a further connection to the American West. ❸ ❻ ❽

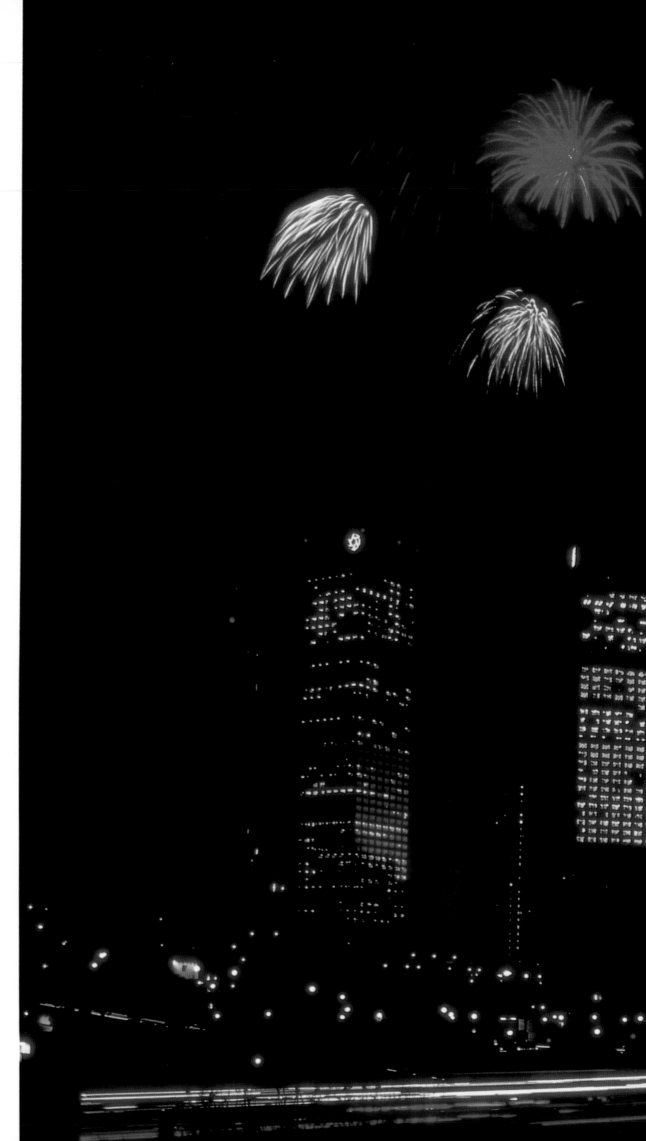

PHOTO-GRAPHING EVENTS

Many visual elements combine to make an exciting photograph of fireworks over downtown Los Angeles. A long exposure on a tripod recorded several bursts of the fireworks, as well as traffic and the lights of the buildings, with a remaining touch of sunset afterglow to outline the buildings.

❸ ❻

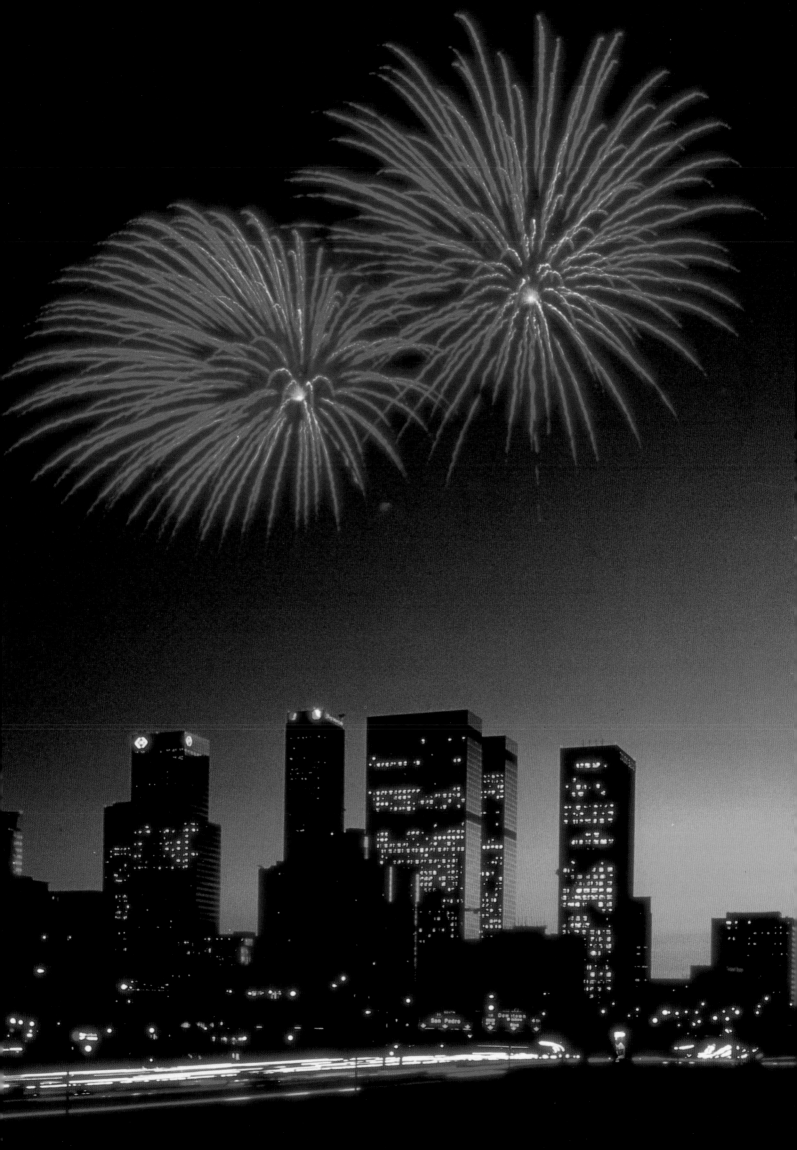

STILL-LIFE PHOTOGRAPHY

Still-life images require particular attention to composition because their appeal is almost equally divided between subject matter and the way it is presented. Besides, a still-life image invites close scrutiny, as it is presenting a static situation. Most commercial still-life work is done on large-format cameras, but it can also be done with 35-mm cameras. Such images are generally given sharp definition, but here the photographer turned an ordinary bathroom sink into a wonderfully impressionistic still-life by using a high-speed film, push-processed to achieve a larger grain structure, and a filter smeared with petroleum jelly to cause the light from the window to streak across the image. ❺ ❻ ❽

LANDSCAPE PHOTOGRAPHY

Unusual weather makes for interesting photographs, and most photographers should explore bad-weather options as well as good ones. A time exposure during the approach of a lightning storm at twilight captured the beauty of this natural phenomenon. Nature here has provided its own version of natural electronic flash, but the unpredictable nature of lightning requires the use of longer exposure times in hopes of catching a bolt on film. Clearing bad weather and a bit of sun helped turn a small Vermont town in winter into a striking image. The dark clouds as a backdrop for the sunlit snow and white buildings create a vibrant natural landscape. The soft color of an overcast day on Cape Hatteras shows the effect bad weather can have upon color rendition of a landscape. Often the sun is refracted through cloud layers in odd ways, and very large shifts in the color of the light can result. ❸ ❻ ❼

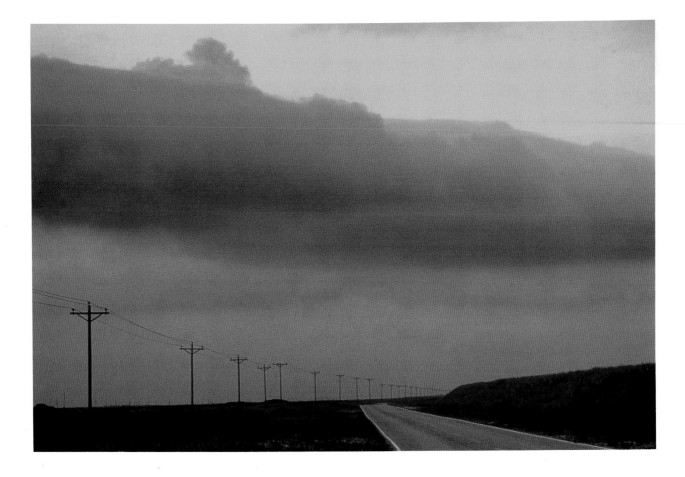

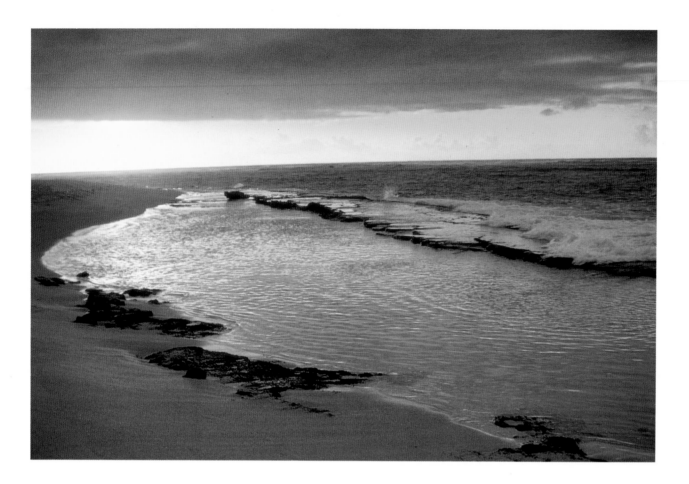

LANDSCAPE PHOTOGRAPHY

By late afternoon the clouds had taken on an orange-red cast that was worth waiting for to evoke the mood in the pier photograph made in the tropics. The beach sunset in Hawaii (above), was enhanced with a color-graduated filter, half of which was orange. By reducing the light from the upper portion of the image, more of the foreground detail could be retained in the same exposure. The creative use of filters can often save a situation where the light is not quite right even though you have waited for the appropriate time of day. ❺ ❻

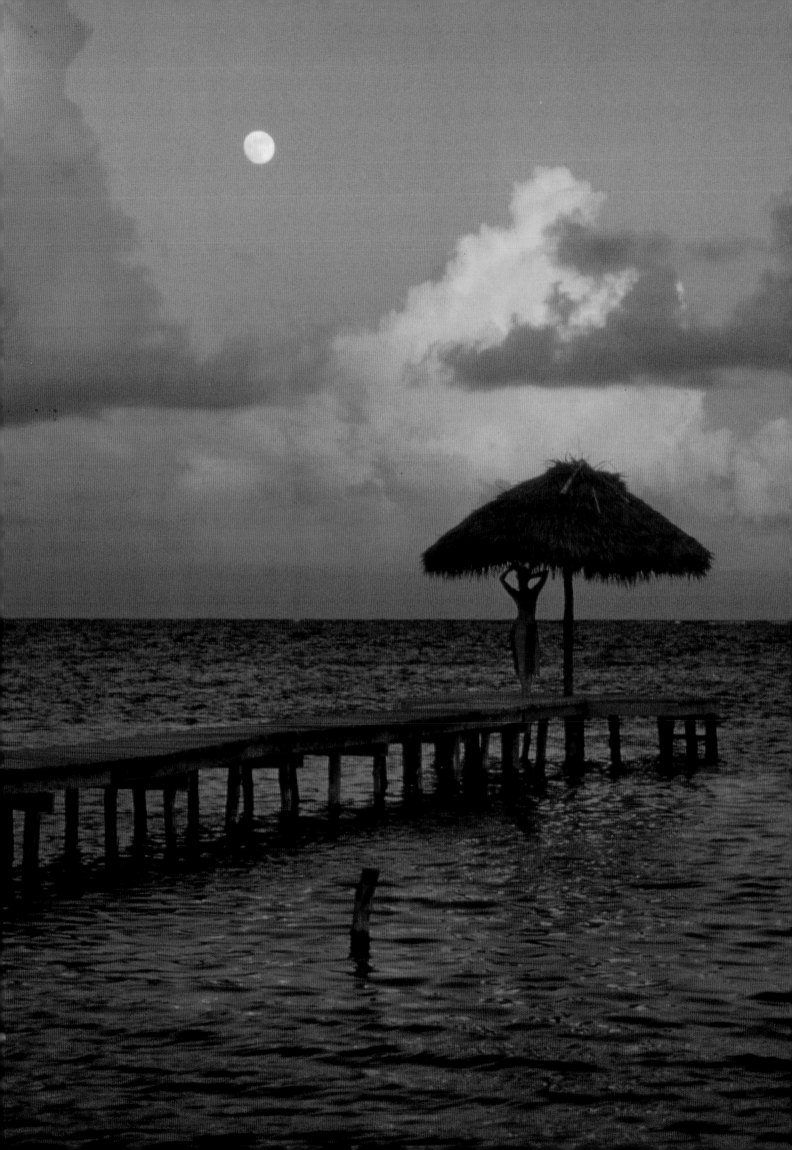

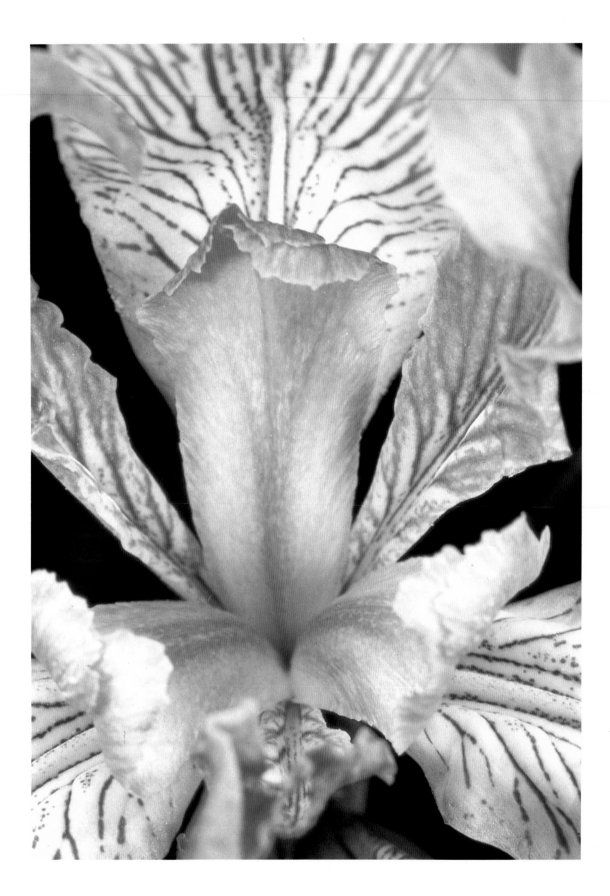

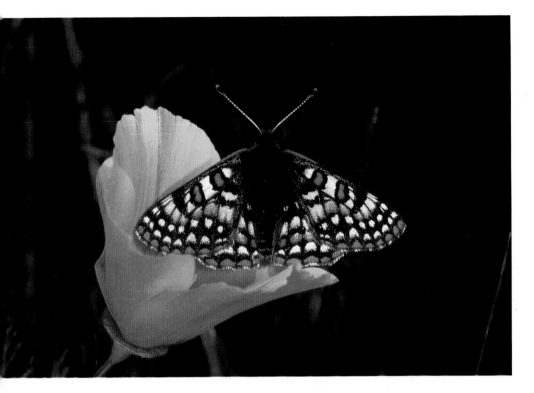

PHOTOGRAPHING FLOWERS

Flowers can be photographed in a multitude of ways: outdoors or in the studio, with electronic flash or by natural light. To obtain a close-up of a flower, you need a macro lens or a close-up auxiliary lens to achieve enough magnification. The composition, particularly the placement of the flower elements within the frame, is essential to the success of the final image. A longer macro or a regular lens with close-focusing abilities can be very useful when butterflies or other insects are present. The increased distance between the lens and the flower or insect can help reduce the human presence that often scares such insects away. Overcast natural light is often best for recording all the details in flower images, as direct sunlight creates deep shadows that obscure the finer areas. ❹ ❻ ❽

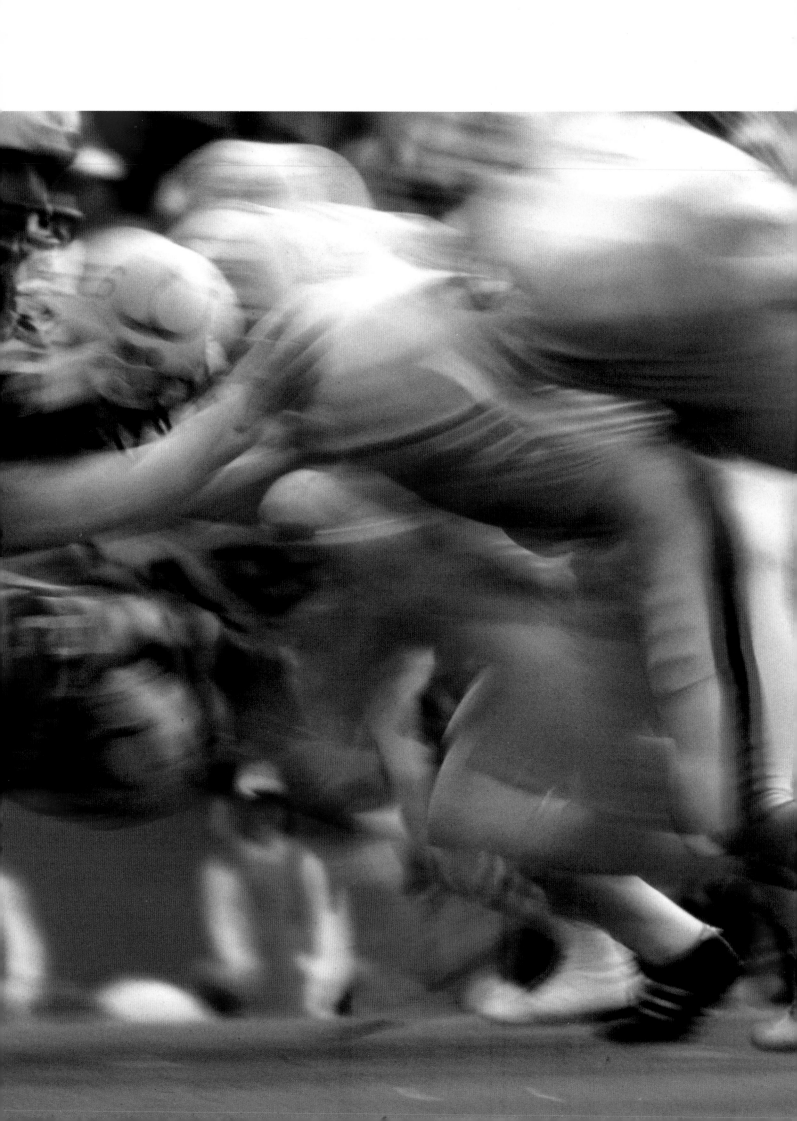

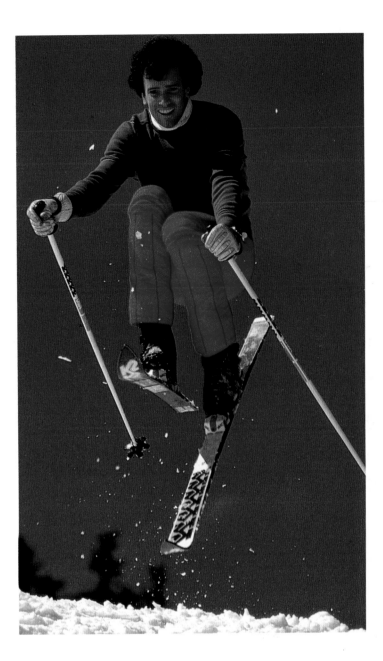

SPORTS PHOTOGRAPHY

The true secret of sports photography is to capture the peak of action that defines the enjoyment or the energy of the particular sport. The downhill skier in midair was caught at the peak of action. It takes practice in coordinating focus, exposure, and timing to be able to create this type of shot consistently. In addition, skill in using a telephoto lens with a wide aperture can help keep you out of the line of action while providing a high enough shutter speed to freeze the moment. The blurred image of football players captures the dynamics of each player at the moment play begins. Using a moderately slow shutter speed with a telephoto lens enabled the photographer to be close to the action visually and to convey a sense of the motion and power of the game that would not have been present in a static, more literal image. ❸ ❹

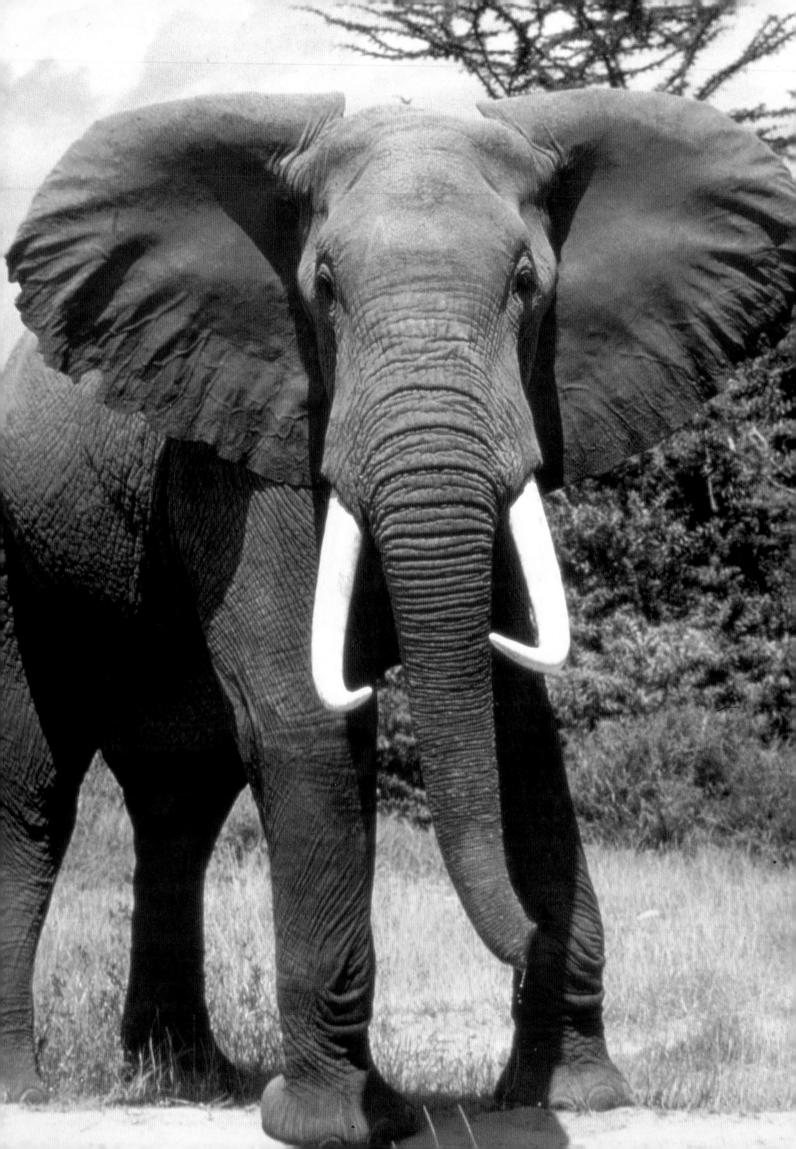

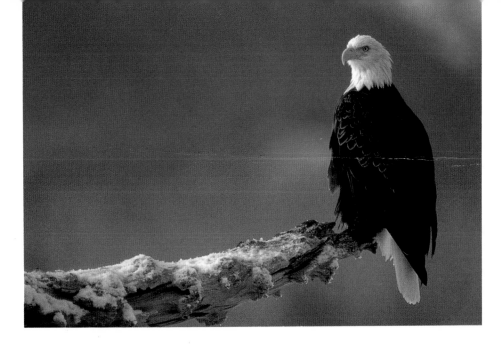

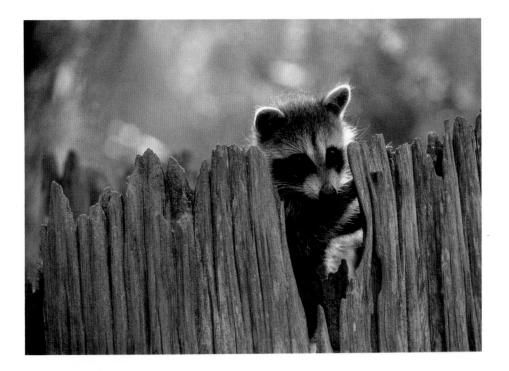

PHOTOGRAPHING WILDLIFE

Medium to very long telephoto lenses are the keys to visual access to many animals. Often from sheer concerns for safety, a telephoto lens is the only way to capture the image of a particular animal. This can be an advantage when photographing animals in a zoo environment because the long focal length and limited depth of field can help remove background distractions and create a more natural look. ❹ ❽

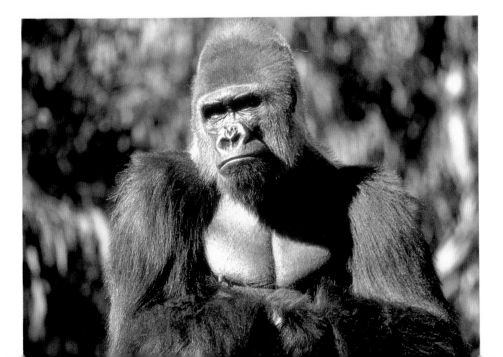

PHOTOGRAPHING ARCHITECTURE

In the outdoor photograph of the house, a natural frame of fall foliage has been employed to provide an interesting visual relief from a more straightforward version of a home shot. The foliage also helps to define the time of year and provide a little more detail as to the location. In photographing the interior of the beach house living room, electronic flash was balanced with the natural light outdoors. The effect created is close to what the eye would perceive in the same situation. Without the flash, the exposure for the interior of the room would cause the outside scene to be overexposed and so nearly invisible; conversely, correct exposure for the outdoors would seriously underexpose the room's interior and leave the viewer, too, in the dark. ❹ ❼ ❽

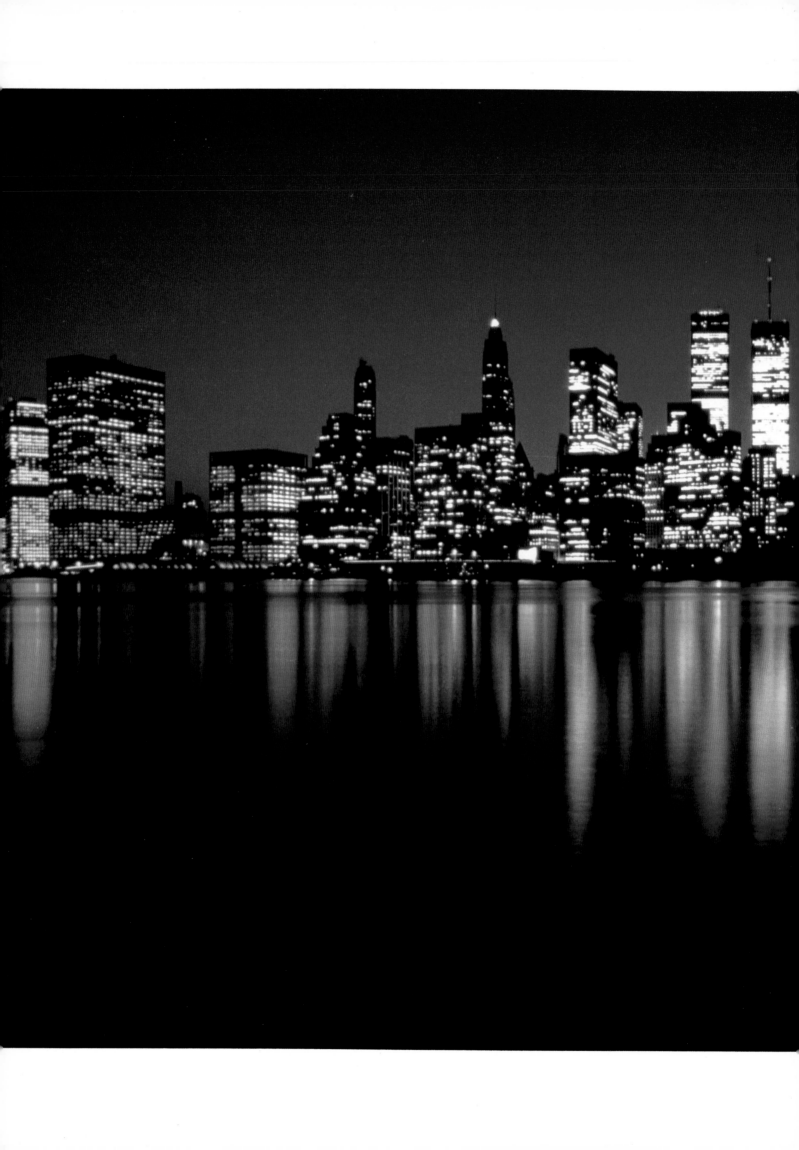

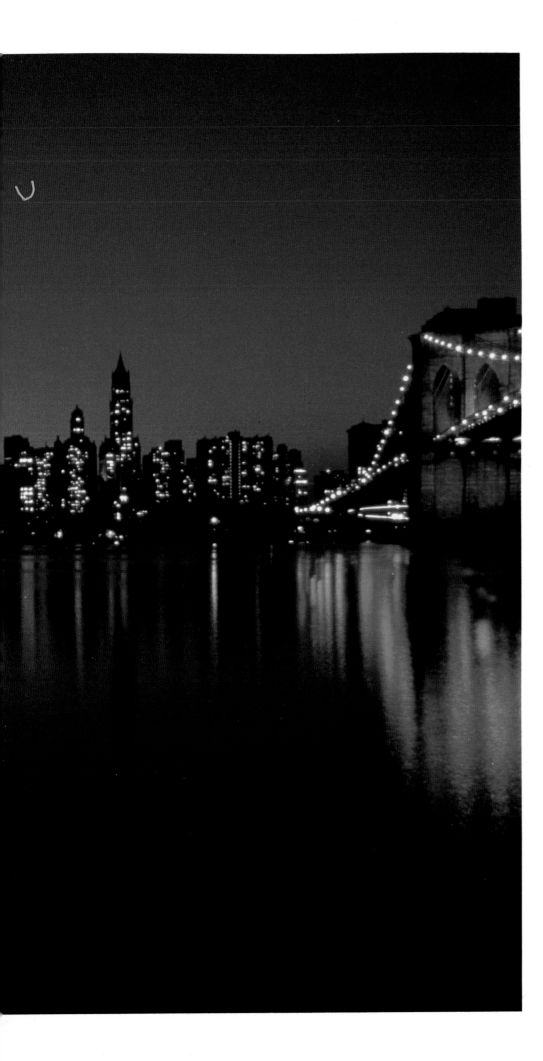

LANDSCAPE PHOTOGRAPHY

The lights and buildings of a city offer great photographic possibilities. In some cases twilight exposures have almost become a cliché, and new ways to show the same old scene are welcome. By an intentional mismatch of film and lighting, a new variation of a familiar theme can be obtained. In this case, it was a tungsten-balanced film exposed for several minutes to capture the lights of Manhattan at sunset. The blue color balance of the film has shifted all the colors to the cool side and neutralized the normally warmer tones of twilight. The very long exposure also smoothed the wave patterns of the water in the foreground, creating an almost mirrorlike effect for this scene of New York. No filtration was used.

❸ ❻

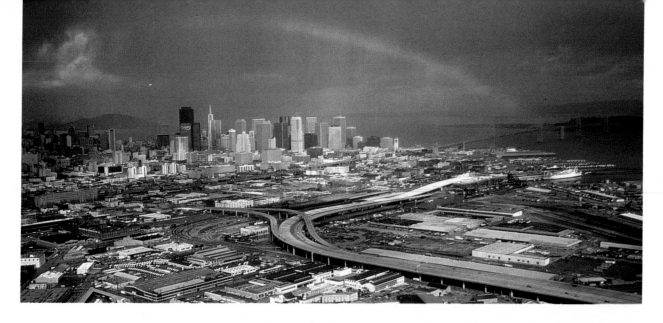

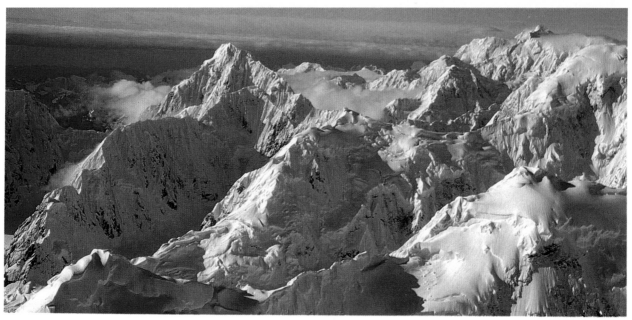

AERIAL PHOTOGRAPHY

Photographing from planes and helicopters often requires both steady nerves and a great deal of patience. Most aerial photographers generally work with either the window or door removed, so that they have a clear field of view outside. For many people, this is enough to cause a great deal of apprehension, if not panic. Lens choices can run from full-frame fisheye lenses up to telephotos of about 200 mm in focal length; longer lenses are too susceptible to vibration from the aircraft engine. Indeed, care must be taken with every lens to use very high shutter speeds to prevent blur from motion or vibration. The practical limit for wide-angle lenses is about 28 mm, but lenses as wide as the full-frame fisheye can be used if you are certain it will not catch any part of the aircraft in the corners of the frame. Although clear days are best for most aerial work, one photographer was able to capture a rainbow over San Francisco in a clearing rainstorm for this great aerial view. When photography is done from any appreciable height, there is always the chance for aerial haze to either turn the color balance to blue or limit visibility over the larger distances. An ultraviolet filter of high strength will help counteract this. The UV 17 filter is ideal for aerial work, and it also provides front-element protection for the lens. Even though the view of the Grand Canyon was not taken from an aircraft, a UV filter enhances the color rendition for the more distant portions of the scene. The shutter speed and lens recommendations of course do not apply to ground-based work from high vantage points. ❹ ❺ ❻

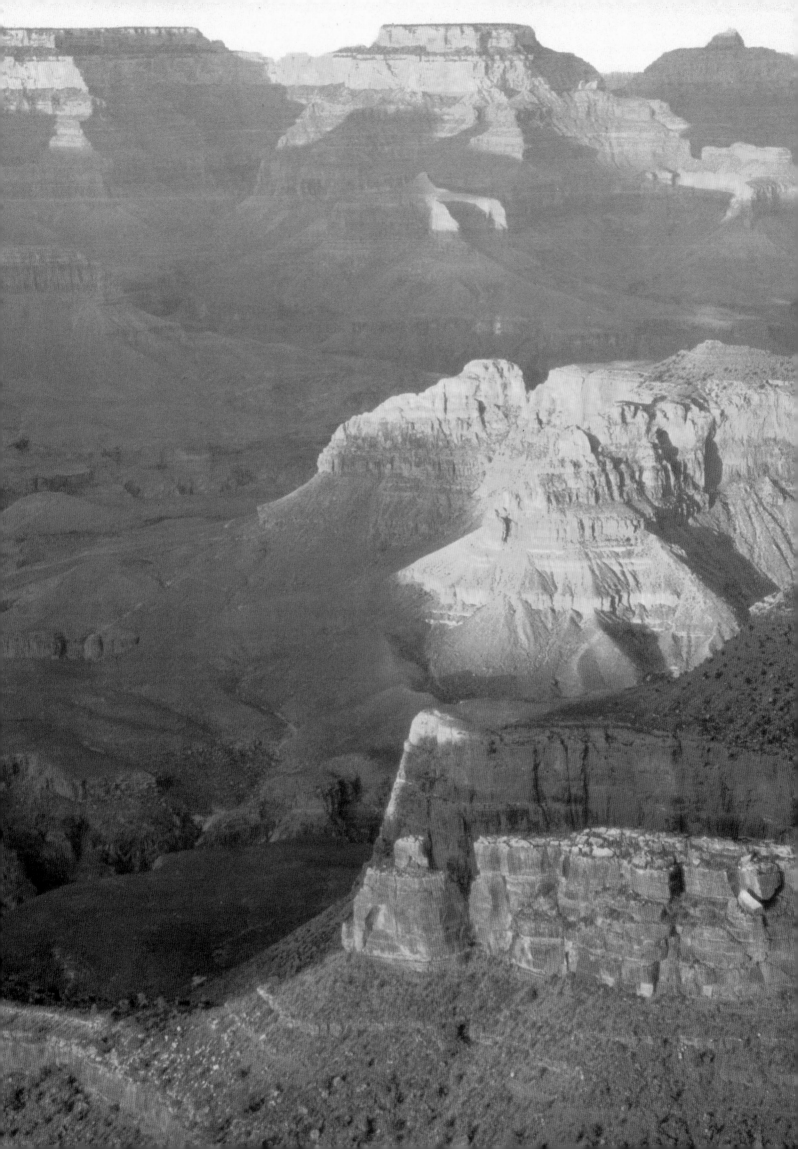

PHOTOGRAPHING MEN

Men can be photographed in an infinite variety of ways, but often the most revealing images are those that include something about the man's personality. A small element added to a straightforward portrait can provide the viewer with some clue to the man's interests and life-style. Direct lighting is frequently used in photographing men because it creates strong contrasts and so tends to invoke a sense of power—even though it brings out more lines on the face. These lines can be seen as adding character. A photographer should be aware of this, as it opens the door for more opportunities to use lighting that would be considered unsuitable for photographing women. The reverse does not happen: Soft-focus and other effects that alter the sharpness of a photograph are still not very well accepted in images of men. And yet, as the traditional role of men changes through social evolution, the manner in which they can be photographed has expanded. Not so long ago, most photographs of men presented them in a very traditional manner. It was unheard of to present a man in anything but a classic, squared-off pose, with stiff shoulders and rigid body position. Introspective views were not popular.

This is beginning to change, and more sensitivity is being revealed in many pictures of men. The photograph of the man reading a book is just such an image. There is nothing classic about the pose on the bench; it shows the man simply as he is, without pretense or role playing. The other photographs here illustrate the variety that can be had within the framework of a simple portrait. Ⓖ Ⓢ

A P P E N D I X

FURTHER RESOURCES

Major Photographic Magazines

American Photographer, Diamandis Communications, Inc., 1515 Broadway, New York, NY 10036

British Journal of Photography, Henry Greenwood & Co., London, United Kingdom.

Studio Light, Eastman Kodak Company, 343 State St., Rochester, NY 14650

Modern Photography, ABC Consumer Magazines, 825 Seventh Ave., New York, NY 10019

Photo/Design, Billboard Publications, One Park Ave., New York, NY 10016

Popular Photography, Diamandis Communications, Inc., 1515 Broadway, New York, NY 10036

The Rangefinder, Box 1703, Santa Monica, CA 90406

Zoom, Zoom USA, P.O. Box 2000, Long Island City, NY 11101

Books on Photographic Technique

This selection of books, some by famous photographers, provides information both on photographic technique and on its use for a wide variety of interests. The books with specific topics in their titles will guide those who seek information on photographing specific subjects.

Bernstein, Gary, *Pro Techniques of People Photography,* HP Books, P.O. Box 5367, Tucson, AZ 85726

Bernstein, Gary, *Pro Techniques of Beauty and Glamour Photography,* HP Books, P.O. Box 5367, Tucson, AZ 85726

Caulfield, Patricia, *Capturing the Landscape with Your Camera,* Amphoto, 1515 Broadway, New York, NY 10036

Eastman Kodak, *The Joy of Photography,* Addison-Wesley, Reading, MA

Eastman Kodak, *More Joy of Photography,* Addison-Wesley, Reading, MA

Eastman Kodak, *The Kodak Workshop Series,* Eastman Kodak Company, 343 State St., Rochester, NY 14650

Feininger, Andreas, *Principles of Composition in Photography,* Amphoto, 1515 Broadway, New York, NY 10036

Hedgecoe, John, *The Art of Color Photography,* Simon & Schuster, 1230 Avenue of the Americas, New York, NY 10020

Livingston, Kathryn E., *Special Effects Photography,* Amphoto, 1515 Broadway, New York, NY 10036

Miller, Peter, and Janet Nelson, *The Photographer's Almanac,* Little, Brown & Co., Boston, MA

O'Connor, Michael, *The Image Bank,* Amphoto, 1515 Broadway, New York, NY 10036

Sharabura, Richard, *Shooting Your Way to a $-Million,* Chatsworth Studios, 76 Hazelton Ave., Toronto, Ont. M5R 2E2, Canada

Shaw, John, *The Nature Photographer's Complete Guide to Professional Field Techniques,* Amphoto, 1515 Broadway, New York, NY 10036

Books by Famous Photographers

Included here are several works by famous photographers. Some of these are monographs—collections of an individual's work. In others, the photographers write about their own personal style and their approach to photography.

Carroll, Don & Marie, *Focus on Special Effects,* Amphoto, 1515 Broadway, New York, NY 10036

Farber, Robert, *Professional Fashion Photography,* Amphoto, 1515 Broadway, New York, NY 10036

Gordon, Larry Dale, *The Versatile Photographer,* Amphoto, 1515 Broadway, New York, NY 10036

Haas, Ernst, *Realms of Light,* Walker & Co., New York, NY

Meyerowitz, Joel, *Cape Light: Photographs by Joel Meyerowitz,* New York Graphic Society, Boston, MA

Meyerowitz, Joel. *St. Louis and the Arch,* New York Graphic Society, Boston, MA

Muench, David and Edward Abbey, *Desert Images: An American Landscape,* Harcourt Brace Jovanovich, New York, NY

Satterwhite, Al, and Joy Satterwhite, *Satterwhite on Color and Design,* Amphoto, 1515 Broadway, New York, NY 10036

Turner, Pete, *Photographs,* Harry N. Abrams, Inc. 100 Fifth Avenue, New York, NY 10011

Photography Career Guides

Brackman, Henrietta, *The Perfect Portfolio,* Amphoto, 1515 Broadway, New York, NY 10036

Gambaccini, Peter, *Getting to the Top in Photography,* Amphoto, 1515 Broadway, New York, NY 10036

Rosen, Frederic W., *Promoting Yourself As a Photographer,* Amphoto, 1515 Broadway, New York, NY 10036

Books on Photographic Esthetics

Here are two books that are unusual in the photographic book world. They do not present a great deal of information on equipment in specific terms but do convey much information on developing a sense of "seeing" pictures before they are made. Both cover many important aspects, from film choice to composition, and are excellent reading.

Patterson, Freeman, *Photography for the Joy of It,* Van Nostrand Reinhold, Toronto, Ont., Canada

Patterson, Freeman, *Photography and the Art of Seeing,* Van Nostrand Reinhold, Toronto, Ont., Canada

Photographic Organizations

The groups listed below are the major professional photographer's societies in the United States. Each maintains a national headquarters as well as many regional chapters. To find the chapter nearest you, write to the national office listed here.

Advertising Photographers of America (APA), 45 East 20th St., New York, NY 10003

American Society of Magazine Photographers (ASMP), 419 Park Ave. South, New York, NY 10016

Professional Photographers of America (PP of A), 1090 Executive Way, Des Plaines, IL 60018

INDEX OF PHOTOGRAPHERS

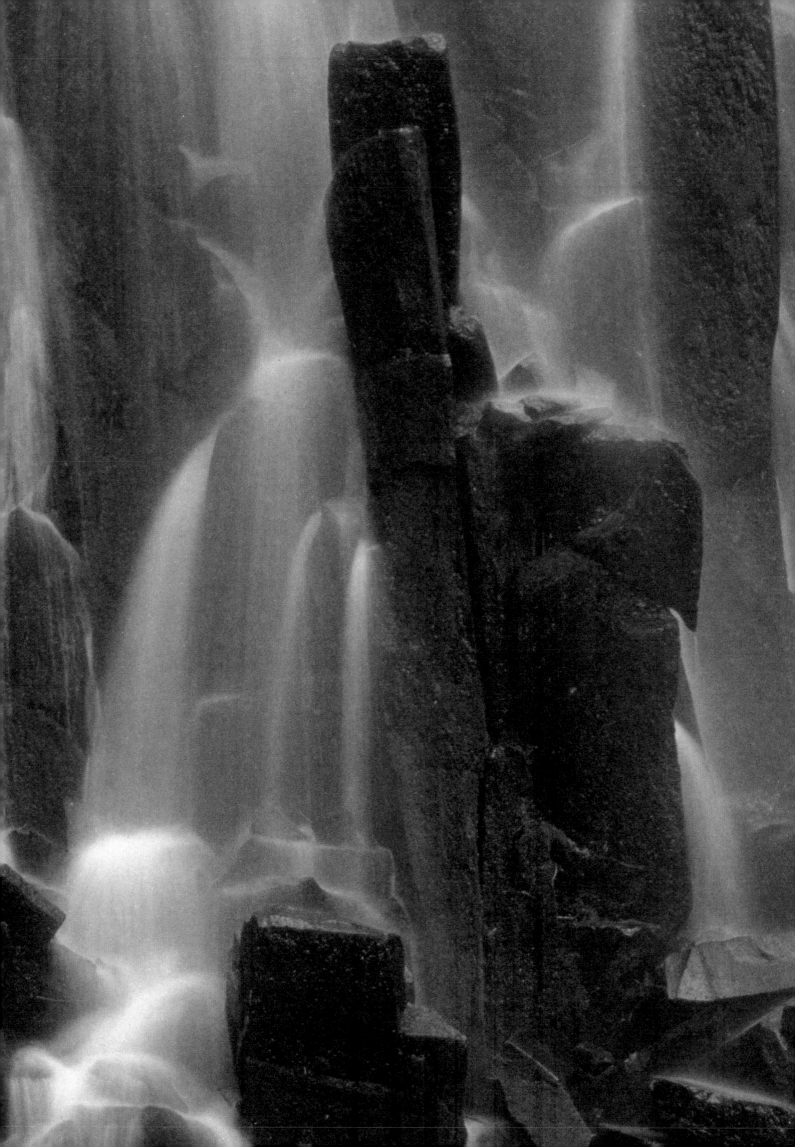